MW00787434

EMBROIDERY

– The Art of Stitches –

GINGKO PRESS

EMBROIDERY

The Art of Stitches

First Published in the USA and in Europe in 2021 by

GINGKO PRESS

Gingko Press, Inc.
2332 Fourth Street, Suite E
Berkeley, CA 94710 USA
Tel: (510) 898 1195
Fax: (510) 898 1196
Email: books@gingkopress.com
www.gingkopress.com

Gingko Press Verlags GmbH
Schulterblatt 58
D-20357 Hamburg / Germany
Tel: +49 (0)40-291425
Fax: +49 (0)40-291055
Email: gingkopress@t-online.de

ISBN 978-1-58423-768-6

By arrangement with
Sandu Publishing Co., Ltd.

Copyright © 2021 by Sandu Publishing
First published in 2021 by Sandu Publishing

Sponsored by Design 360° — Concept & Design Magazine
Edited and produced by Sandu Publishing Co., Ltd.
Book design, concepts & art direction by Sandu Publishing Co., Ltd.

Chief Editor: Wang Shaoqiang
Executive Editors: July Wu, Katherine Ye
Copy Editor: Kim Curtis
Designer: Pan Yuhua

Cover embroideries by Georgie K Emery, Kseniia Guvesa, Mariam Satour
Cover illustration by Youngjin Jang
Cover Design: Pan Yuhua

info@sandupublishing.com
sales@sandupublishing.com
www.sandupublishing.com

All rights reserved. No part of this publication may be reproduced or transmitted
in any form or by any means, electronic or mechanical, including photocopy,
recording or any information storage and retrieval system, without prior permission
in writing from the publisher.

Printed and bound in China

CONTENTS

EMBROIDERY ARTISTS

023

INDEX

217

ACKNOWLEDGMENTS

224

PREFACE

Slow, but Wonderful

By Amy Jones

How exciting it is to be creating in an age where embroidery isn't confined to pretty flowers on hankies or pillowslips, and isn't considered just a women's hobby. Yes, the history of embroidery has given so much in terms of technique and imagery, but it has now become a form of abstract expression and experimentation. More than a craft, embroidery is art. Contributors in this book are not merely crafters, they are textile artists utilizing all the wonderful properties of embroidery and fabric to create new narratives. Welcome to *Embroidery: The Art of Stitches*.

Embroidery equals time. It is a fleeting idea placed on fabric one stitch at a time. In fact, it is so very time-consuming that one must have extreme patience. One leaf, one hour. One face, 10 hours. Some may think this is a downfall, but it becomes a meditative process. Up, down, over, under. Often the mind wanders, thinking of the next idea or concept before the current piece is even complete. Sometimes a piece morphs and changes as stitches are placed—the idea at the beginning is no longer the same by the end. Time seems to slow down when stitching—the cadence and rhythm of hand movement combined with fine detailing make the stitcher absorbed in the work. Therefore, not only should a piece be appreciated for its image and its story, but it should also be respected for the time taken to create it.

Time is inherent in the piece. Slow as it is, embroidery is also wonderful because it provides artists with diverse approaches to self-expression and provides space for experimentation.

The process of creating embroideries is, of course, different for all. Oftentimes, the stitcher sketches the idea on paper first, then transfers that onto fabric to begin. Even with a detailed template, the first pierce with the needle through the fabric is exhilarating because you will never know how the sketch will translate to thread.

Maybe the stitches will need to be unpicked or mistakes stitched over. Some of the artists may even freehand their stitching, going where the needle takes them. With each stitch, the embroidery emerges, and finally an idea comes into being. Once the stitching is complete, the artist must decide how best to display their work. Fabric is extremely versatile and can be manipulated in many ways. Wall hangings, hoops, wrapped canvas, clothing, and so on, the options are limitless.

Just like the medium of embroidery, technique and stitch types are so very broad. From disciplined blackwork to free-form needle painting, most embroidery artists have a distinct set of stitch techniques they commonly use. Not all techniques are necessarily learned through dog-eared library books or YouTube tutorials, however. The key is experimentation. Play with the thread, colors, and texture. Do you prefer thread of one strand or six? Blue or green? Coarse or soft? For instance, by experimenting with long and short stitches, needle painting makes images come to life, not only in terms of the form, but also the texture. Even for the experienced embroiderer, every piece is the result and the process of learning at the same time.

As artists experiment and play, embroidery is becoming more multidisciplinary in terms of commonly used combinations of techniques and materials. New trends are emerging of stitching over painted backgrounds, adding punch rug hooking for more texture, even photos can be stitched on. Background fabric, the base of the story and another layer for the artist to express their vision, can be frayed and delicate, thick or see-through. Sometimes a piece looks better viewed from behind where the intention is not as forced and abstraction is the aim.

Texture is yet another way to tell the story. Bobbly, smooth, fluffy, shimmery are all textural properties embroidery possesses. Embroidery is often so enticing that viewers want to go up close, stare at, and touch the work. Stitches can be overlapped to create three-dimensional illusions, stitches can be woven, and knots can be made on the surface. Metallic thread creates shimmers and flashes of light. Texture is a great instrument to create a focus, to make the viewer look at a certain part of the narrative.

Unlike many other art forms, embroidery has one big bonus: it is portable. No need to haul around an easel, potter's wheel or loom. Embroidery can be picked up and placed down whenever and wherever you are. It is perfect to do while sitting outside, in front of the fire or perhaps from the bed. It can be made while traveling the world or even on an airplane. All you need is good lighting. It is also easy to stop and restart as you please. Stitch around the kids' interruptions or during the commercial break of your favorite show. To have your work with you wherever you go is an incredible reason to love embroidery even more.

There has been an influx of interest in embroidery in recent years. Could the reason be the desire to slow down, to be present? To achieve something that takes patience? To try something new? Maybe it's a less intimidating choice of art considering the few materials needed and the low cost to begin. A combination of all of these has given the art of embroidery new life. New styles have emerged. New non-traditionalists are pushing the limits of what thread and fabric can do. It is fascinating to watch and be a part of.

You are invited now to delve into this embroidered world with these insights in mind—the time they took to create, the techniques used, the process, and the storytelling. All artists featured are so different and distinct, and yet all use similar tools. They are all on a journey exploring new ways of embroidering, pushing boundaries of the past, and what has been done before. Enjoy peeking into the artists' minds and studios, and you may even gain some new inspiration of your own.

EMBROIDERY BASICS

WHAT TOOLS DO WE NEED?

By Youngjin Jang

1. Scissors

Two sizes of scissors are needed for embroidery—a larger one for cutting the fabric and a smaller one for cutting the threads. Any kind of scissors with sharp blades is helpful, you may just choose the one with a design you like to make the experience of embroidering more enjoyable and less boring.

2. Embroidery needles

Within the large range of embroidery needles, sizes 3–9 are mainly used. Bigger numbers correspond to smaller needle eyes and points. Thus, you might coordinate the size of the needle with the number of strands of embroidery floss. For example, when using a size 3 needle, you usually pick six strands of floss; when using size 9, you might pick only one strand.

3. Thread

There are many different kinds of thread. DMC thread 25 is commonly used for beginners. One bundle of DMC thread 25 is made up of six strands of floss, so you might need to separate them beforehand. For embroidery, cutting the thread to 20 inches is recommended. If the thread is too long, it might get tangled easily.

4. Bobbins

Bobbins are for organizing the embroidery floss. You can wrap the floss around bobbins and put them in a box. Well-organized bobbins can help you to find the specific thread you need easily.

5. Thimble

A thimble might not be necessary, but with it you can better protect your fingertips. For some particular stitches like the French knot or bullion rose, wearing a thimble might help you to finish it more easily.

6. Embroidery hoops

Using hoops allows you to maintain even pressure during stitching. They are especially helpful when you are using stitches like satin stitches or long and short stitches that need long, straight lines. Smaller hoops within 10 cm are recommended because you can grab them in one hand.

7. Fabrics

Fabrics commonly seen in embroidery include cotton, linen, Aida cloth, and so on. Soft, but also solid fabric is the best. 10 to 30 counts are recommended.

8. Pin cushion

A pin cushion offers you a place to rest the needles during a break. Yet, if you prefer to take the tools and materials with you, a portable needle case is a better choice.

9. Pens

A water-soluble pen is helpful for you to draw your own design on fabrics. The ink will disappear when soaked in water. An erasable pen can be another option. In this case, the ink will disappear if exposed to heat over 140°F (60°C). Be careful not to heat it for too long.

Youngjin Jang is a Korean embroidery designer. To share the joy of embroidery, she runs a craft shop named "ette" in Seoul, South Korea. Most of her artwork is inspired by ordinary things around us. She has completed a course given by Japan Handicraft Instructor's Association, and is teaching embroidery through video lectures and face-to-face classes.

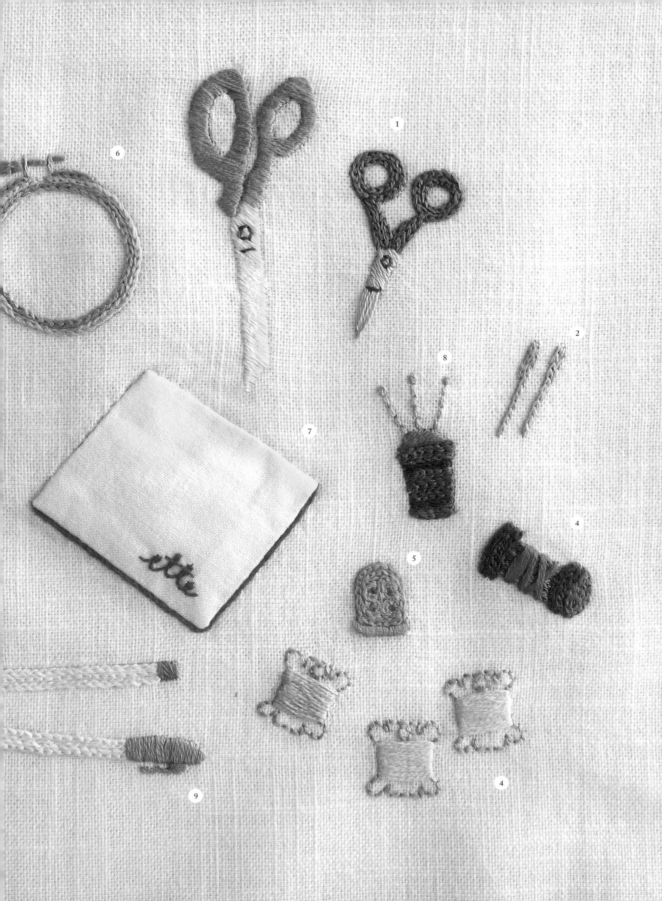

HOW TO MAKE STITCHES

By Youngjin Jang

*Note: *o*—the starting point; *a*—the point the needle goes in; *b*—the point the needle comes out; *oa*, *ob*, *ab*—sections between each two points; ✳—difficulty of each stitch.

1. Back Stitch ☆ ☆ ☆ ☆ ✳

From point *o*, insert the needle at point *a* against the direction the line goes, pull it up at point *b* (line *ob* is the same as line *oa*), and keep repeating. If seen from the back of the fabric, sections of the thread are overlapping.

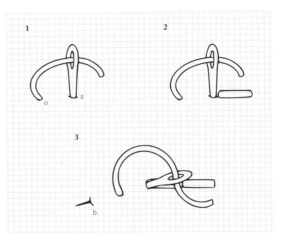

2. Outline Stitch ☆ ☆ ☆ ☆ ✳

Start from point *o*, insert the needle at *a*, and bring out the needle at *b* (line *ab* is half of line *oa*). Make sure that the floss is always beneath the needle. As a result, each stitch overlaps the other a little bit.

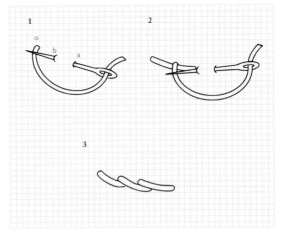

3. Chain Stitch

☆ ☆ ★ ★ ★

After pulling up the needle from point o, make a circle with thread, insert the needle again at o, and come up from point b simultaneously. Before straightening the thread, make sure the needle goes above the circle.

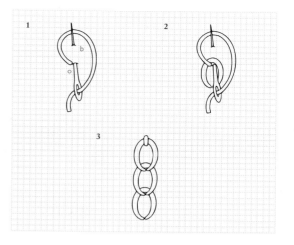

4. Bullion Stitch

★ ★ ★ ★ ★

Start from point o, insert the needle below at point a, and pull it out again at o. Before pulling out the needle fully, wind the thread around the needle till the wrapped part is as long as line oa. Hold the wrapped thread and keep pulling it until tight, and insert the needle downwards to fix the stitch.

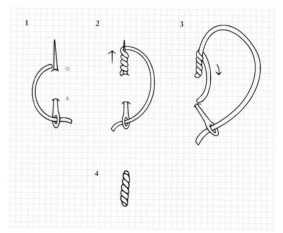

5. Spider Web Stitch

☆ ★ ★ ★ ★

Embroider eight straight lines from the peripheries to the center and then pull the needle out close to the center. Go through the next two branches from below and repeat in order, wrapping the branches until the end. Once finished, insert the needle right under one of the branches.

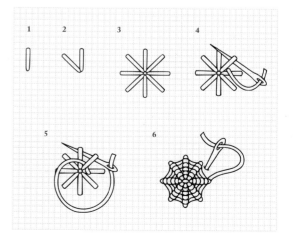

6. Spider Web Rose Stitch

☆ ☆ ★ ★ ★

Make a Y shape, pass the thread beneath the two branches, and bring the needle up next to the center. Go through one branch from below and pass the next one from above in turn until the branches are hidden. Finally, bring the needle down along an outer line of the rose.

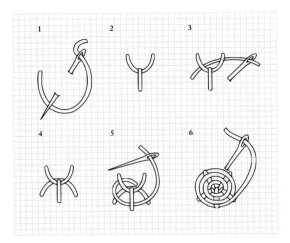

7. Satin Stitch

☆ ☆ ★ ★ ★

The satin stitch is used to fill an area with a series of straight stitches. First, draw the area to be filled to guide the satin stitch. Pull the needle up and push the needle down just like straight stitches, repeat this action closely until the area is filled.

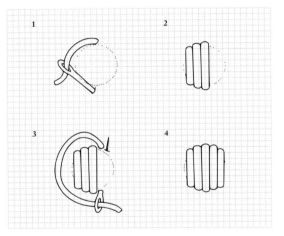

8. Long and Short Stitch

★ ★ ★ ★ ★

Embroider a long straight line and a short one in turn. You could keep the same lengths throughout the process and fill the design like stacking bricks. Making the stitches in random lengths is also a good option for mixing different colors.

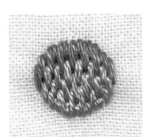
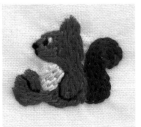

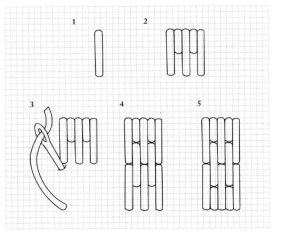

9. Blanket Stitch

☆ ☆ ☆ ★ ★

The blanket stitch can be commonly found decorating the fabric's edge or outlining patterns. Start from point *o*, insert the needle down at point *a* and bring it at *b* which aligns to *o*, making a reverse *L*-shape with the thread. Repeat as needed.

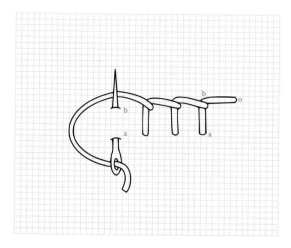

10. Leaf Stitch

☆ ☆ ★ ★ ★

Start from a short straight line, bring the needle up on one side of the line. Insert it symmetrically on the other side of the line, and push it diagonally down, right below the line. Meanwhile, pull the needle up over the thread. Repeat until a leaf shape is made.

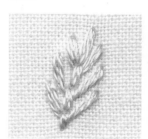
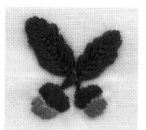
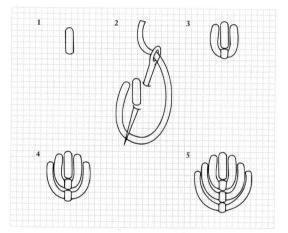

11. French Knot

☆ ☆ ★ ★ ★

To start, pull up the needle and wrap it with the floss two times. Then, insert the needle right beside the beginning point. Be sure not to pull the thread too fast or it will get tangled easily.

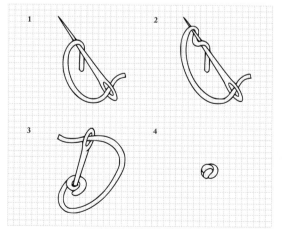

Tiny Embroidery Motifs

By Youngjin Jang

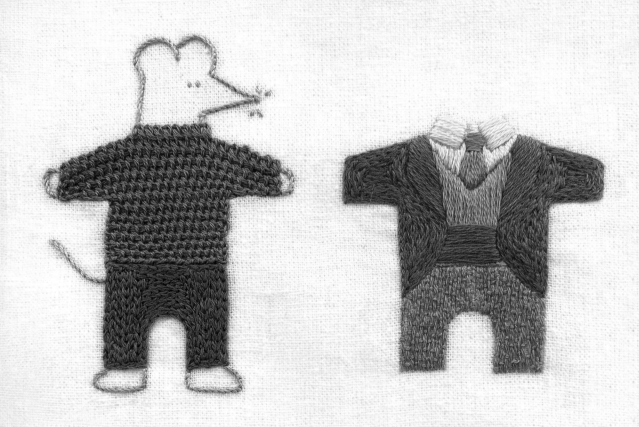

Dress Up Game

As 2020 was the Year of the Rat, Youngjin Jang made a design to celebrate the new year. When making the motifs, she felt it was hard to choose the clothes for the rats, so she decided to draw every piece of clothing that she liked and made the whole piece of embroidery a "Dress Up Game."

❖

Tools: Needle, hoop, scissors

Materials: Linen, DMC thread, printing fabric, silk ribbon

Stitches: Detached buttonhole stitch, buttonhole stitch, chain stitch, outline stitch, straight stitch, split stitch, satin stitch, couching stitch, back stitch, long and short stitch

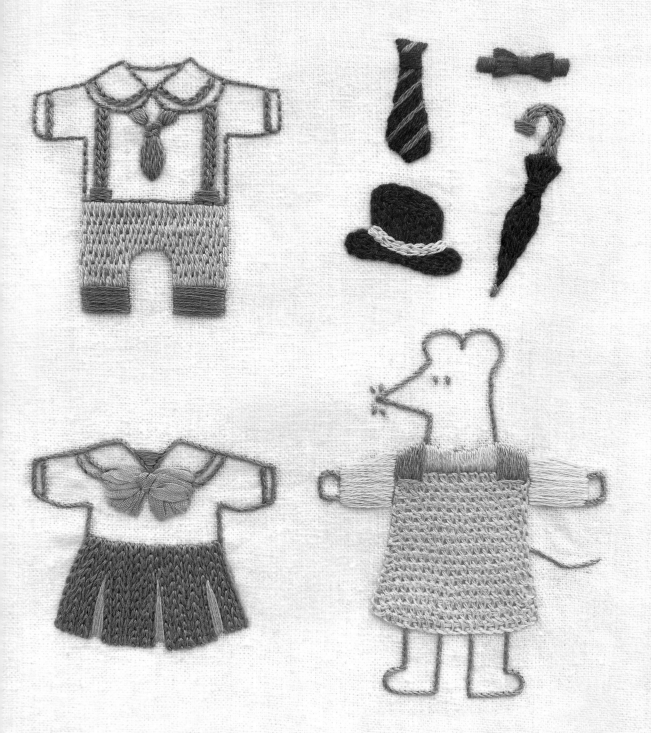

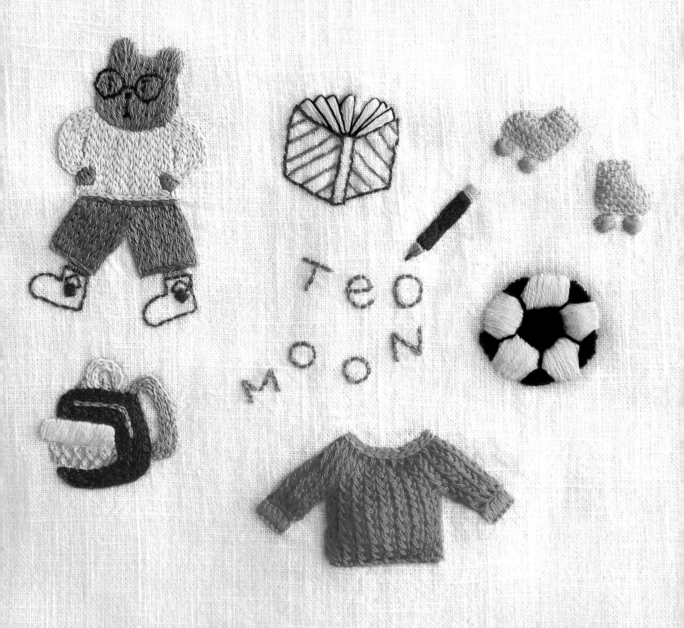

The Day of Teo

Youngjin always had a dream to illustrate a fairy tale book, so she designed this motif imagining she was making a cover for the book. "Teo" is the imaginary character who might be in the book.

⊠

Tools: Needle, hoop, scissors

Materials: Linen, DMC thread

Stitches: Long and short stitch, chain stitch, back stitch, straight stitch, split stitch, detached buttonhole stitch, Ceylon stitch, satin stitch

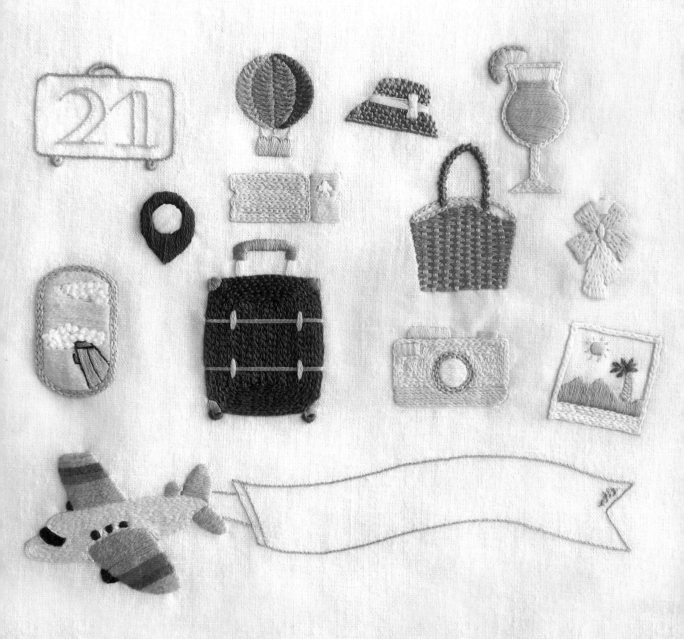

Voyage

Because of COVID-19, traveling was difficult. So, Youngjin designed a set of motifs about traveling, expressing her wish for a pleasant journey.

❌

Tools: Needle, hoop, scissors

Materials: Linen, DMC thread

Stitches: Outline stitch, shadow stitch, bullion ring, chain stitch, satin stitch, buttonhole stitch, detached buttonhole stitch, basket stitch, cable stitch, split stitch

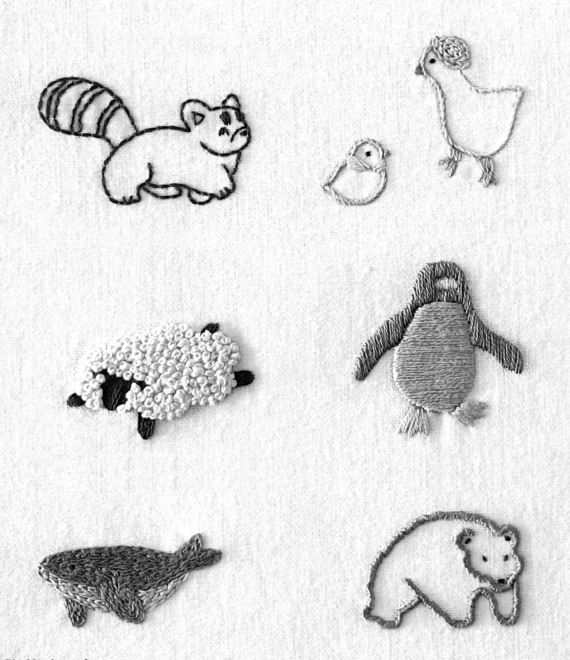

Chubby Animals

Animals are one of Youngjin's favorite motifs. These designs are not only cute, but also easy to make, which makes them popular with beginners.

✄

Tools: Needle, hoop, scissors

Materials: Linen, DMC thread

Stitches: Back stitch, outline stitch, French knot, satin stitch, coral stitch, straight stitch

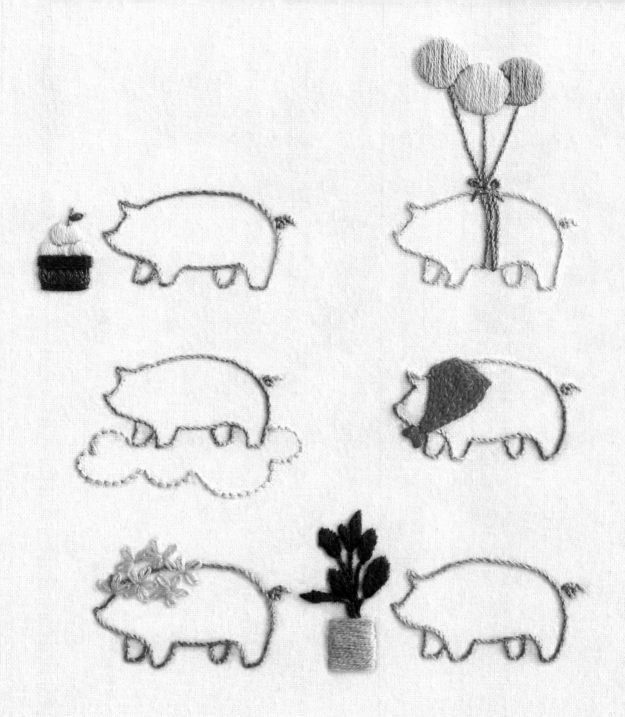

Pig Family

Youngjin made this work in 2019 to celebrate the Year of the Pig. The six pigs are simple line sketches, but any item such as balloons, flowers, clothes, and so on can be added to them.

⁖

Tools: Needle, hoop, scissors

Materials: Linen, DMC thread

Stitches: Satin stitch, outline stitch, lazy daisy stitch, back stitch, leaf stitch, chain stitch

michaelmas daisy

tulip

golden rod

sunflower

globe thistle

bleeding heart

Vintage Flowers

Inspired by a vintage gardening book, Youngjin drew various flowers and tried to make her own garden in fabric with thread.

✂

Tools: Needle, hoop, scissors

Materials: Linen, DMC thread

Stitches: Lazy daisy stitch, French knot, leaf stitch, satin stitch, outline stitch, long and short stitch, flat stitch, split stitch, cable stitch, double outline stitch, raised leaf stitch

EMBROIDERY ARTISTS

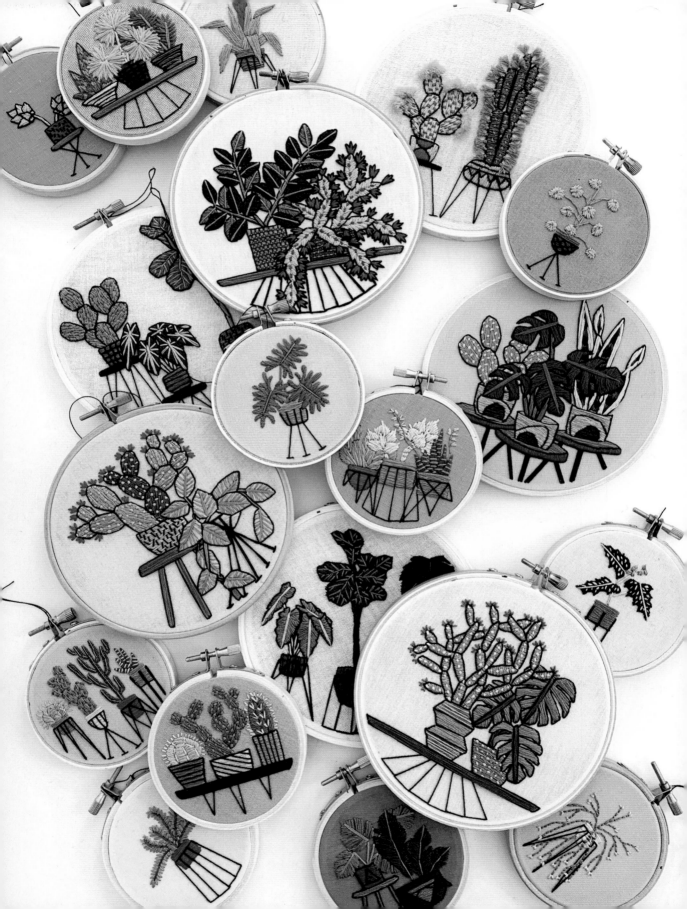

"I don't think I will ever tire of the subject matter as there is so much variety of shape, texture, pattern, and color to be found in plants."

Sarah K. Benning

U.S.

Sarah K. Benning is an artist, educator, and designer working within the realm of contemporary embroidery, creating hand-stitched artworks, thoughtfully designed DIY kits, and digital embroidery patterns. She now works with Davey F. Mandesea—the love of her life and business partner—in their home studio, dedicated to bringing embroidery out of the past and into the present, and blurring the line between art and craft with a contemporary approach to the ancient medium. (Portrait photo by Elizabeth Sanders.)

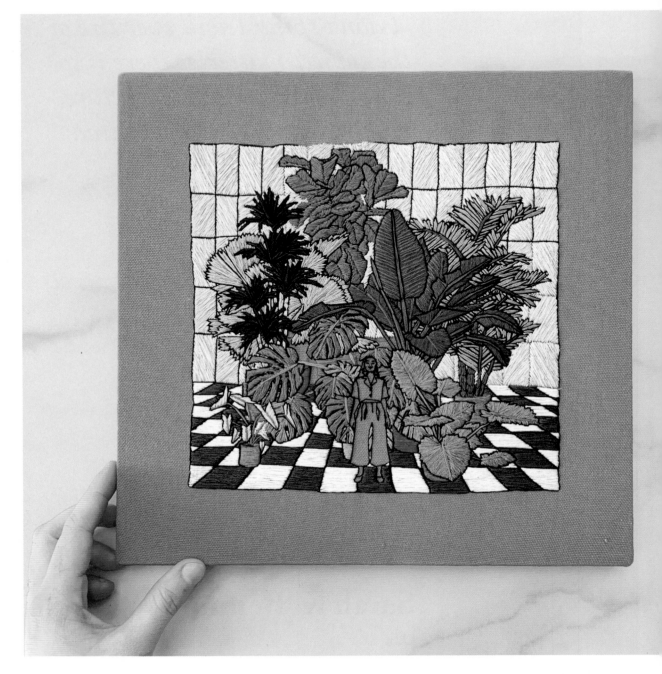

↑ Plant Queen

This original artwork was nine months in the making. It started as an original drawing before being meticulously hand-stitched by Sarah. It was inspired by the towering tropical plants often found in botanical garden conservatories. The figure's confident stance implies the powerful role in maintaining these natural wonders.

⁑

Tools: Needles, wooden frame

Materials: Cotton thread, duck cotton fabric

Stitches: Straight stitch, satin stitch

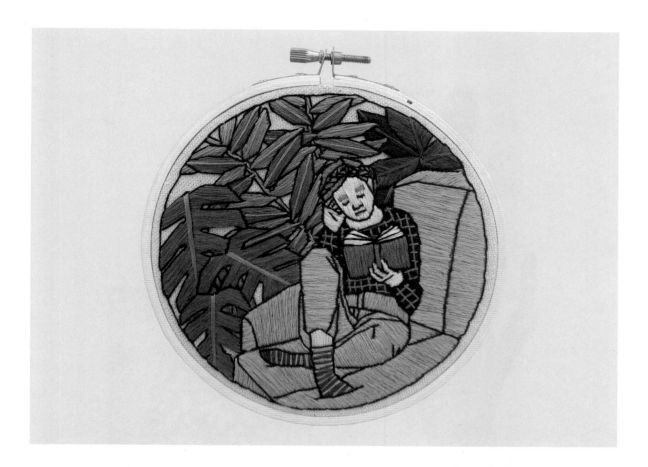

↑ Readers

Sarah creates patterns for her #SKBDIY Pattern Program, through which she shares her techniques and imagery, fosters creativity and community, and cultivates a wilder love for contemporary embroidery. This is one of her six "Readers" patterns with some extra greenery added.

✂

Tools: Needles, wooden hoop
Materials: Cotton thread, fabric
Stitches: Straight stitch, satin stitchh

→ Book Club

Also from her #SKBDIY Pattern Program, this piece is one of the two "Book Club" patterns. She added another layer of fabric on the background as the wallpaper.

✂

Tools: Needles, wooden hoop
Materials: Cotton thread, fabric
Stitches: Straight stitch, satin stitch

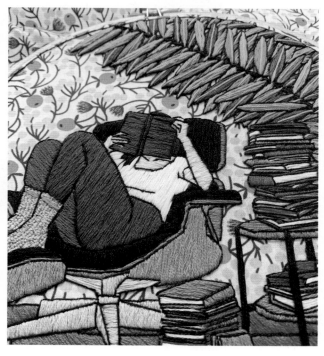

↑ Plant Trio and Grids

A hand-stitched artwork inspired by some of Sarah's favorite potted plants.

※

Tools: Needles, wooden frame

Materials: Cotton thread, cotton yarn, wool yarn, linen fabric

Stitches: Straight stitch, satin stitch, long and short stitch, back stitch

↑ → Best Books of 2019

In 2019, Sarah was commissioned by The Washington Post to create six pieces for the "Best Books of 2019" list corresponding to six topics: romance, thriller/mystery, children's books, science fiction, and two more general "books forward" pieces. Here are two included in the series.

⁛

Tools: Needles, wooden frame
Materials: Cotton thread, fabric
Stitches: Straight stitch, satin stitch

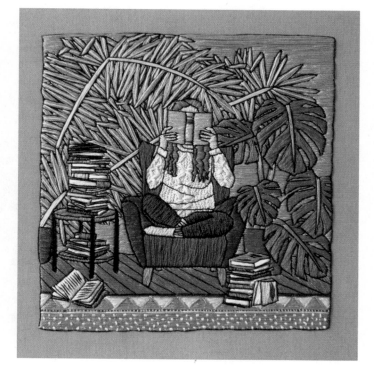

Interview with
Sarah K. Benning

Could you share with us your artistic background? What or who initially attracted you to become a contemporary fiber artist?

As clichéd as it may be, I always knew that I wanted to be an artist. I was so fortunate that my mom supported my dreams and gave me opportunities to pursue art throughout my childhood. Growing up surrounded by artists, I believed that it was a reasonable and viable career path. For high school, I attended the Baltimore School for the Arts and then received my bachelor of fine arts degree from the Art Institute of Chicago. It was only after graduating from college that I turned to embroidery as a medium. At no point did I specifically set out to be a "fiber artist," things just organically evolved that way.

You also run a studio with your partner Davey. How did you start your business?

Our business started as my hobby in 2013 when I had just graduated from college and was working as a nanny. I started playing around with embroidery techniques on paper, and then fabric as a creative outlet—removed from the pressures of living up to my education and making serious work as a fine artist. Over the course of a year and a half, my hobby transitioned into my full-time employment. In 2018, my partner Davey officially joined the "team," though he has been helping me from the beginning. We now work together from our home and run a three-pronged business: I create one-of-a-kind artworks, we develop a range of DIY embroidery products, and I occasionally teach in-person workshops.

When choosing colors, Sarah starts with a single color and all subsequent choices are based on each other. Typically, she pairs colors with equal vibrancies while looking for pops of highly contrasting details.

We always find house plants in your work. What's the connection between your work and plants?

I made my first houseplant pieces about a year into my embroidery journey. Those early works were inspired by my own struggling house plant collection. When a plant died, I stitched it. So, my early pieces were little memorials. Over the years, I have greatly improved at house plant care and don't experience the same casualties as I did, but my house plant collection continues to be a constant source of inspiration in my work. I don't think I will ever tire of the subject matter as there is so much variety of shape, texture, pattern, and color to be found in plants.

Would you like to share with us your creative process?

All of my embroideries begin as original drawings first. I keep sketchbooks of composition ideas and make drawings of our plants from observation that are then manipulated and translated into imaginary scenes in my final embroideries. Once I have worked out the drawing, I either redraw it directly onto my fabric or, if I have been drawing digitally on my iPad, I transfer the design to fabric using stabilizer. Once the composition is on the fabric, it is just a matter of meticulously hand-stitching the design. I usually start with large areas of color using satin stitches and then build up the textures and patterning on top. The surface details are added intuitively and often don't rely on any kind of under drawing. Since embroidery is so labor intensive and I draw much faster than I stitch, I usually work on several pieces simultaneously.

Do you have any tips or tricks for people wanting to get started?

I think patience is key if one is just getting started. Like all things, embroidery does get easier with practice. Although certain techniques may feel clunky and awkward at first, that is only temporary. The best part is that any mistakes can always be corrected—the worst case scenario is just cutting out stitches and trying again.

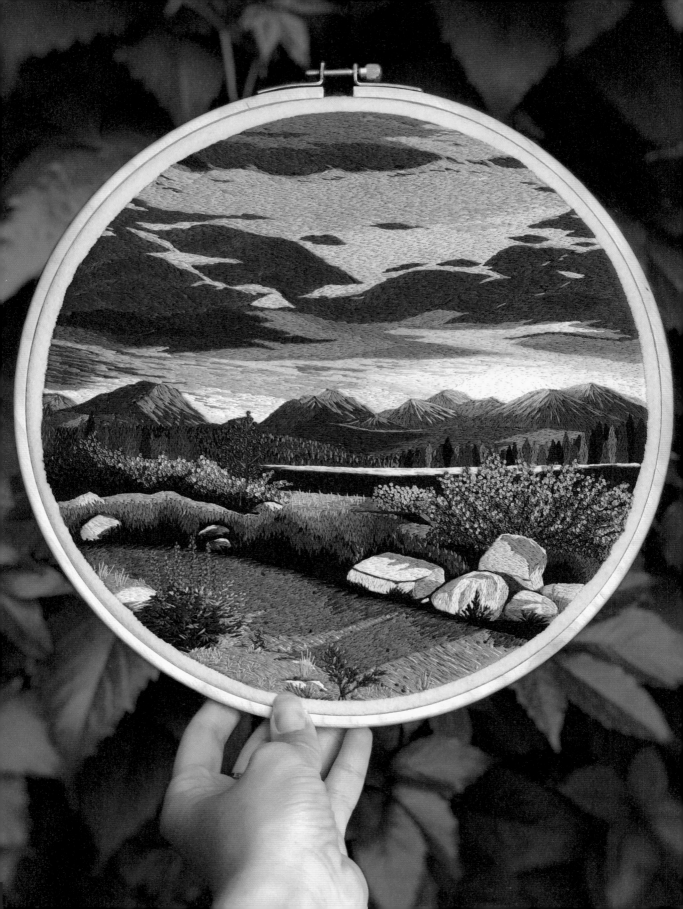

"To me, the best and most indispensable tool is my imagination, which assists me to fulfill what I want."

Tatiana

Russia

Tatiana is a Russian embroidery artist keen on landscapes because to her, embroidery is the best way to feel the vitality of the landscape and literally touch the "sky." Her credo is "the way you share is the way to make people happy."

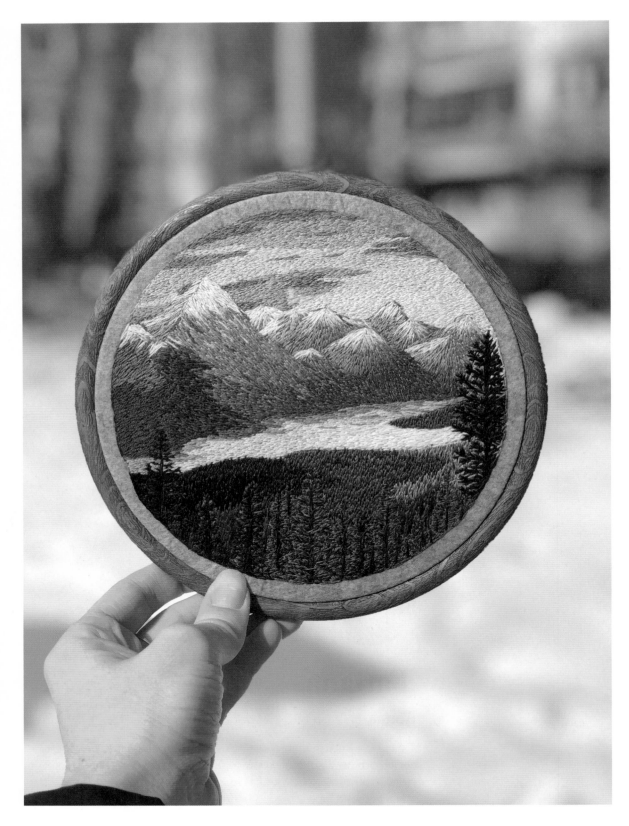

← Calm in the Mountains

This is the first embroidery that Tatiana created. After this work, she started her journey with embroidery and couldn't imagine her life without it.

⁌

Tools: Needles, hoop, scissors

Materials: Cotton threads, felt

Stitches: Satin stitch, long and short stitch

↑ Untitled Work

This embroidery is a commissioned piece based on a photo that the customer provided. Tatiana tried to convey all the colors from the photo and to embroider a very realistic wave.

⁌

Tools: Needles, hoop, scissors

Materials: Cotton threads, felt

Stitches: Satin stitch, long and short stitch, French knot

↓ At the Beginning of the Raising

In this piece, Tatiana mixed the beautiful mountains with a forest in autumn.

⁌

Tools: Needles, hoop, scissors

Materials: Cotton threads, felt

Stitches: Satin stitch, long and short stitch

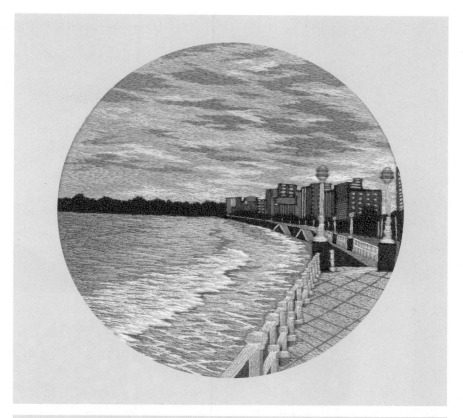

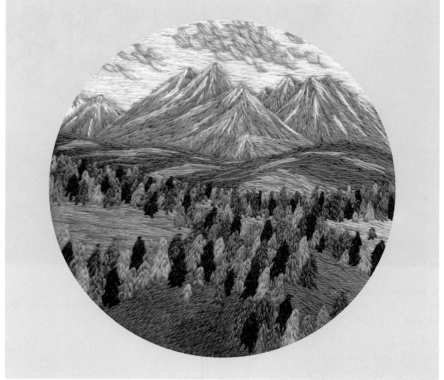

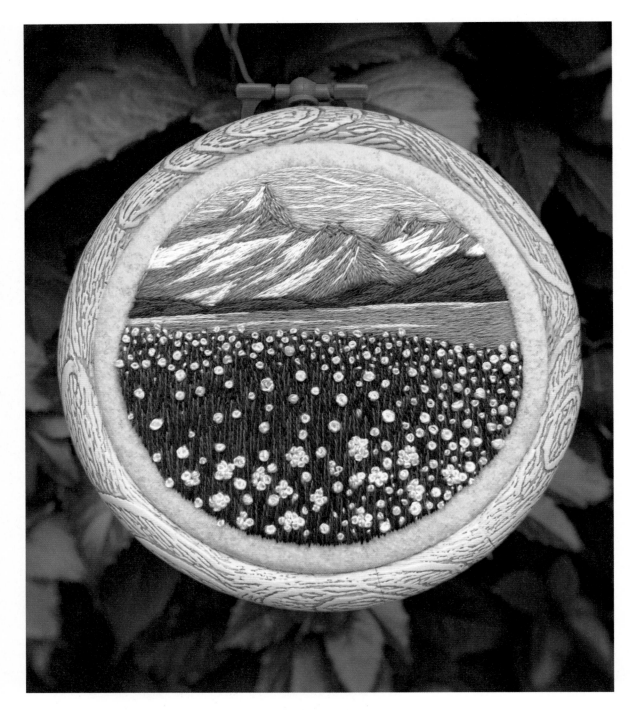

↑ Tenderness

A sea of dandelions, gray mountains, and grass make an ideal mix in this embroidery piece. During the creative process, Tatiana was trying to give it a tender touch.

⁙

Tools: Needles, hoop, scissors

Materials: Cotton threads, felt

Stitches: Satin stitch, long and short stitch, French knot

→ Pink Tulips

This is the first embroidery that Tatiana made for a commission. Spending a lot of time embroidering the tulips and the colorful sky, she wanted to make them realistic.

❖

Tools: Needles, hoop, scissors

Materials: Cotton threads, felt

Stitches: Satin stitch, long and short stitch

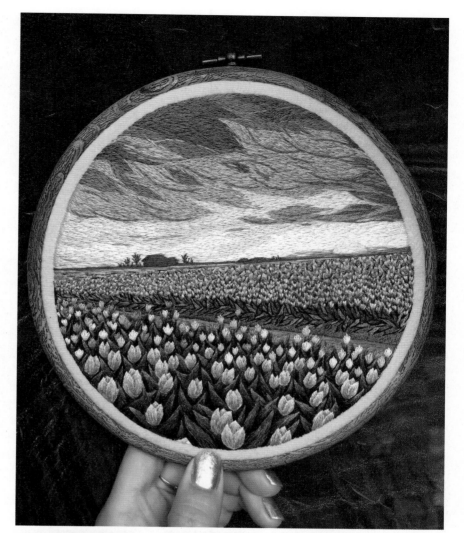

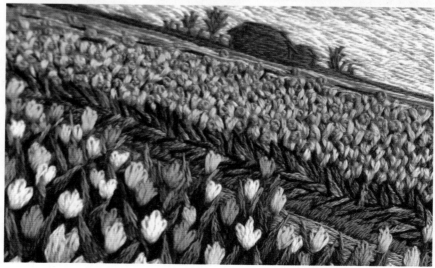

Tutorial

Through the piece of embroidery "Azenhaz do Mar," Tatiana unfolds how she divides a whole piece into sections and how she proceeds with each section using several different stitches and different strands of thread.

Step 1: Draw a draft on the felt with a Thermapen. Pick the colors during the work process.

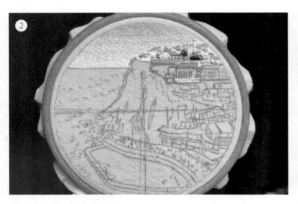

Step 2: Start by embroidering the sky using long and short stitches with two strands of thread. Switch to satin stitch to embroider the houses with two strands and the shadows and windows on the walls and roofs with one strand.

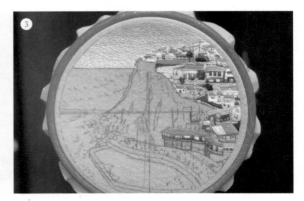

Step 3: Finish the houses and move to embroidering the grass using French knots with two strands of thread.

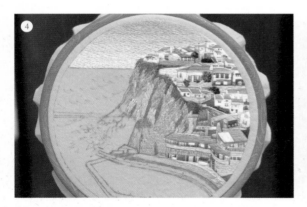

Step 4: Embroider the mountain with two strands using long and short stitches.

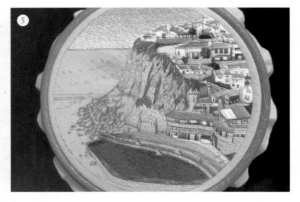

Step 5: Add the shapes of cracks to the mountain and grass. Embroider the sea using threads of viscose for the waves and wool for volume. Cut off the extra fabric from the back side of the hoop to finish the piece.

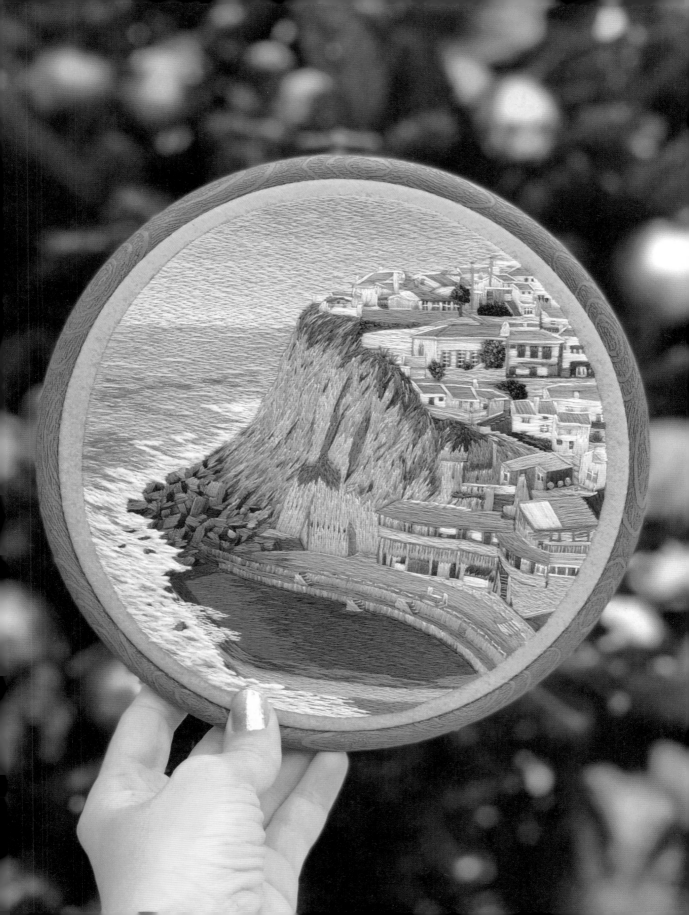

Interview with
Tatiana

How did you start your career as an embroidery artist?

Actually, I never imagined that I would become an embroidery artist. I started by embroidering some landscapes as a hobby and shared them with people all around the world on social media. My technique wasn't difficult to learn. I just drew a beautiful landscape and put it on felt. When I saw a lot of reviews and messages with positive words and wishes, I was very excited about it and couldn't help continuing by embroidering the next landscape.

Why is embroidery special to you?

For me, embroidery makes it possible to feel and touch a landscape. By transforming a picture into embroidery, I can, for example, touch the sky and stroke the sea and grass. Meanwhile, embroidery is also a great way to illustrate my feelings and views, lending me a hand with exploring nature and other different places.

Would you like to briefly share your creative process?

Firstly, I sketch on paper and transfer the draft onto felt. Then I start embroidering and choose the colors at the same time. Sometimes referring to pictures of real landscapes helps me provide a lot of details. After the embroidery is done, I usually do some finishing, such as covering the back of embroidery with a piece of paper and photograph the result.

Do you base your embroideries on real landscapes or ones in your imagination?

I usually base my embroideries on real landscapes by referring to photos and experiencing the natural world myself. Yet, they are more than objective landscapes because I try to communicate a lot of feelings and emotions towards nature in my embroideries.

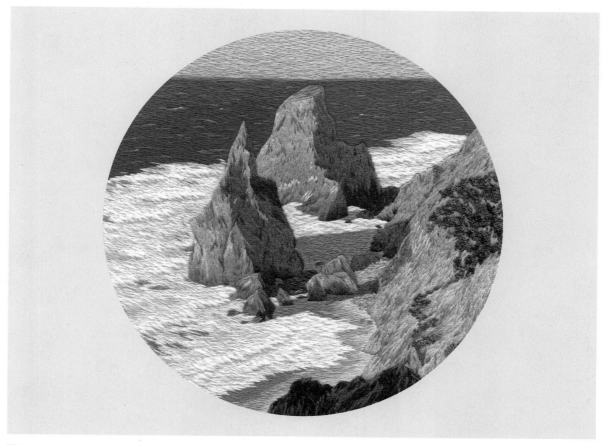

This piece is based on Praia da Ursa, a beach in Portugal.

Your embroideries are colorful and splendid, and the colors you use are bright and bold. Could you share your skills and experiences of working with the color palette?

I don't consider myself to have special skills and I believe that every person has their own skills to do something great and perfect. My advice is not to give up and try as many techniques as you can. Using your imagination and looking at a landscape from the other side are also important. Sometimes adding shadows to the embroidered landscape may lead to surprising results.

Do you have any preference when choosing the tools? What kind of visual effects can they help create?

It depends on which work I am going to do. I usually use different tools and materials for different works, but some tools are the same: a needle, scissors, and thread. Another helpful tool that people might have overlooked is light. With more light, you can attain better results, especially in those colorful embroideries. To me, the best and most indispensable tool is my imagination, which assists me to fulfill what I want.

What have you been working on recently?

Recently, I finished a picture with penguins, which was huge. I like my last work because I embroidered birds for the first time in my life. I can say it was a step up and my skills improved when I was working on that embroidery.

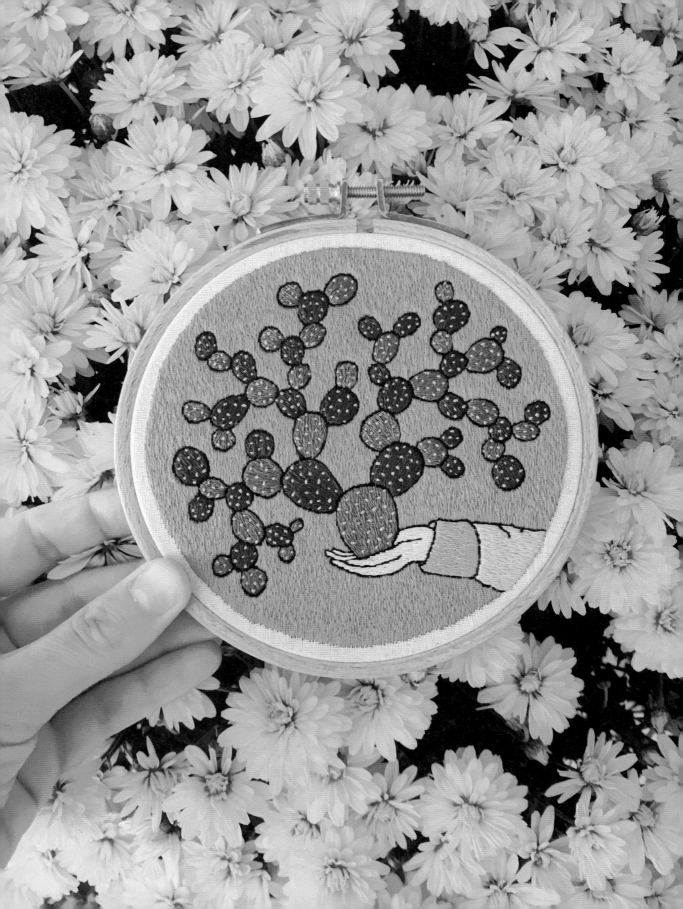

"I want to see people pushing through the limits of this craft and showing that there are no boundaries when referring to art."

Mina Ivanova

Bulgaria

Mina Ivanova has been stitching embroideries since 2017, mostly inspired by her love of nature. She is eager to experiment with embroidery and to try out new variations of presenting contemporary embroidery by using different tools and materials.

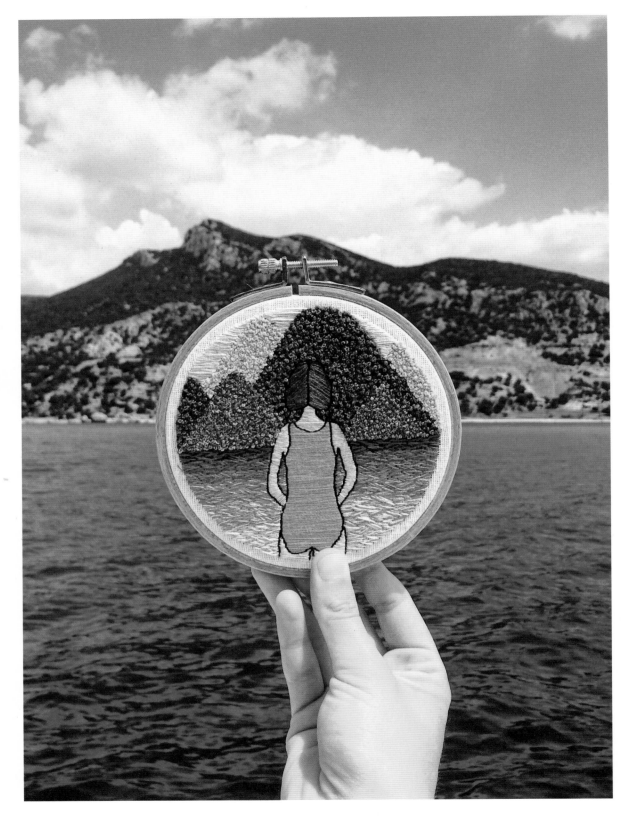

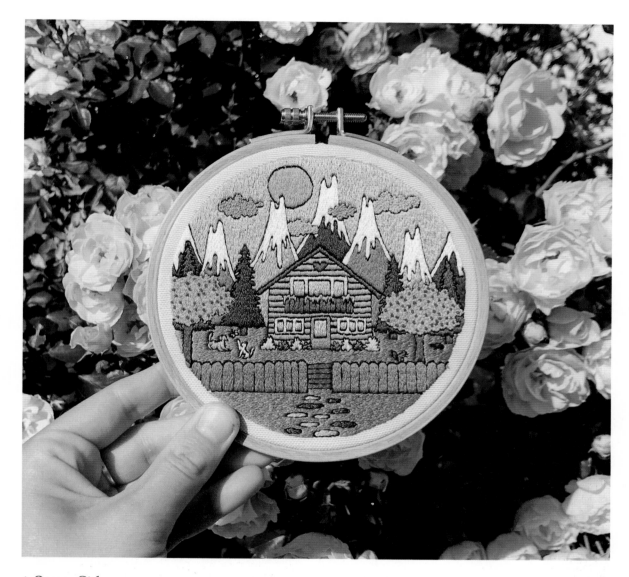

← Orange Girl

This piece with a girl in an orange bathing suit was Mina's first highly detailed embroidery piece.

✂

Tools: Needle, hoop

Materials: Cotton fabric, cotton embroidery thread

Stitches: Back stitch, satin stitch, French knot

↑ Wooden House

Mina likes challenging herself by accepting custom orders. People's demands provoke both her imagination and abilities. The tiny details in this embroidery piece were a struggle for her, and by overcoming this difficulty, she feels she has improved her stitching skills.

✂

Tools: Needle, 12.5-centimeter hoop

Materials: Cotton fabric, cotton embroidery thread

Stitches: Back stitch, long and short stitch

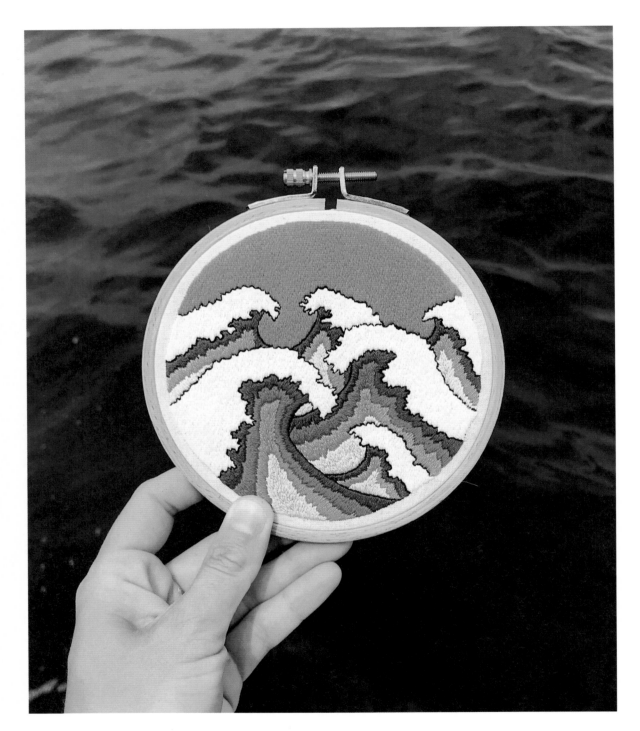

↑ Waves

This embroidery is inspired by *The Great Wave* by Katsushika Hokusai.

⊠

Tools: Needle, hoop

Materials: Cotton fabric, cotton embroidery thread

Stitches: Back stitch, satin stitch, French knot

↑ Fuji-Todorka Collage

This collage combines Mina's embroidery skills and her love for photographing. The embroidered peak overlaps with the top of the mountain in the photo seamlessly, resulting in an intriguing contrast between the real and the created.

⁂

Tools: Needle, hoop, iPhone 7, VSCO, Adobe Photoshop

Materials: Cotton fabric, cotton embroidery thread

Stitches: Back stitch, satin stitch

↓ Mountains

This embroidery was inspired by Mina's love for the mountains. She used back stitch to finish the black outlines and satin stitch to fill in the mountains.

⁂

Tools: Needle, wooden frame

Materials: Linen fabric, cotton embroidery thread

Stitches: Back stitch, satin stitch

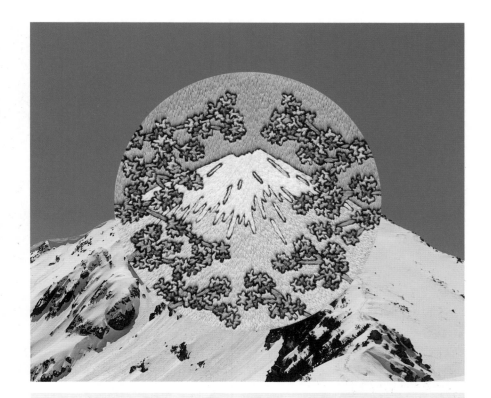

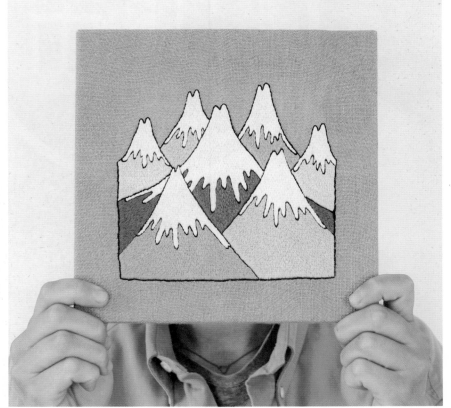

047

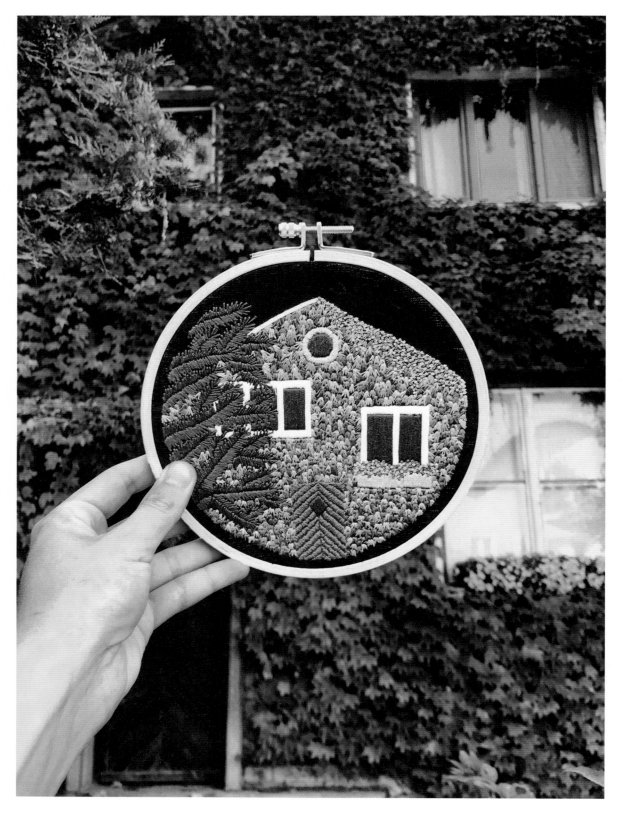

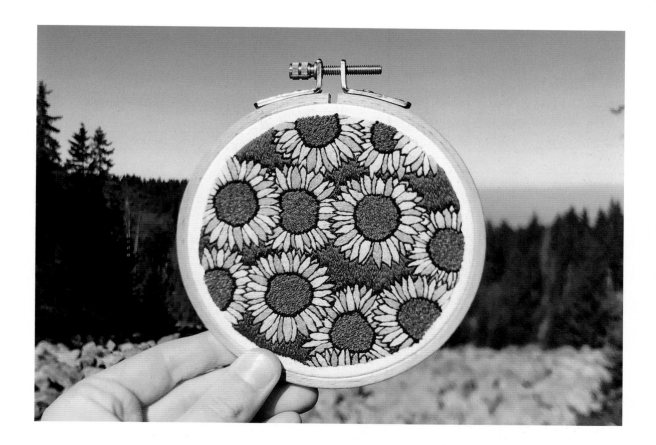

← Leaf House

This piece was inspired by a real house that Mina saw in her neighborhood.

::

Tools: Needle, hoop
Materials: Cotton fabric, cotton embroidery thread
Stitches: Back stitch, satin stitch, French knot

↑ Sunflowers

On one of her many trips around her country, Mina saw a huge field with sunflowers and, at that moment, she knew that she had to embroider it.

::

Tools: Needle, 10.5-centimeter hoop
Materials: Cotton fabric, cotton embroidery thread
Stitches: Back stitch, satin stitch, French knot

Tutorial

This piece, "Lake Girl," involves two strands of thread, using back stitch, satin stitch, split stitch, and long and short stitch.

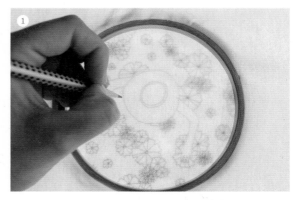

Step 1: Transfer the sketch onto the fabric (not a very thick one) by using a light table or a window with good light.

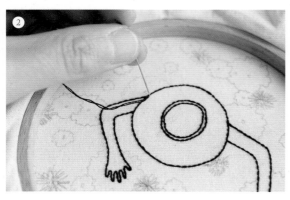

Step 2: Outline the main elements of the embroidery using back stitch with two strands of black thread.

Step 3: Use satin stitch to fill the top of the hat, starting from the center and making circles. Then, turn to split stitch to finish the brim. Embroidering the hands is similar—use satin stitch and start from the fingertips.

Step 4: To embroider the lilies, before outlining them, choose threads of different colors to sew snowflake-like shapes in various sizes, starting from the edges and bringing the thread towards the centers. For the leaves, do the outlining before coloring.

Step 5: Use satin stitch or long and short stitch, sewing the background with random lengths of stitches to make the overall piece look neat and smooth.

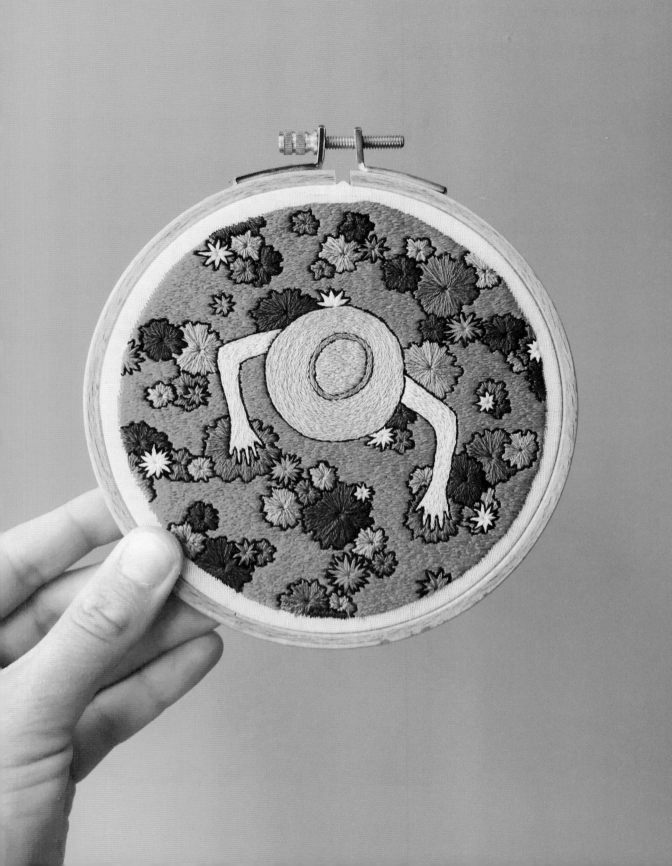

Interview with
Mina Ivanova

Could you tell us about your artistic background?

Actually, I don't have an academic background in the field of arts. I graduated from a regular high school with English and mathematics as first and second majors. For my third major I chose humanities, which was focused on literature and that's the closest I got to the arts in terms of my education. After that, I graduated with a bachelor's degree in psychology. However, I've always been fascinated by talented people and I dreamed that one day I would find my own way of self-expression.

Why did you choose embroidery? What is special about it?

The whole process of choosing this medium happened naturally and out of the blue. Three years ago, I came across an embroidery workshop that was going to take place in an art space in Sofia, Bulgaria and I decided to go and try it out. Cross-stitching embroidery is an essential part of our culture and a popular craft in Bulgaria. But contemporary embroidery is unknown to the majority as it was for me at that time. I remember browsing through the Internet and discovering the work of artists like Sarah K. Benning, Tessa Perlow, and Teresa Lim. I was blown away by their art and got really inspired to try this medium. Besides, the fact that I was going to be one of the first to introduce modern embroidery to the Bulgarian crowd got me even more motivated to dive into this field.

What is the most difficult part of creating an embroidery piece? What about the most enjoyable part?

The most difficult part for me is the process of sketching. I am not good at drawing, which definitely limits me. I have so many ideas for embroidery pieces in my head, but fail to give life to them because I can't draw. I guess that with time and a lot of practice I'll get better and better. The most enjoyable part is seeking interesting and thematic places to take photos of the finished embroideries or just to get inspiration for new pieces.

In this piece, Mina tried to represent her "dream home," a wooden bungalow somewhere in the mountains hidden in a forest and away from the crowded cities.

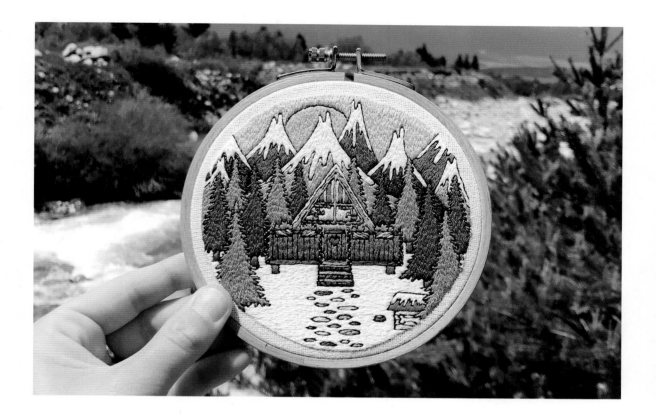

Your art is not merely embroidery, but the collaboration between embroidery and photography. How did you come up with the idea of combining them?

I like taking pictures, but my skills are amateur and I don't consider myself a photographer. I simply use my phone because it's easy to carry around. I wanted to create a consistent view of my Instagram feed and, after a lot of trials, I realized that this combination—embroidery with a catchy landscape as a background—satisfies me the most. In this way, my love for nature intersects with my passion for embroidery.

How do you choose the background when photographing the embroidery pieces?

Most of the time, the backgrounds are spur of the moment decisions. I plan a hike, take my finished embroideries, and look for good lighting and interesting views on the route. Sometimes the process is vice versa—the background precedes the embroidery. I see something in nature and it inspires me to stitch a piece that would look good in a photo with that place in the back. Also, I consider the color combination or thematic similarities or contrasts between the embroidery and the background.

In your opinion, what defines a good piece of embroidery art?

The most important thing for me in any piece of art is that it provokes feelings in me. When I look at it, I want to be enchanted, to be astonished, to get inspired! As for embroidery art, I am really intrigued by pieces that have a lot of details and look like illustrations. I am also interested in artists who combine stitching with other media. I want to see people pushing through the limits of this craft and showing that there are no boundaries when referring to art.

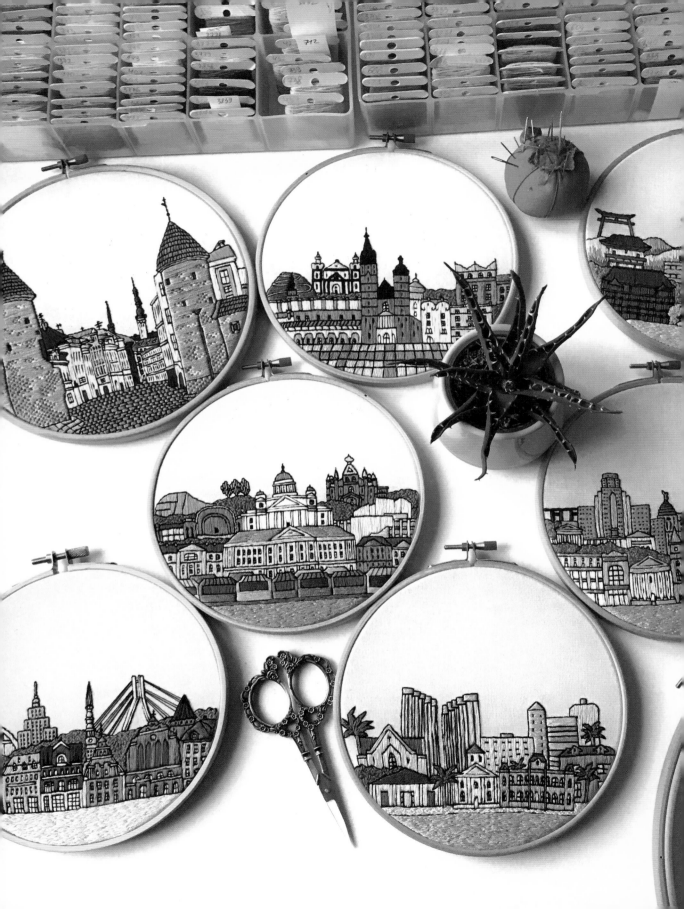

"I love how my architectural embroideries bring me back to the places I've visited—the sentimental value of them."

Kseniia Guseva

Russia

Kseniia Guseva is a Russian embroidery artist now based in Berlin. After trying knitting, crocheting, beadwork, and so on, she finally found her favorite medium of art—hand embroidery. Since 2016, she has kept a habit of embroidering every day. Architecture is the main theme of her embroideries and she has created a series of city views.

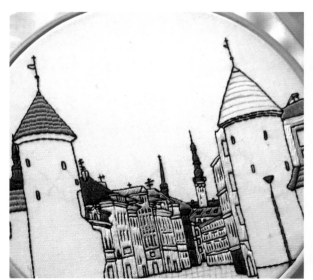

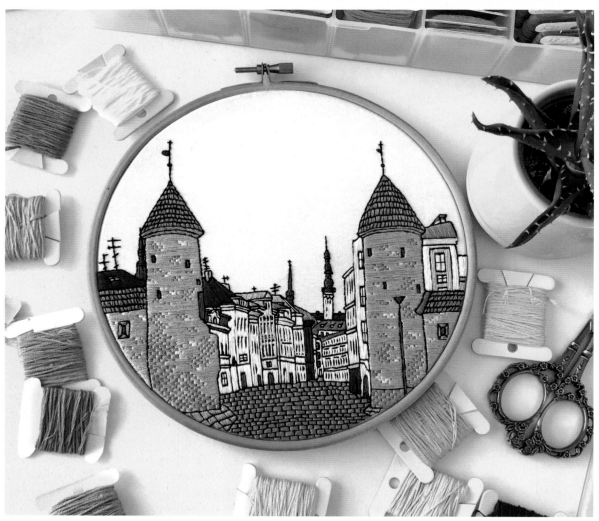

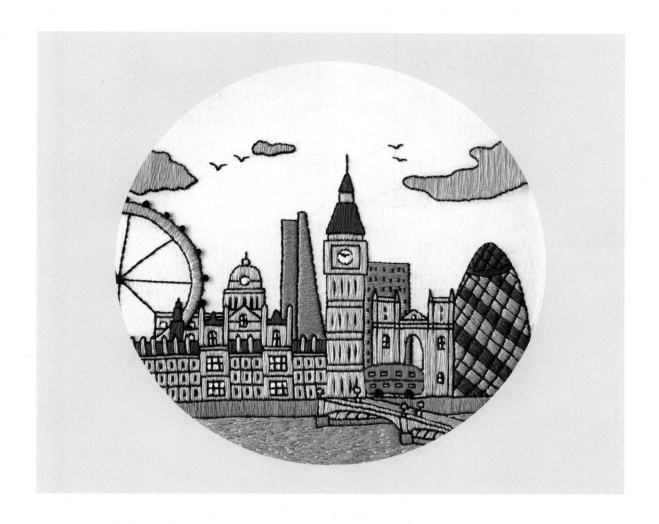

← Tallinn, Estonia

Tallinn is one of the cities that Kseniia has visited several times. This embroidery was inspired by her trip to Tallinn in 2018.

⁛

Tools: Tapestry needle, seven-inch wooden hoop

Materials: Cotton, six-strand cotton thread

Stitches: Satin stitch, back stitch, straight stitch, split stitch, long and short stitch, stem stitch

↑ London

This landscape embroidery was created on a six-inch hoop, depicting the landmarks of London.

⁛

Tools: Tapestry needle, six-inch wooden hoop

Materials: Cotton, six-strand cotton thread

Stitches: Satin stitch, back stitch, straight stitch, split stitch, long and short stitch, stem stitch, French knot

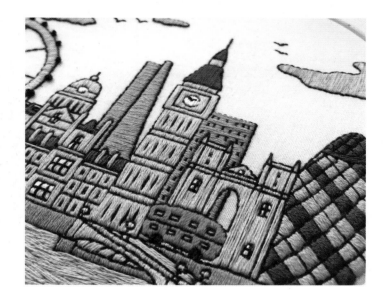

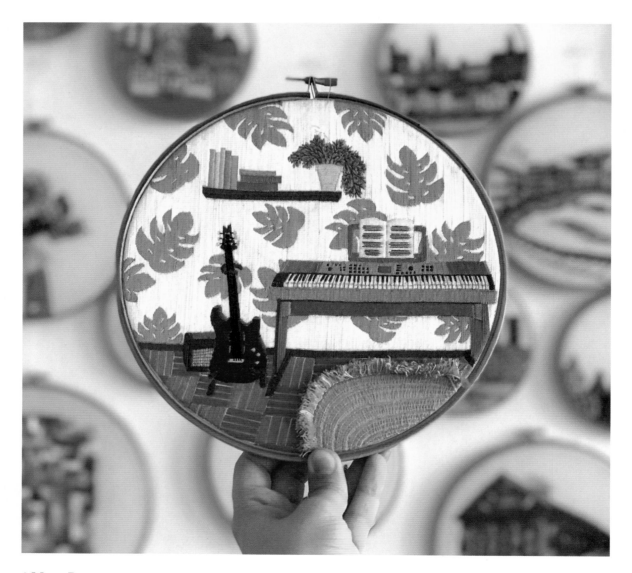

↑ Music Room

Part of Kseniia's "Inside and Outside" collection, this piece is a detailed embroidery of an imaginary music room—inspired by her studio space—with piano, guitar, monstera wallpaper, and fringes on the carpet.

✂

Tools: Tapestry needle, eight-inch wooden hoop

Materials: Cotton, six-strand cotton thread

Stitches: Satin stitch, back stitch, straight stitch, split stitch, stem stitch, turkey work, basket stitch, seed stitch

→ The Past is Inside, the Future is Outside

This diptych, a project in Kseniia's "Inside and Outside" collection, consists of two embroideries— "The Future is Outside" with the view from the windows and "The Past is Inside" with the view to the windows.

✂

Tools: Needle, 10-inch hoops, scissors

Materials: Cotton, threads

Stitches: Straight stitch, back stitch, split stitch, satin stitch, French knot, stem stitch

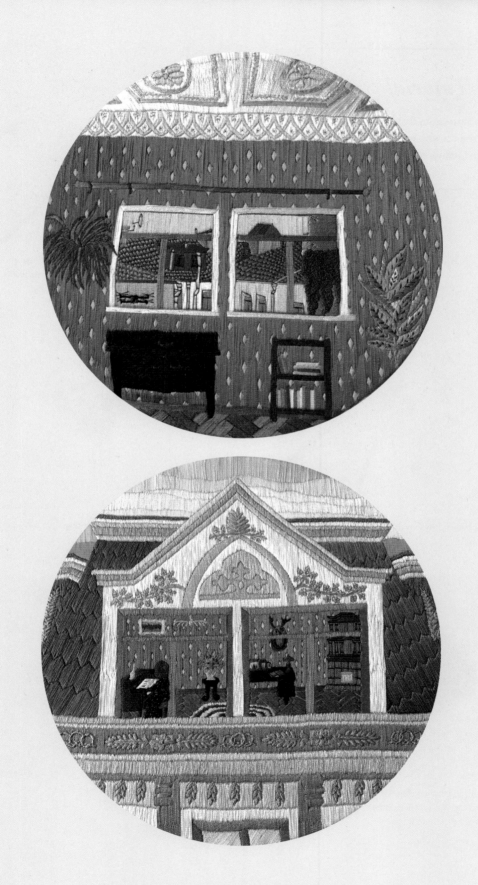

Tutorial

One of Kseniia's favorite textures is what she uses for the tree crowns, which can be seen in her Ottawa embroidery.

Step 1: Draw the tree crown on the fabric and use short straight stitches with three to six strands of cotton thread.

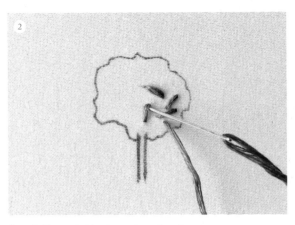

Step 2: Keep stitching in random directions.

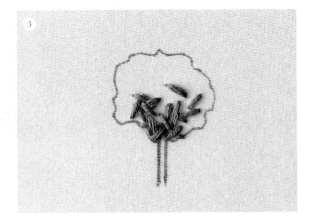

Step 3: Try to fill the whole area, making sure each stitch goes in a different direction.

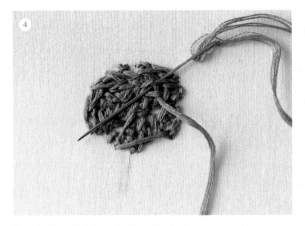

Step 4: Once finished stitching, flip the hoop over and sew under the stitches for two or three times to make the stitches firm and help them keep their shape.

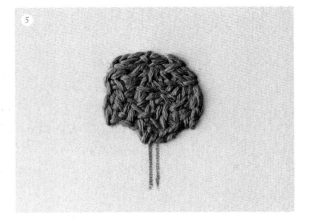

Step 5: Trim the extra thread.

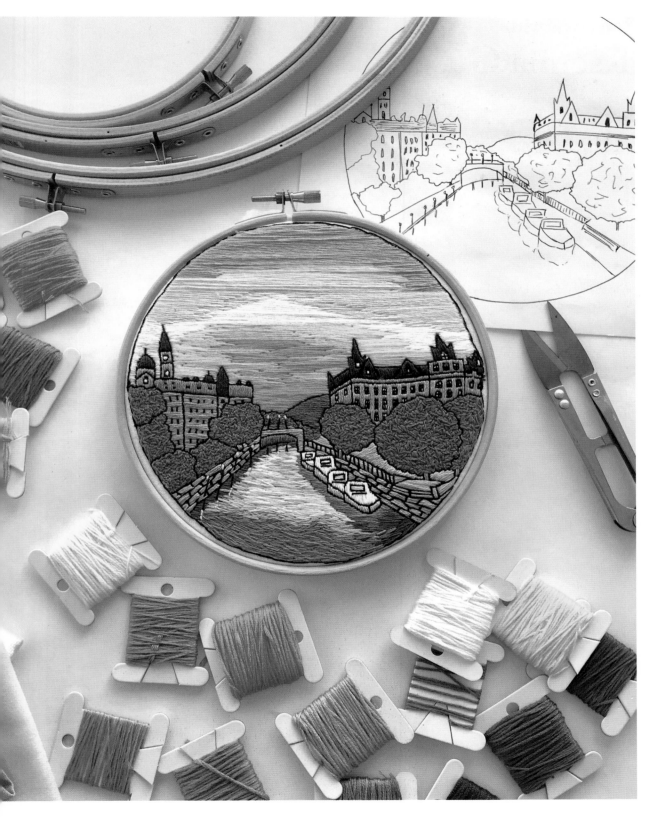

Interview with
Kseniia Guseva

When and how did you start your journey of embroidery? Would you like to tell us about your artistic background?

I'm a self-taught artist. At the age of six, I learned to crochet and cross-stitch, and later more embroidery basics at school. Yet I didn't pick them up again for almost 17 years until 2015 when I left my full-time job due to the anxiety it gave me. I couldn't sleep and properly function, so I went back to cross-stitching, which really helped. As I kept learning and practicing, I made more complicated embroidery rather than cross-stitch. After a short journey to the Baltic countries of Sweden and Finland, I was impressed by the architecture there and wanted to embroider what I saw. That was how my love for architecture, travel, drawing, and handcrafting finally became one—the architectural embroidery I am making now.

Why did you choose embroidery? What is special about it?

Drawing and embroidery are the forms I'm most familiar with. I understand how to use them to create what I have in mind. I don't embroider my pieces freehand—I sketch my idea first, transfer it to the fabric, and then start embroidering. So it's the combination of two art forms. Some of my embroideries include both paint and thread. I love drawing for its speed and embroidery for its textures. Also, embroidery is a meditative process that can calm me down and give me time to think.

Kseniia was working on the second "Windows" embroidery while imagining what people were doing inside their homes.

Why do you like to depict landscapes in your artwork? Do you base your artwork on real landscapes or ones in your imagination?

I was born in Saint Petersburg, the former capital of Russia with a huge historical heritage: palaces, bridges, amazing architecture, and sculpture. Also, as a child, I traveled a lot throughout Europe with a choir. Thus, it is natural that I love to look at the architecture, details, decorations, doors, door handles, and so on. When I wanted to try hand embroidery, architectural landscapes were the first theme I thought of. I love how they bring me back to the places I've visited—the sentimental value of them. My series of city views are based on the real landmarks in these cities while some artworks are based on my imagination, such as "Windows" embroidery and "Kebab" embroidery.

Some of your embroideries are outlined with black thread while some are not. What do you take into consideration when deciding whether to contour a piece?

My series of city embroideries was outlined because I made patterns with instructions for each of them so that people could embroider the same design. Outlining helps to make the right shapes and simplifies the embroidery process. I also have a series of architectural embroideries in a larger scale without outlines. They are very detailed and I don't make these designs twice.

What is the biggest difficulty that you have experienced so far?

Creating a piece of embroidery takes a lot of time, so when you have a lot of ideas, it's hard to create all of them. I usually work on five to six projects at the same time, which helps me save time. Therefore, while I'm working on a project that will take months, I can still feel satisfied by completing other projects. The other difficulty is common for artists who share their works through social media: copying. Each photo, video, and artwork we see on the Internet belongs to someone, but not everyone knows about copyright infringement and how it works.

What have you been working on recently? What kind of new projects do you want to try?

Recently, I have switched to larger-scale projects of about 10 inches, One of them is an embroidery of one spot from different views: inside and outside the windows. In the future, I'd like to continue my experiments with paint and thread and incorporate more media into my artworks.

"The only thing that matters is whether I enjoy it and whether it reflects exactly what I want to express."

Agnesa Kostiukhina

Ukraine

Agnesa Kostiukhina was born in Ukraine, in the beautiful city of Odessa and it was there where she learned to appreciate and admire nature—her main source of inspiration both for embroidery and for life. She was taught to do cross-stitch as a kid. Years later, she turned to embroidery because there are fewer limits. Since then, her imagination has become the canvas onto which she can fully apply her skills.

↑ Costa Vella
Costa Vella is Agnesa's favorite café, which has a beautiful garden and a lovely fountain.
⁕
Tools: Needle, wooden hoop
Materials: Cotton threads, linen
Stitches: Outline stitch, satin stitch

→ By the Lake
Agnesa wanted to embroider an idyllic landscape, fresh and inspiring, but realistic enough to believe in.
⁕
Tools: Needle, wooden hoop
Materials: Cotton threads, linen
Stitches: Outline stitch, satin stitch

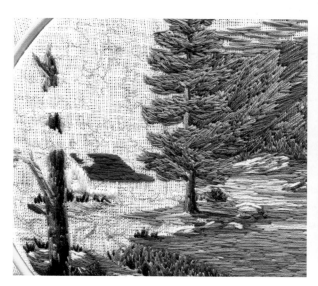

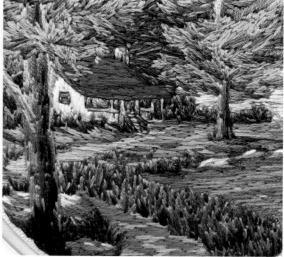

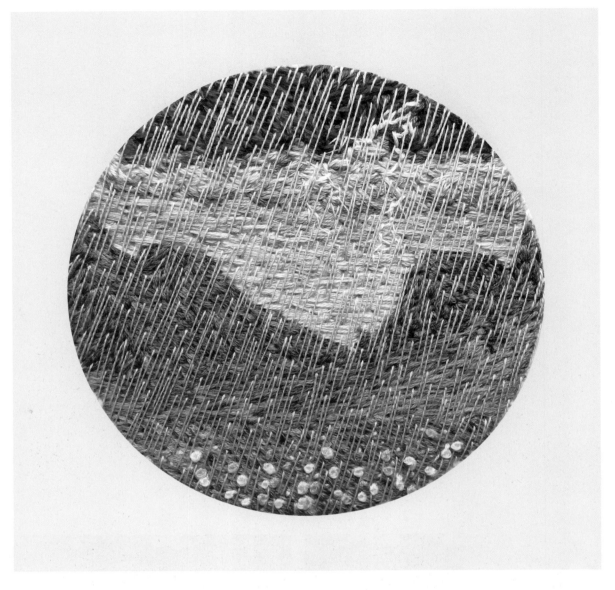

↑ Storm

Through this piece, Agnesa wanted to depict the intensity of a stormy day.
⸭
Tools: Needle, wooden hoop
Materials: Cotton threads, linen
Stitches: Outline stitch, satin stitch

→ Twilight

Agnesa was playing with light and colors to depict a warm twilight evening in the mountains.
⸭
Tools: Needle, wooden hoop
Materials: Cotton thread, felt fabric
Stitches: Outline stitch, satin stitch

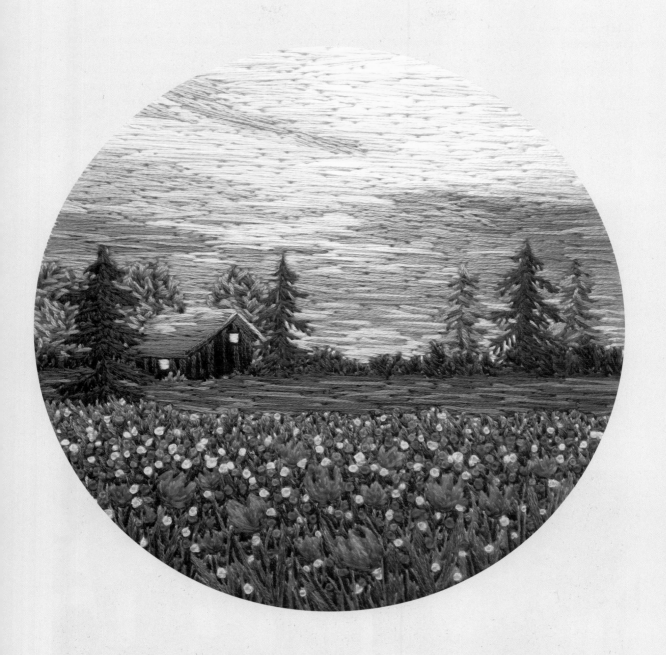

Interview with
Agnesa Kostiukhina

Could you share your creative process?

The process starts from looking for an idea, a photo, or a reference for inspiration. Once I know more or less what I want to do, I choose the colors from two boxes of thread, which are neatly organized by colors and shades. I really like order in everything because it calms me down. So, when I have the picture in my head, I pick all the colors I might use and set them apart in another box. I sort them by elements and end up with several rows: colors for the mountain, the tree, the grass, the sky, etc. With all the colors selected, I analyze the picture and consider what elements will be in front and in the background. I start with the foreground and move from color to color, always doing the front elements first and proceeding to those in the back.

The funny thing is that the finished project is never the same as the picture in my head, so, for me, the process of creating is like having a child. I envision the final result and know that it will somehow resemble the reference picture, but it will always be surprising. Thus, I am always eager to finish it and find out what my "child" will look like.

As a self-taught artist, what are the advantages and disadvantages of learning embroidery by yourself?

The only disadvantage for me is that every new element may be a challenge. I never know how it will turn out in the end and sometimes I have to undo some parts until I'm satisfied enough with the result because I am a perfectionist.

The advantages are endless: There are no rules for me as no one has ever taught me—so there are no limits. I can do anything any way I like and I will never think that it's wrong. The only thing that matters is whether I enjoy it and whether it reflects exactly what I want to express. If I can't achieve a certain effect, I just undo it and try some other ways.

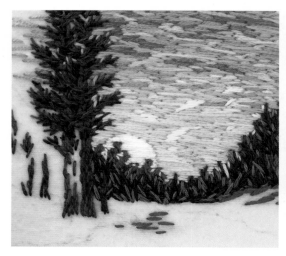

This is one of Agnesa's early works inspired by a photo found on the Internet.

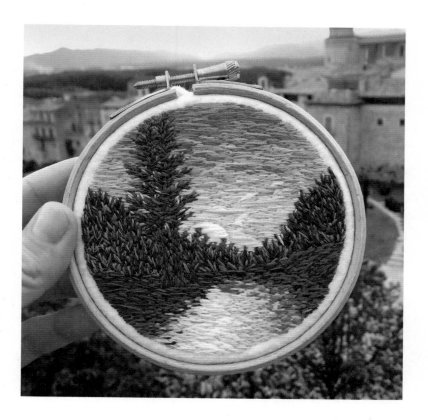

Landscapes are one of the main subjects of your artworks. Why do you enjoy depicting them and drawing inspiration from nature?

I guess it comes from my childhood—my mother used to take me for long walks in the parks and by the seaside. Along the way, she taught me to pay attention to the details and admire the little things: the sunlight coming through the leaves, the dew on the grass, the snowflakes on the skin, sunsets, rain, thunderstorms, autumn colors, wildflowers in the field. There's no bad weather for me and I feel strongly connected to nature—it brings me peace, reminds me of who I am, and helps me to keep my mind clear. That is why I tend to choose landscapes as the main theme of my embroideries—they reflect my state of mind.

How do you work on the color palettes of the skies?

Usually I prefer them to be as close to the natural colors as possible, so if a reference for my embroidery is a photo, I choose the colors that correspond to those in the picture. If the reference is created by me, I usually prefer to do the sky in the end and I choose the colors that will help the rest of the landscape stand out.

How would you describe your style of embroidery?

It's completely freestyle contemporary embroidery—there are no rules, no wrong or right. I don't even know the names of the stitches except the French knot, but I don't worry about it—I just keep on experimenting and figure out where and how I should place a stitch by trying, practicing, and imagining the final result.

Nr. 119
Meadow of the Valley

"While I am making embroideries, it feels so natural to me and inspirations start to bloom."

Artemis W Chung

Hong Kong, China

Artemis W Chung is an embroidery artist who specializes in landscape embroidery. To her, embroidery is more than needlework. Instead, she "paints" with needles and thread, simulating the textural stroke of oil painting on fabrics and brings her viewers to a whimsical and fantastic world of nature.

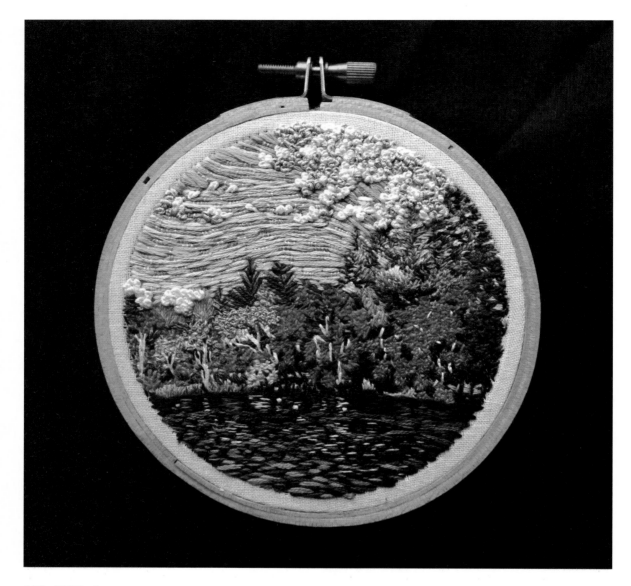

↑ Nr. 20 Maple

Created in July 2018, this piece depicts the autumn scenery in Karuizawa, Japan. Artemis was very impressed by the clear blue sky, blood red maple, and the dark lake. Therefore, she decided to turn her memory into an embroidery.

※

Tools: Needles, scissors, pencil, four-inch hoop

Materials: DMC cotton threads, DMC metallic threads, cotton material

Stitches: French knot, couching stitch, back stitch, running stitch

→ Nr. 48 Autumn in the East

This thread-painted landscape embroidery depicts the autumn scenery and it took Artemis more than 64 hours to finish by hand.

※

Tools: Needles, scissors, pencil, hoop

Materials: DMC cotton threads, cotton material

Stitches: Cast-on stitch, backstitch, stem stitch, satin stitch, running stitch, French knot

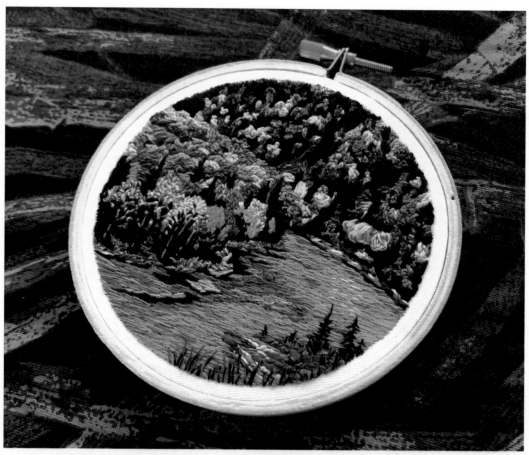

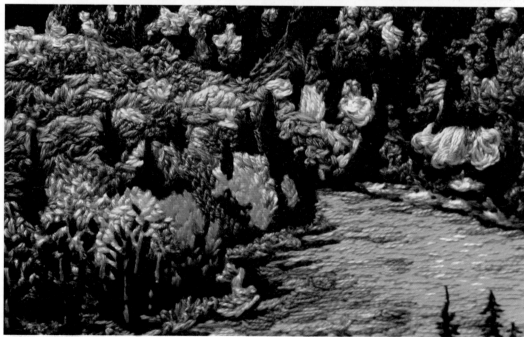

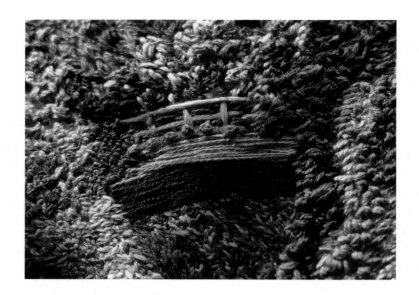

← Nr. 18 Lost

"Nr. 18 Lost" was inspired by a Japanese-style bridge, but created based on imagination. Artemis hand-embroidered it with more than 30 shades of green to create realistic textures.

✄

Tools: Needles, scissors, pencil, hoop

Materials: DMC cotton threads, cotton material

Stitches: Cast-on stitch, backstitch, stem stitch, satin stitch, running stitch, French knot

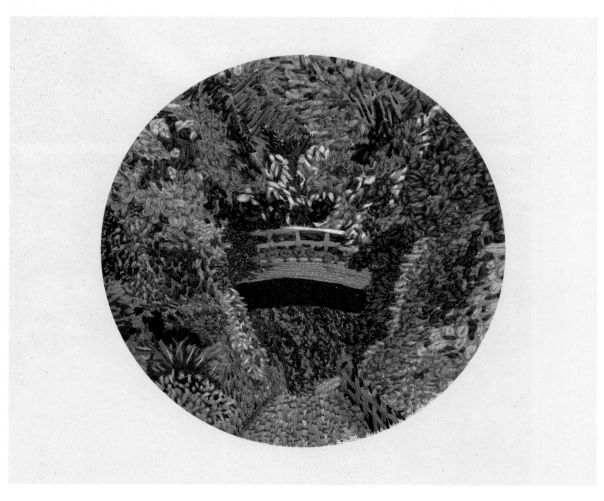

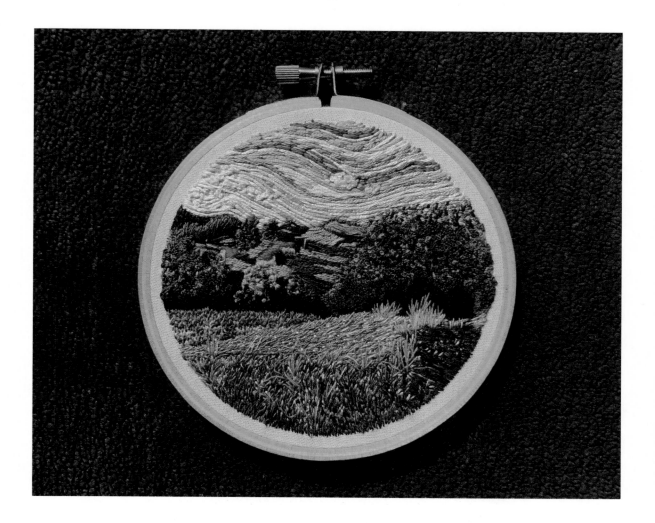

→ Nr. 9 Appenzell

"Nr. 9 Appenzell" preserves a memory, a magical summer holiday in Appenzell, Switzerland. With more than 50 shades of thread, Artemis hand-embroidered it using various stitches.

Tools: Needles, scissors, pencil, hoop

Materials: DMC cotton threads, cotton material

Stitches: Satin stitch, French knot, couching stitch, running stitch

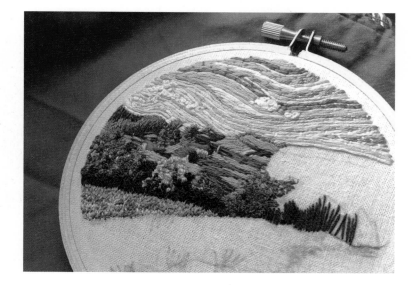

Interview with
Artemis W Chung

Could you tell us about your background? When and how did you become a full-time embroidery artist?

I graduated with a science degree that had nothing to do with art. Diving into the embroidery world was merely a beautiful accident. In 2017, I made my first hoop art when I came across a couple of nicely stitched flower hoops on the Internet and thought, "why not give it a try?" Since then, I've been completely hooked. Plucking up literally 20 seconds of insane courage, I went for it as if there was no turning back.

Why do you prefer embroidery?

I've liked to paint and draw since I was a kid, but the older I get, the fewer inspirations I have. Although I crave painting, it hurts me so much when I'm holding a brush, but can't paint anything. To me, embroidery is another form of painting, only I hold a needle instead of a brush. While I am making embroideries, it feels so natural to me and inspirations start to bloom.

Could you please briefly introduce your creative process?

It is a very spontaneous and messy process that happens anywhere anytime, as soon as the whims hit me—I may begin at midnight or when I am traveling. Once I get started, it involves a lot of work: choosing the right color palette, sketching, picking a theme, considering whether to capture the emotion and mood, or to add realism to my work. After all the preparation, I then embroider while listening to one song on repeat.

Landscapes are one of the most common themes of your embroideries, so why do you enjoy depicting them?

A few years ago, landscape embroidery was not as popular as now. I seldom saw embroidery painting on the Internet back then and I wanted to try something different and simple. Living in a hectic city is too much to me as I love everything in nature such as mountains, oceans, sunsets. The natural world calms me down and deepens the bond between me and the universe. It is pretty rewarding when I turn threads into a painting.

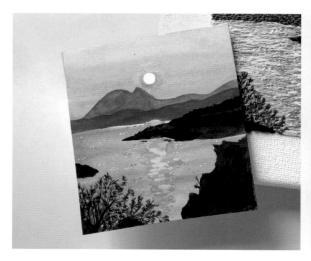
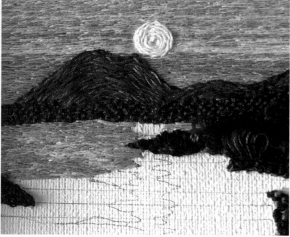

Depicting the sunset scenery, "Nr. 61 Promise of a New Dawn" is Artemis' second embroidery art created on canvas, based on a watercolor illustration of hers. This piece was rather time-consuming, taking the artist 120 hours to finish.

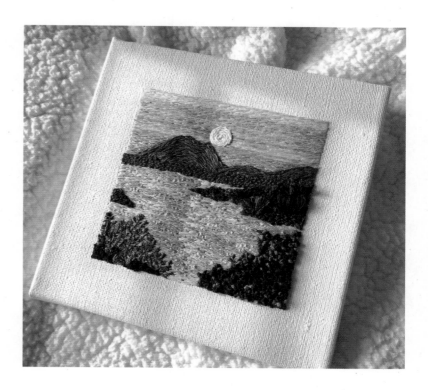

Where are your inspirations from?

Mostly my inspirations are from real landscapes I see when traveling. Novels, vivid dreams, videos I took in daily life and my paintings and drawings are also my sources of inspiration. It might sound weird, but the artworks that I am most content with are actually inspired by my intense negative emotional experiences, e.g. heartbreak, pain, anger… "Nr. 2 Blossom" and "Nr. 4 Starry Night" are exceptions, based on a talented German photographer's work and Vincent Van Gogh's painting *The Starry Night*, respectively. I have stopped recreating other artists' work since Nr. 4 as I wanted my work to be unique and fully original.

Some of your embroideries look like oil paintings. Do you intentionally give them a touch of oil paint?

Yes, I do. I love the consistency of oil paint. Although I never tried oil painting because the equipment and drying time hinder me, oil painting is always on the top of my bucket list. I see embroidery as real painting which is more than threads and needles. I want to add textures and volume to my art so I try to fuse different painting styles into my embroidery art. The texture of oil paint shapes the overall aesthetic look of my artwork.

What have you been working on recently? What kind of new projects would you like to try in the future?

I've been recently trying different materials, paper, canvas, silk thread, and so on. The creating process is much harder, but the results are worthwhile. Aside from landscape embroidery, I would like to try animal and human portraits, which I have been avoiding for a long time due to my lack of confidence. However, I believe it is time to step out of my comfort zone and achieve more. You will never know if you don't try.

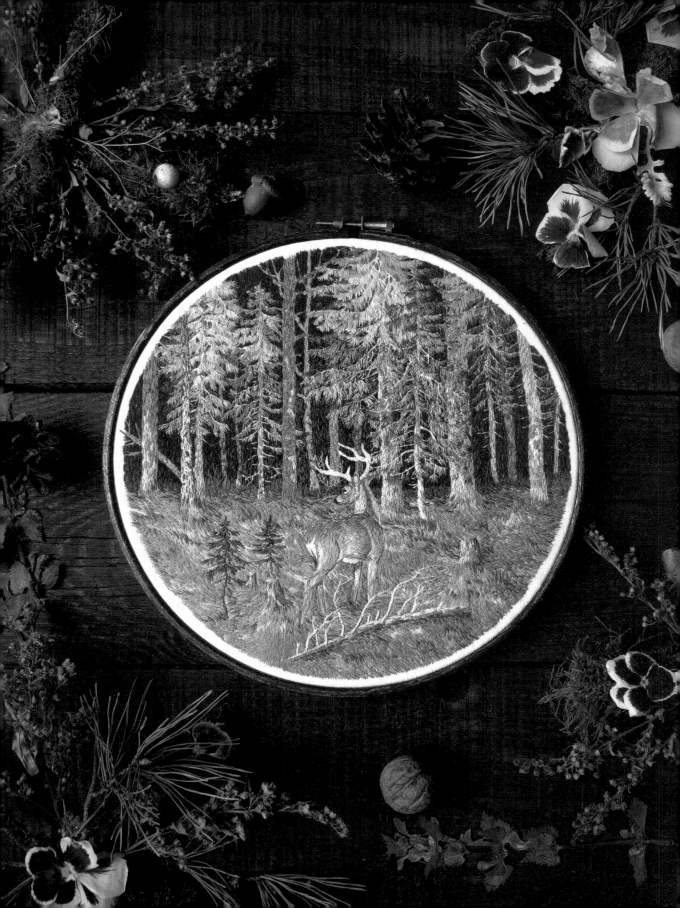

"Intricate and time-consuming as it is, embroidery is the remedy that I need in today's fast-paced world addicted to instant gratification."

Jūra Gric

Lithuania

Because of her passion for textile arts, Jūra Gric merges oil painting with embroidery to create needle painting. Inspired by the natural world—forest, plants, lakes, wildlife, and so on, she creates pictures of her imaginary realms of joy using lush and natural colors to tell tales of the far-off, forgotten, and enchanted places in nature.

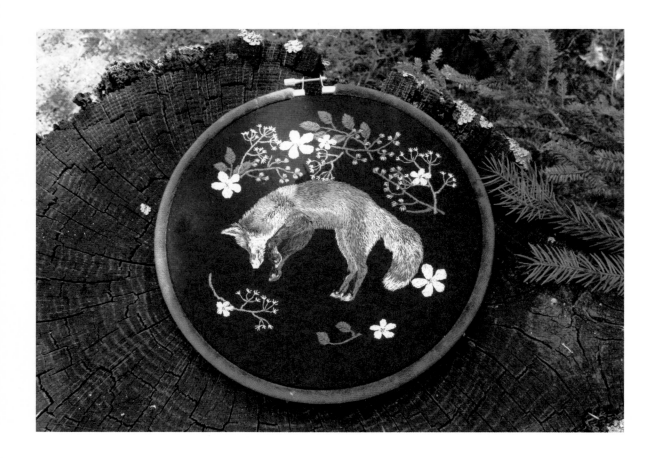

↑ Fox in the Meadow

Jūra wanted to create a world in embroidery that stands still and silent. A sleeping fox and wildflowers are floating weightlessly in a black background. With this composition, she intended to achieve a feeling of calm and tranquility.

⁛

Tools: Hoop, shears

Materials: Sewing threads, cotton fabric, cotton velour

Stitch: Long and short stitch

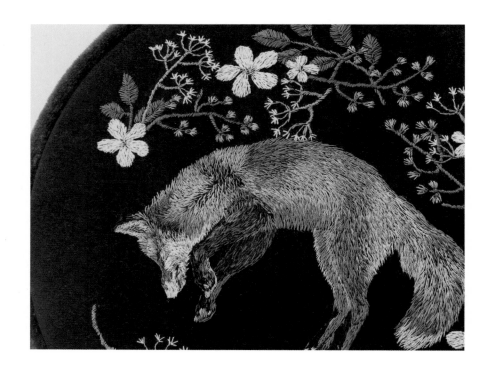

↑ Rabbit I

With lush and natural color, this piece looks like an illustration from a children's book.

⁙

Tools: Hoop, shears

Materials: Sewing threads, cotton fabric, cotton velour

Stitch: Long and short stitch

↓ Rabbit II

This embroidery was inspired by vintage illustrations.

⁙

Tools: Hoop, shears

Materials: Sewing threads, cotton fabric, cotton velour

Stitch: Long and short stitch

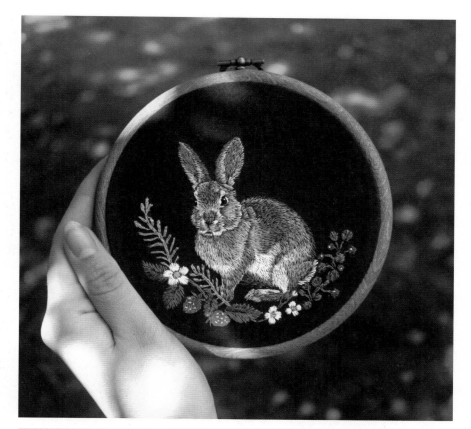

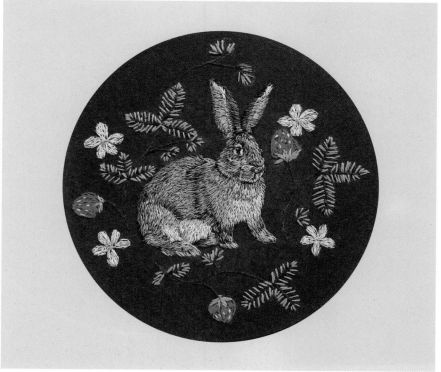

→ The Lake

Jūra was inspired by an unknown painting and wanted to create similar imagery and to see the difference the embroidery thread would make. She most often uses one thread in her work, but for this one she used two so that it looks more expressive and more like brush strokes.

✂

Tools: Hoop, shears

Materials: Sewing threads, cotton fabric

Stitch: Long and short stitch

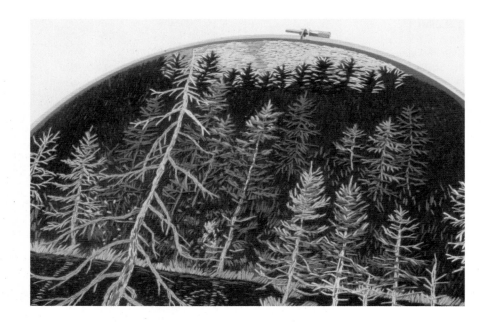

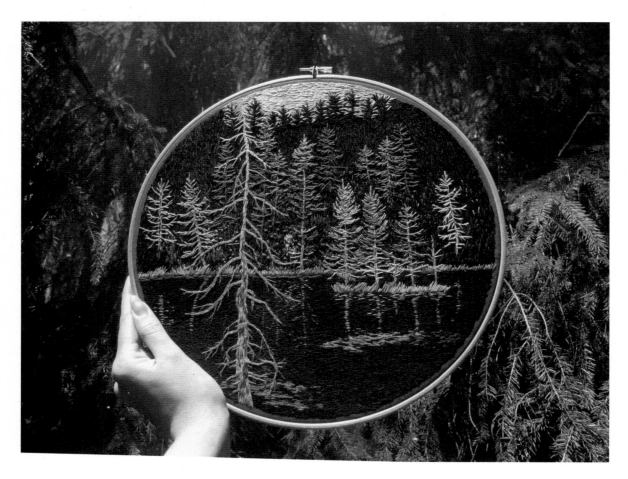

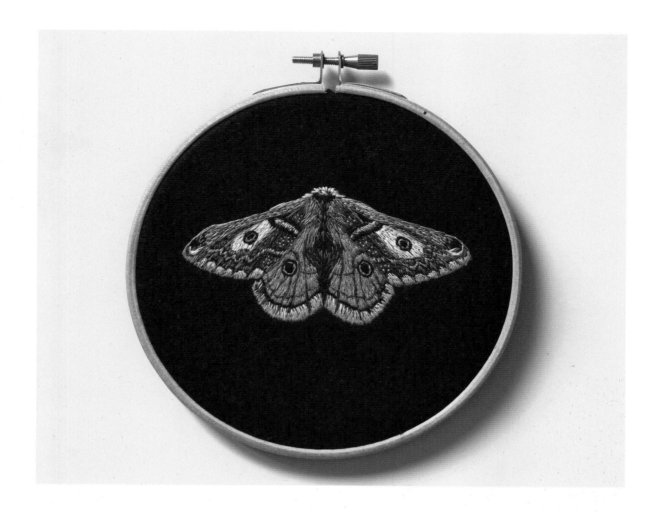

↑ Still Life

For this piece, inspiration came from Victorian moth and butterfly taxidermy. Jūra wanted the whole embroidery to be in muted colors, so it looks old and has a vintage touch.
::

Tools: Hoop, shears

Materials: Sewing threads, cotton fabric, cotton velour

Stitch: Long and short stitch

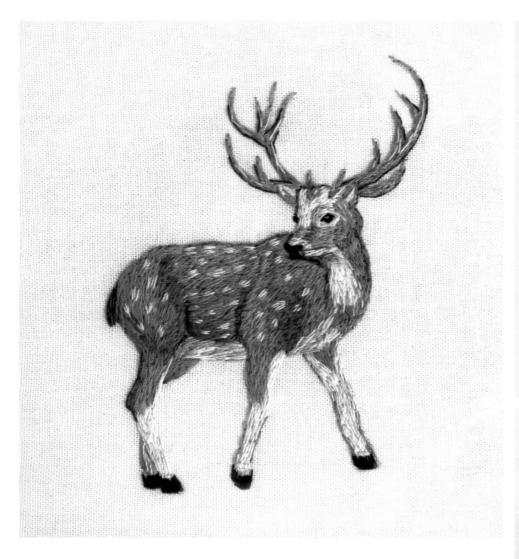

Forest Creature Collection

Jūra's needle paintings are inspired by forests, plants, lakes, wildlife, and other natural forms. With her forest creature embroidery collection, Jūra wants to explore the deep human need to be close to animals and the importance of seeking a relationship with nature.

Interview with
Jūra Gric

Would you like to tell us a bit about your artistic background?

Very early in my life I tended to notice details and color combinations and had a huge capacity to sense and respond emotionally to beauty in the natural environment. After secondary school, I enrolled in an art academy and majored in painting. Since I always felt a pull towards embroidery and folk arts, it was natural for me to combine these different forms of art into one—needle painting.

Why did you choose embroidery as the form of your artistic expression? Why is it special?

To me, embroidery has a mystical power because I have seen it in folk art, religious traditional garments, and old household furnishings since I was little. The feeling of magic and the unknown is still present when I stitch in quiet—it brings me closer to my ancestors and their more mythical way of thinking. In this sense, hand embroidery is truly a form of meditation as it forces me to disconnect from my surroundings and immerse myself in a different reality. Intricate and time-consuming as it is, embroidery is the remedy that I need in today's fast-paced world addicted to instant gratification.

Most of your embroideries are about forests—the scenery and the wildlife. Could you tell us why you are so attracted to it?

Being a shy and sensitive kid, I was drawn to solitary places in nature, which became my source of solace. From time to time, I found myself wandering in nature and daydreaming, feeling curious about what was beyond the forests and everything unreachable and unknown. As an artist, I can lift the veil of mystery a little bit now with my imagination and embroidery. While I am creating a needle painting of nature, I feel engaged in my childlike daydream again, letting my inner child decide what is beautiful and meaningful without judgment.

Could you briefly introduce your creative process? What kind of preparation do you usually do?

Most of the time, I wander around and look for a motif that evokes some kind of feeling and I start sketching. For landscape embroidery, I make simple sketches, sometimes I even draw straight on top of the fabric, giving myself

In this piece, Jūra wanted to convey that every human has a deep desire to feel connected, to interact with their surroundings, and to coexist with nature.

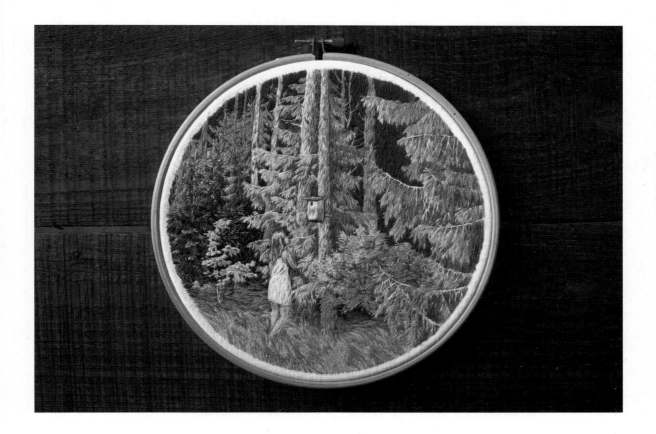

more freedom to improvise. My animal embroideries require more precise drawing, so I tend to look more at images for reference. Once the base is finished, I decide how elaborate my embroidery painting is going to be and choose the thread and fabric accordingly.

Your embroideries are enchanting and mysterious. How do you create this vibe?

I always use central composition, the simplest one, but widely used in folk and religious art. That simplicity creates the feeling of stillness and tranquility and it leads the gaze towards the main subject. I deliberately choose dark backgrounds and always exclude the sky from the composition because this method makes the whole feeling more fantastic and creates good contrast with the foreground. Shadows, bright highlights, and short stitches add another layer of depth and leave a mysterious impression.

What is the biggest difficulty you have come across so far? How did you solve it?

The biggest difficulty is that the whole process is time-consuming. There are no shortcuts when it comes to exquisite embroidery. I tried painting fabric and embroidering on top, but the result just wasn't as agreeable as I imagined. The detail and texture just weren't adequate and looked rather flat. Suddenly, I realized that it was because of all the intricate details and textures that I was so attracted to embroidery in the first place. From then on, I embraced the time-consuming aspect of embroidery and started to truly appreciate it.

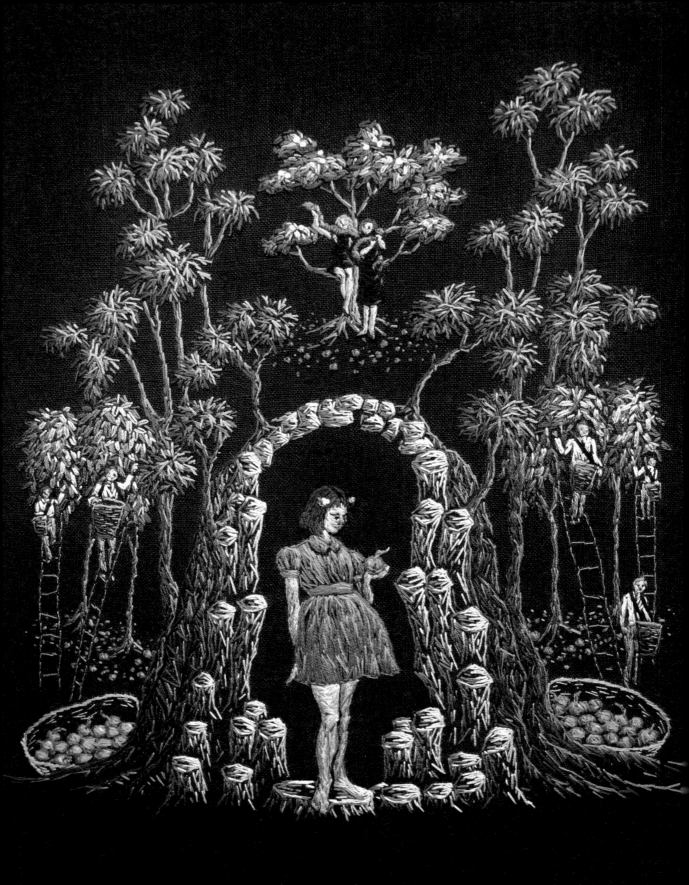

"It has an incredible tactile quality that touches not only the seamstress in me, but connects me to the memory of so many women with stories buried in threads."

Michelle Kingdom

U.S.

Michelle Kingdom's work explores psychological landscapes, illuminating thoughts left unspoken. She creates tiny worlds in thread to capture elusive, yet persistent inner voices. Decidedly small in scale, the scenes are densely embroidered into compressed compositions. While the work acknowledges the luster and lineage inherent in needlework, she uses thread as a sketching tool to simultaneously honor and undermine this tradition. Beauty parallels melancholy as conventional stitches acquiesce to the fragile and expressive.

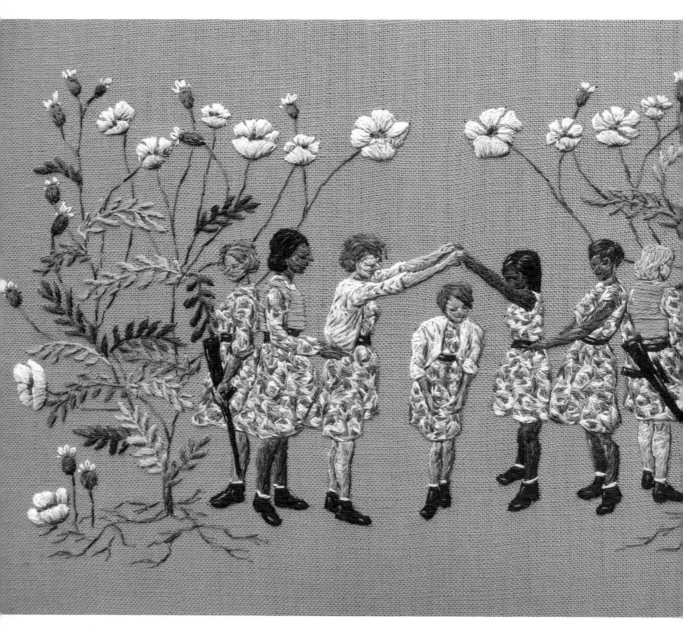

↑ Though Poppies Grow

With a title taken from the poem "In Flanders Fields" by John McCrae, this piece was made in response to the tragic Stoneman Douglas High School shootings in the U.S. in 2018, and the egregious callousness and inaction from politicians. Mirroring this sad reality, the figures in the piece are prepared for combat, wearing military garb and armed with automatic weapons. Unfazed, they carry on as usual, playing a childhood game, surrounded by white poppies.

⁙

Tools: Needle, embroidery floss

Material: Linen

Stitches: Stem stitch, satin stitch, split stitch, French knot, lazy daisy stitch

↓ Tighter and Tighter

"Tighter and Tighter" portrays characters clutching each other in the round. They are serious and intent, working together to keep the symbolic, enormous bird of paradise plants intact. There is no time for questioning or taking a pause, despite the flames beginning to consume the hearts of the flowers.

⚒

Tools: Needle, embroidery floss

Material: Linen

Stitches: Stem stitch, satin stitch, split stitch, French knot, lazy daisy stitch

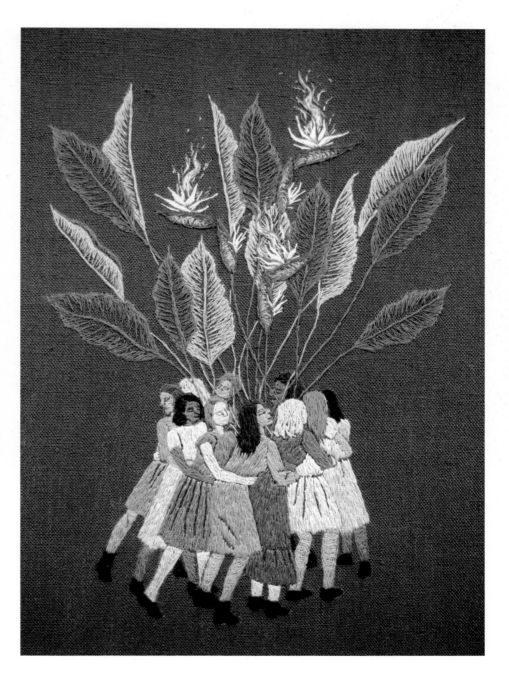

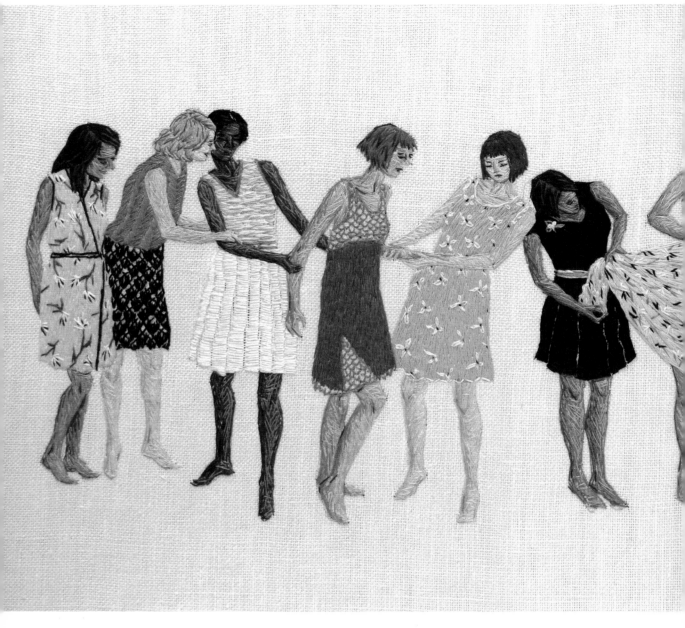

↑ All in a Row

"All in a Row" addresses our interdependent, yet divided society, while exploring a parallel dynamic of personal relationships. Depicted is a solid column of women from many walks of life. Each is holding her own, an equal, and intertwined in a tangled flux of movement. They pick, prod, and poke each other, enmeshed and united for better or worse. There is no extraneous background and the sole focus is on the tension of their entirety. The title comes from the final line of the infamous nursery rhyme ("Mary, Mary, Quite Contrary") furthering the dual interpretation of stereotypical femininity against the realistic social complexities of women.

⋇

Tools: Needle, embroidery floss

Material: Linen

Stitches: Stem stitch, satin stitch, split stitch, French knot, lazy daisy stitch

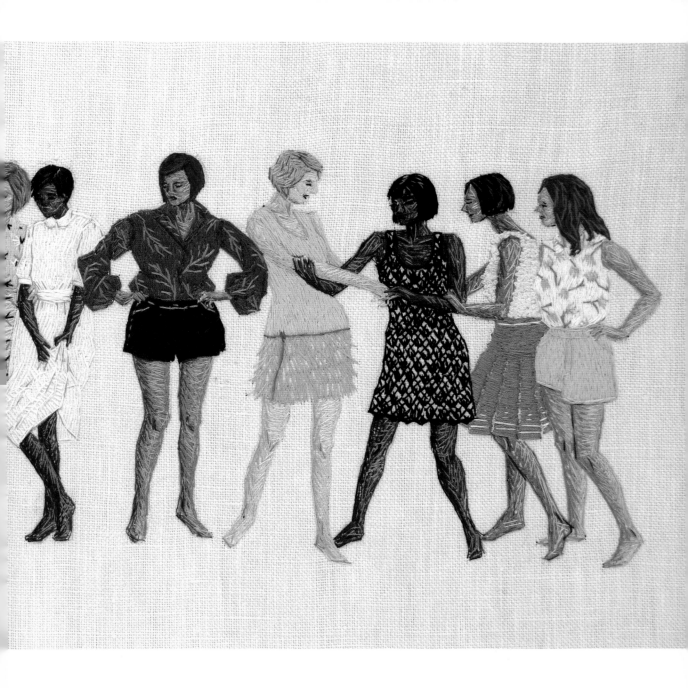

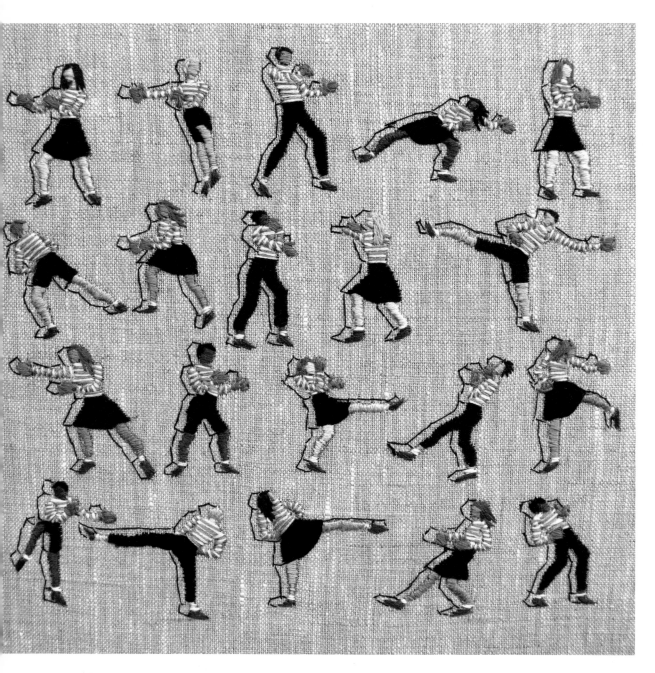

↑ Doubling Down

This is a smaller work portraying a multitude of figures fighting imaginary foes. Each tiny character is caught up in their own myopic world, never looking beyond their solitary mindset. Conflict and opposition is magnified, creating shadows of invisible enemies and resulting in an endless battle in futility.

⁂

Tools: Needle, embroidery floss

Material: Linen

Stitches: Stem stitch, satin stitch, split stitch, French knot

↓ State of Oblivion

"State of Oblivion" is an exuberantly disillusioned take on a culture on the verge. In a world full of division, misinformation, and ignorance, all of the figures blindly dive into the depths. Though the surface of the waters appears like welcoming cloud-like flowers, a closer look beneath reveals figures now drowned and indistinguishable from the consuming sea.

∷

Tools: Needle, embroidery floss

Material: Linen

Stitches: Stem stitch, satin stitch, split stitch, French knot

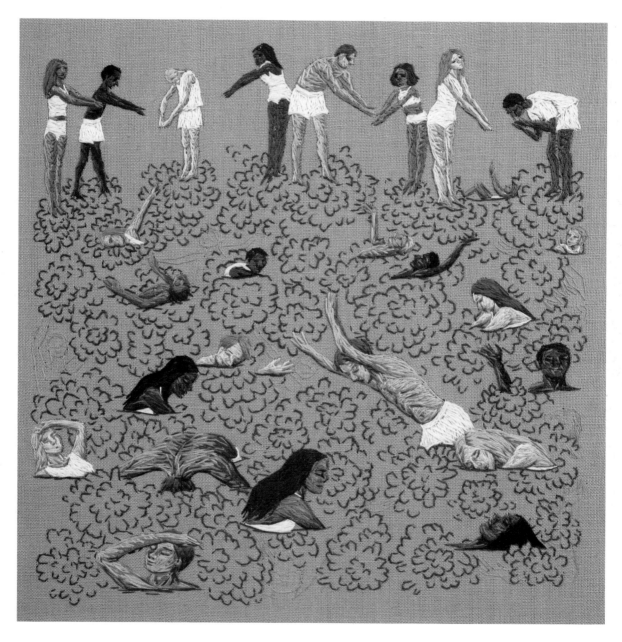

Interview with
Michelle Kingdom

When and how did you start your journey with embroidery?

My initial interest in hand embroidery began while I was studying drawing and painting at school. This was around 1990 when the art world was dominated by oversized, highly conceptual, and impossibly clever work, which mostly left me cold. Instead, I turned to embroidery as an experiment, creating odd and tiny narratives with no expectations. Early pieces were a safe refuge off the judgmental radar of the "serious" art world. Often textile work was overlooked as craft or women's work, and needlework was particularly fraught with stigma—it was for grandmothers or colonial school girls, small in scale, fussy, domestic, nostalgic, feminine, and deemed irrelevant. However, this was precisely why I adored it and found it to be the perfect medium to tap into the mysterious world of the psyche.

Why do you prefer embroidery among all art forms?

Embroidery speaks to me on a very personal level and seems the best way to express my private thoughts. Something about it is primitive and strange in its awkwardness, which strikes me as both compelling, raw, and honest. Yet it also has an incredible tactile quality that touches not only the seamstress in me, but connects me to the memory of so many women with stories buried in threads.

Can you briefly introduce your creative process?

Each embroidery starts with formulating and developing the concept. Sometimes I have a clear vision from the beginning, but more often I have several vague images and ideas that I want to investigate. Through many sketches, ideas laid out like a collage are refined to be a final drawing for a pattern. From there, it is transferred to fabric as a skeletal framework. With a preliminary concept, I make room for experimentation and unexpected discovery along the way. Stitching is done with a dense, intuitive, fluid approach, and each piece stays in flux until the very end. After that, much thought is given to the title to crystallize my intent and complete the work.

"Duties of Gossamer," and its creating process from a sketch to the result.

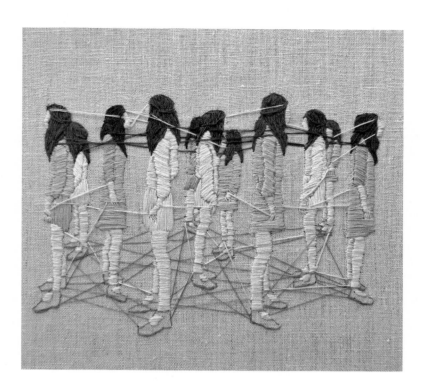

You once said your work explores psychological landscapes. What attracts you to do so?

My inspiration and motivation to make work come primarily from within. I am interested in exploring identity and relationships, and how our perceptions—especially filtered through the lens of our inner lives—shape our reality. The continual tension of opposing dynamics such as aspiration and limitation, expectation and loss, belonging and alienation, truth and illusion, fascinates me. Each piece is a synthesis of several influences including memories, relationships, photographs, literature, personal mythology, art history, and imagination. Ultimately, my personal experiences or those I have witnessed drive the concepts.

How do you visualize these elusive and abstract ideas, feelings, or thoughts through thread and needles?

One of the exciting parts of this medium is being continually surprised by the results, even after working with needles and thread for so many years. Visualization and realization of the work rely on concept, composition, gesture, drawing, color, tone, and texture. Despite forethought and planning, each piece requires risk-taking and the flexibility to stay true to the work as it inevitably evolves.

Most of your embroidery illustrations use backgrounds in low-saturation colors. Why do you choose them? How do they help complete your work?

Color is very challenging and a lot of thought is given to it. By nature, I am simply attracted to a low-saturation palette, while bright and clean colors do not speak to me. My work is grounded in the mythology of memory and nostalgia and how it is reconciled with our expectations and reality, which is better represented by subtle colors. I also find limiting and stylizing the palette is more evocative than trying to portray pure realism.

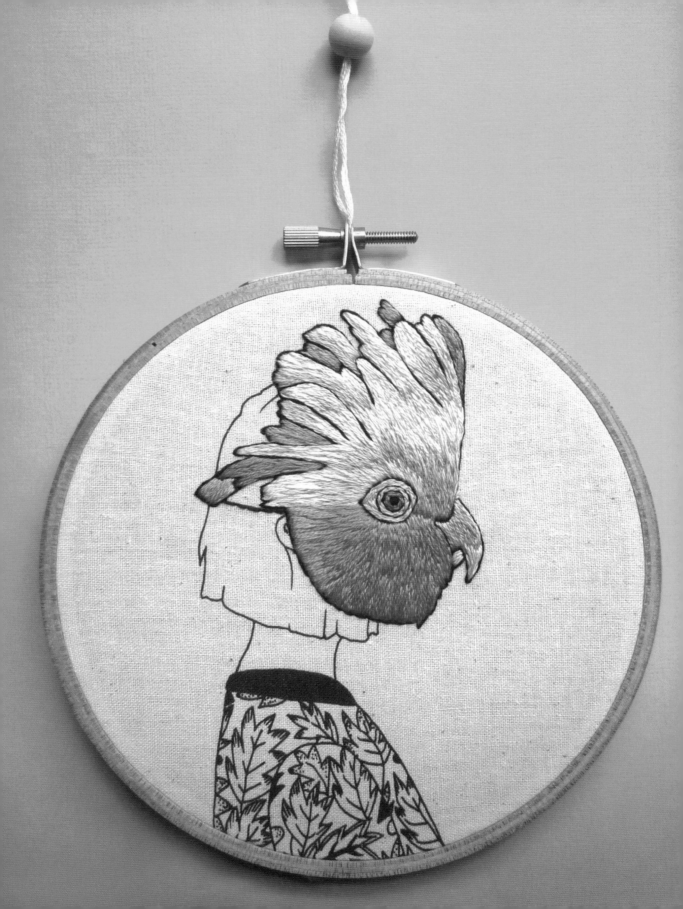

"Even though embroidery is very time-consuming, I love the textures it creates, the shimmers, the patience, the emerging."

Amy Jones

New Zealand

Amy Jones loves to create quirky embroideries rich with details and texture and thus established her studio Cheese Before Bedtime. Amy has always been crafty, but wanted to try a medium other than painting so began playing with stitches. Completely self-taught, she has never looked back and began selling her work online. Currently, Amy is enjoying working on large-scale pieces with themes that range from plants and girls to daily memories.

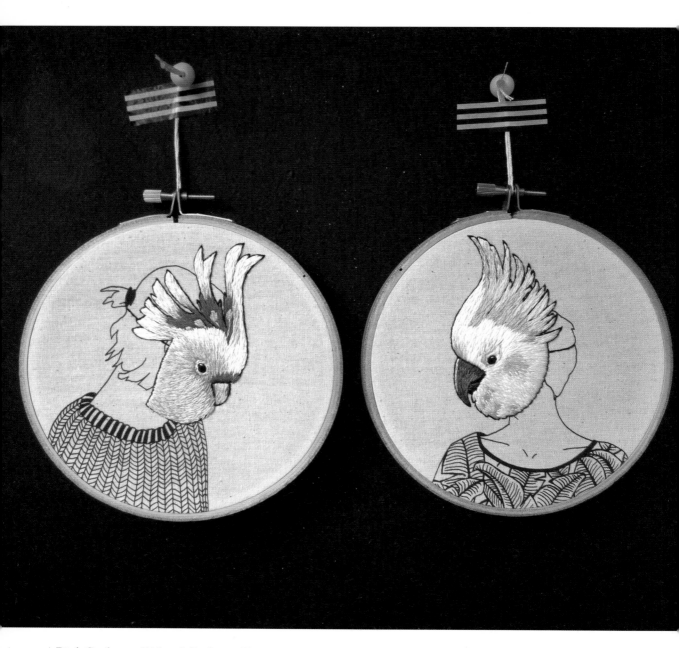

↑ Pink Cockatoo Girl and Cockatoo Boy

Amy loves birds, especially bright birds with interesting features. Australian birds are definitely bright and in your face. The idea of the mask comes from her introverted personality and wanting to hide away sometimes. But these masks are bright and showy, so maybe they're drawing attention to themselves?

✄

Tools: Needle, hoop, computer, printer, lightbox
Materials: Thread, cotton
Stitches: Back stitch, long and short stitch, satin stitch

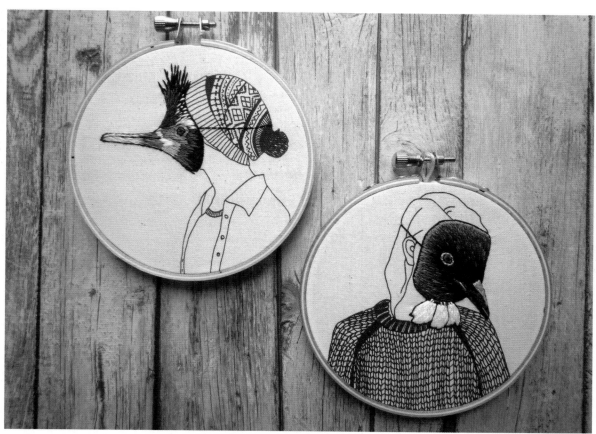

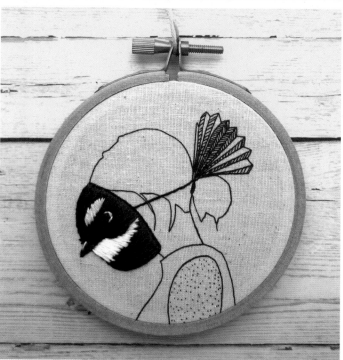

↑ ← New Zealand Birds Series: Spotted Shag and Tui & Fantail Girl

Having such sweet songs and beautiful coloring, New Zealand's birds are among Amy's favorites. She depicted these birds as masks and put them onto the boy's and girls' faces, representing her own introverted tendencies.

⁛

Tools: Needle, hoop, computer, printer, lightbox
Materials: Thread, cotton
Stitches: Back stitch, long and short stitch, satin stitch

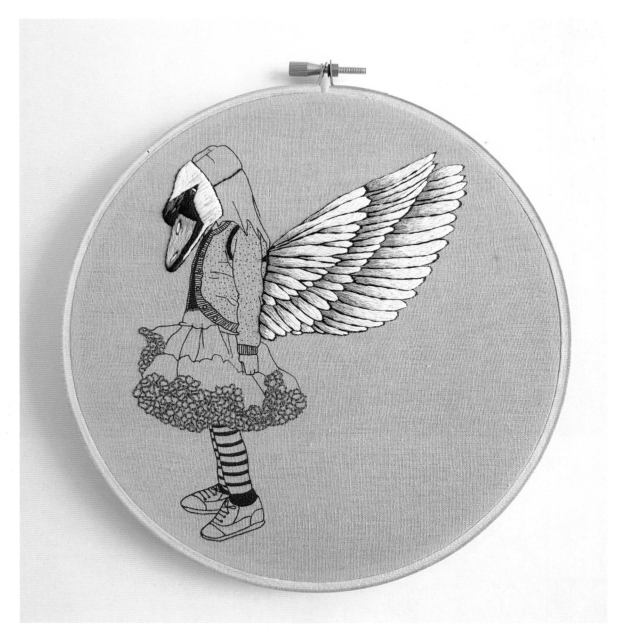

↑ Swan Girl

Amy decided to focus on a series of artworks for kids when she realized there was little original art specifically designed for kids' rooms. With garden animals as the theme, she came up with all sorts of lovely creatures and their costumes. Under the masks, there is space for imagining their expression—sometimes shy, sometimes startled. "Swan Girl" is one in the series.

⁘

Tools: Needle, hoop, computer, printer, lightbox

Materials: Thread, cotton

Stitches: Back stitch, long and short stitch

↓ Dinosaur Children

Adding to her love for fun children's costumes and quirky animals, Amy created this piece.

Tools: Needle, hoop, computer, printer, lightbox

Materials: Thread, cotton

Stitches: Back stitch, long and short stitch

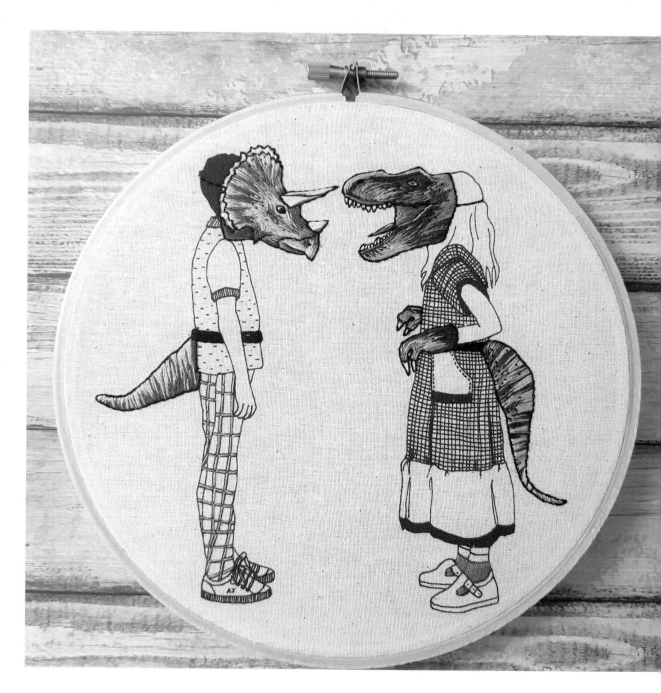

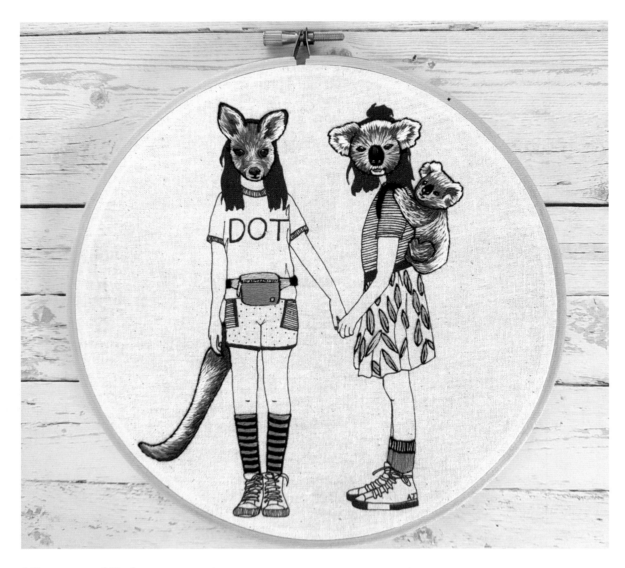

↑ Kangaroo and Koala

This embroidery was made specifically to be auctioned to raise funds for Australia's bush fire recovery in 2020.

Tools: Needle, hoop, computer, printer, lightbox

Materials: Thread, cotton

Stitches: Back stitch, long and short stitch

→ Girl with Ficus

This design is a great combination of many things that Amy loves—textures and details of leaves, girls' fashion, and interior homewares.

Tools: Needle, 30-centimeter hoop, computer, printer, lightbox

Materials: Thread, cotton

Stitches: Back stitch, long and short stitch, satin stitch

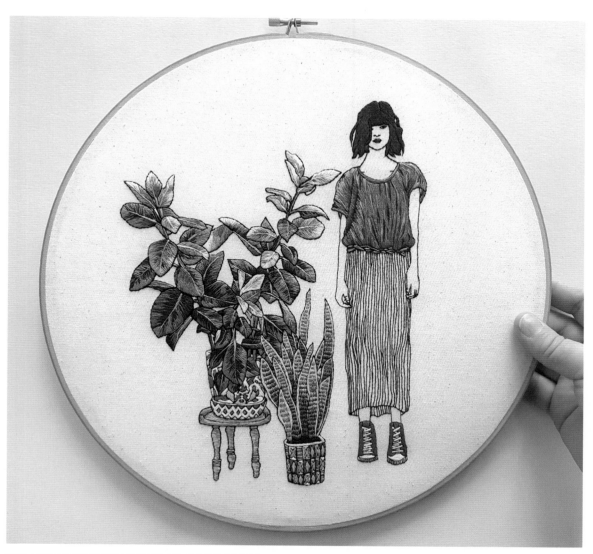

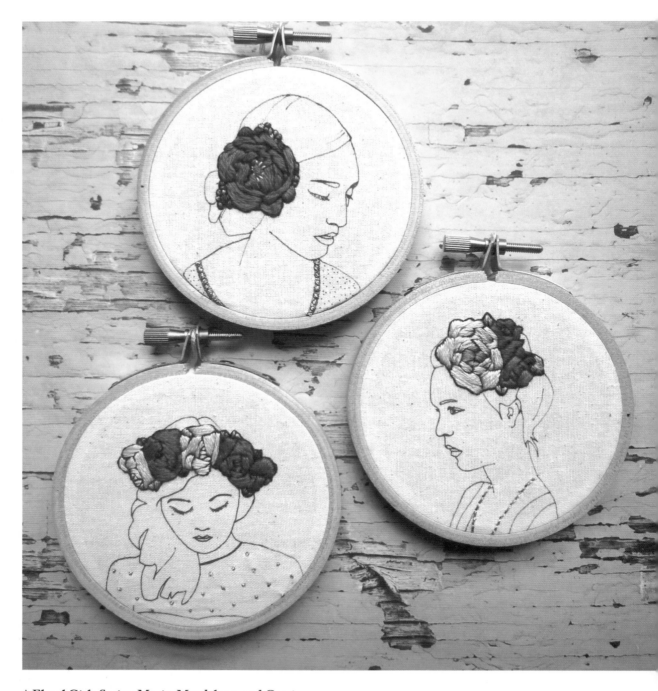

↑ Floral Girls Series: Macie, Magdalena, and Gracie

A lot of Amy's designs are inspired by what's going on in her life. When she was wedding planning, she became obsessed with floral crowns. Thus, she decided a cute collection of "Floral Girls" would be lovely to stitch and people could mix and match their favorites into their own wee collection.

⁝

Tools: Hoops, lightbox, computer, printer

Materials: Cotton, thread

Stitches: Back stitch, satin stitch

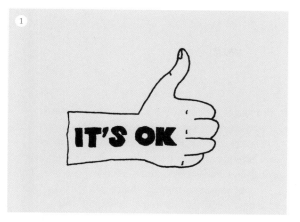

Step 1: Draw a pattern.

Tutorial

In this piece, Amy displays the whole creative process from drawing the pattern to the final modification. Only back stitches and satin stitches are used.

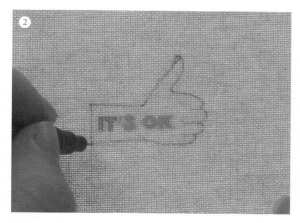

Step 2: Place the image under the fabric and use a lightbox or window to transfer the image onto the fabric with a very fine black pen.

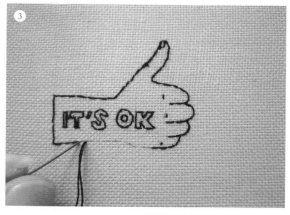

Step 3: Place the fabric in a hoop, making sure it is very taut. Outline the hand and letters in back stitches using one strand of black thread and use smaller stitches around the corners.

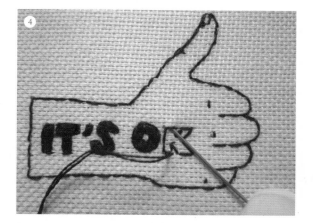

Step 4: Fill in each letter using satin stitches.

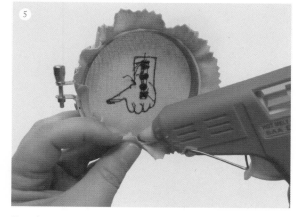

Step 5: Trim a 10-millimeter edge around the hoop. To finish the hoop, glue the hoop's back internal edges using a glue gun and stick the fabric down tightly.

Interview with
Amy Jones

How did you start the journey of embroidery? Why is embroidery special to you?

When I was nine, I was an arty girl intrigued by anything crafty and started cross-stitching, learning the basics of threading the needle, knotting and splitting threads. However, I was soon off onto my next craft obsession and didn't stitch again for many years. After gaining an interior design degree and getting into visual merchandising, I always craved being more creative. I thought of diving into painting, but was intimidated by the techniques and start-up costs. As something about embroidery remained within me, I thought, why not create "paintings" with threads? So, my experimentation of embroidery began. Even though embroidery is very time-consuming, I love the textures it creates, the shimmers, the patience, the emerging.

As a self-taught artist, what kind of difficulties have you come across when learning everything from scratch by yourself?

Really, being self-taught hasn't created any difficulties. I had about a year of pure experimentation, not using online tutorials or instruction books. Just me and various fabrics, threads and stitches. It was a process of discovering my own techniques. Only a few years ago did I look up a French knot tutorial. The only difficulties of being a self-taught artist have been around pricing my work, collaborations, and the admin side of running a creative business.

Could you briefly introduce your creative process?

Ideas come to me before bedtime, in the shower, driving, whilst stitching, just times when I'm in dreamland. I usually like to create a series based on the same idea. I create an outline image in black pen based on photos pieced together using my lightbox. I scan this image into my computer, clean it up and either print or trace it onto fabric. Once the fabric is tight in my hoop, I begin stitching outlines in black. I then decide whether to fill in all parts of the image

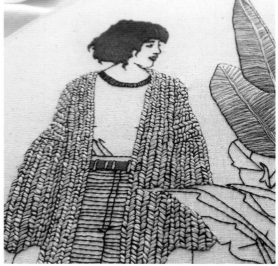

This piece, "Girl with Bird of Paradise," and "Girl with Ficus" in page 109 are in Amy's Plant Girl Series.

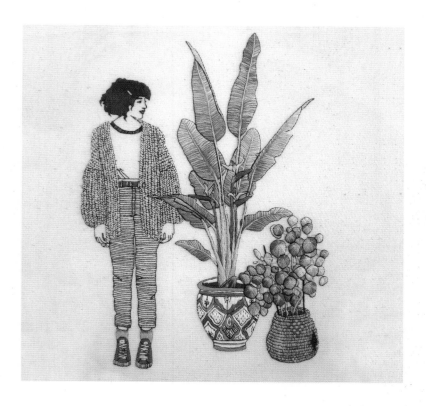

or focus on filling in details and what colors to use. Once complete, the fabric is glued into the hoop to keep it taut, then photographed and listed for sale.

Some of your embroideries are colored, some are only made with black threads and some are partially colored. What are the characteristics of these pieces with different coloring?

There came a point in my journey when the demand for my work outweighed the time I had to create it. I was doing a lot of wholesale orders and needed to think of time-saving, profit-increasing ways to speed up my embroidering. This was when I decided to print or stitch the outlines onto fabric and just stitch in details. As I'm designing a piece I think about where I want to push the viewers' eyes to go. If all parts were colored not only would it take much longer, it would also take away from the idea that I want to focus on. When deciding on filling in with color, I need to consider balance, time, and where I want the focus to go.

Where do you usually get inspiration from? Have you ever experienced a creative block? How did you get through it?

I find inspiration all around, mostly nature. Luckily, I normally have too many ideas rather than none. I have experienced creative blocks, not in an "ideas" way, usually just in terms of motivation or procrastination. In those times, I might read inspirational books or podcasts or stitch a piece that I've done before, which keeps me working, but I don't really need to think about it too much. I may focus on completing admin, tidying my space, getting outside or beginning a 30-day project and announcing it on Instagram to keep myself accountable. I understand that creativity is a process and I will go through lulls but I try not to worry and know that my motivation will always come back.

"As soon as Maricar started playing with color with the embroidery, we knew it was a medium we could have fun with."

Maricor/Maricar

Australia

Maricor/Maricar is a studio run by twin sisiters based in Sydney, Australia. They specialize in hand-embroidered and tactile graphics for advertising and publishing. Their awards include a RYD award from the British Council Australia and a Young Guns Award by the Art Directors Club based in New York.

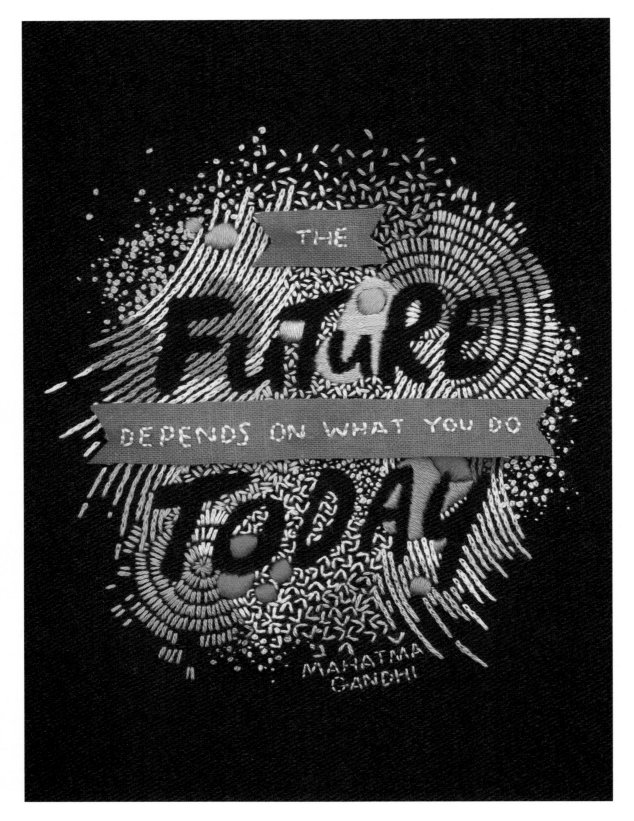

← Future Today

"Future Today" is a commissioned artwork for the Southern Poverty Law Center in the U.S.

Tools: Standard embroidery needle, hoop, chalk transfer paper

Materials: Stranded cotton embroidery floss thread, cotton fabric

Stitches: Split stitch, satin stitch, seed stitch, French knot

→ Love

"Love" is a private commission.

Tools: Standard embroidery needle, hoop, chalk transfer paper

Materials: Stranded cotton embroidery floss thread, cotton fabric

Stitches: Split stitch, satin stitch, seed stitch, French knot, couching

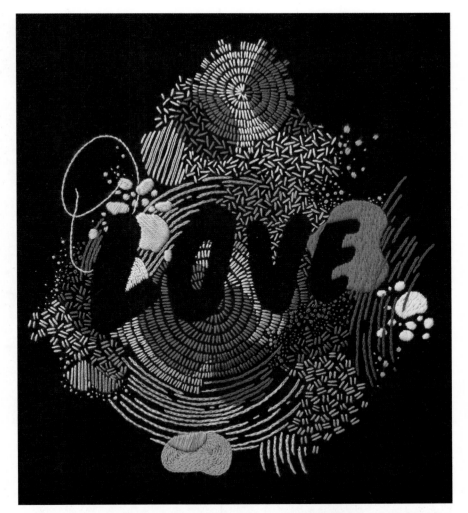

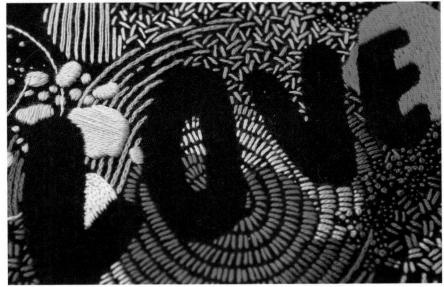

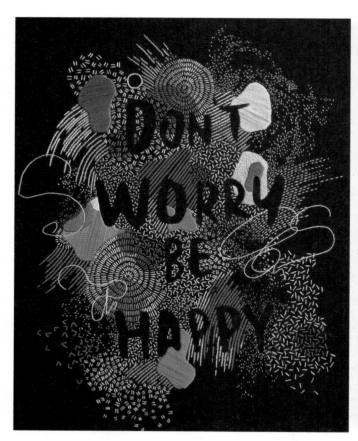
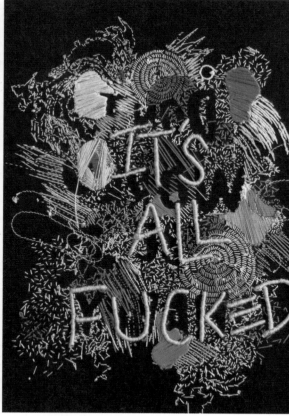

↑ Don't Worry, It's All Fucked

This is a double-sided embroidery sewn onto one piece of fabric. The front reads "Don't Worry Be Happy," while the back reads "It's All Fucked." In this piece, the positive and negative messages are contained within each other. Often uplifting quotes can seem a little overly positive and off-puttingly earnest, so Maricor and Maricar wanted to create a tongue-in-cheek response to that stereotype. Everything is all fucked, so you may as well try not to worry and be happy while you can.

※

Tools: Standard embroidery needle, hoop, chalk transfer paper

Materials: Stranded cotton embroidery floss thread, cotton fabric, wool

Stitches: Split stitch, satin stitch, seed stitch, French knot, couching, whip stitch

→ Out of Order or Sort of Unaligned

Embroidery is a unique medium with two sides to the artwork. While the back is usually considered the "wrong" side and hidden from view, Maricor and Maricar wanted to flip that around and expose the back of the stitching—highlighting the tactile quality of the embroidery and how it exists beyond the surface. The lyric is from the song "I'm on Standby" by Grandaddy.

※

Tools: Standard embroidery needle, hoop, chalk transfer paper

Materials: Stranded cotton embroidery floss thread, cotton fabric

Stitches: Split stitch, satin stitch, seed stitch, French knot, couching

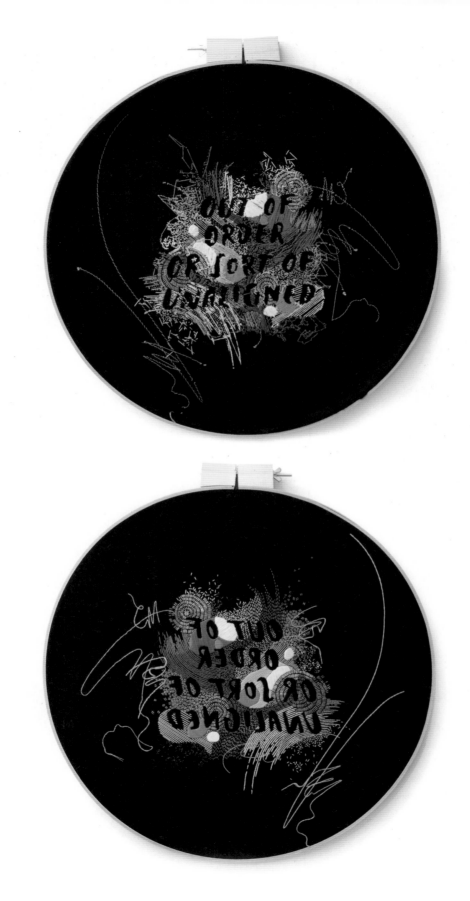

Delicious Alphabet

This English alphabet was created along with a series of gastronomic embroideries commissioned for the Hong Kong airport. The main campaign spelled out "delicious" in various languages.

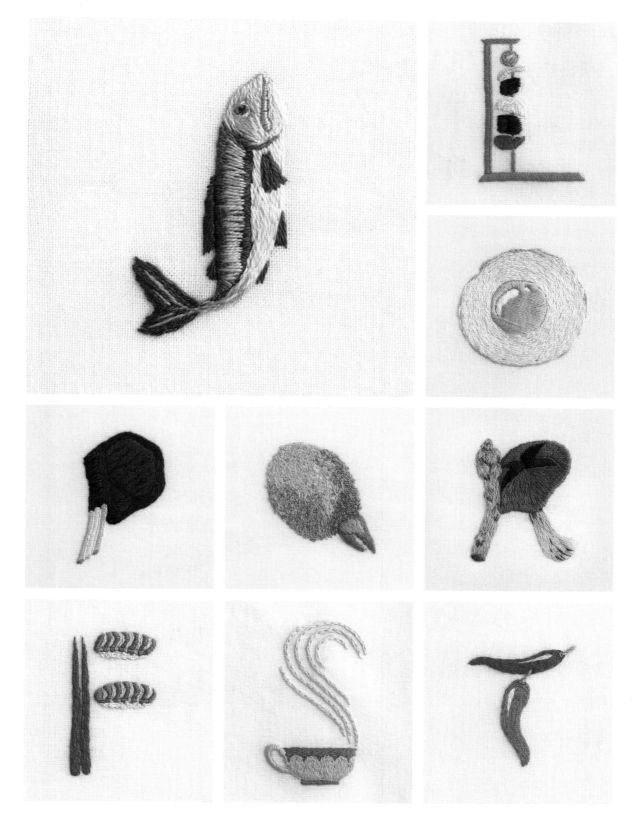

Interview with
Maricor/Maricar

Tell us a bit about your artistic background.

Both of our backgrounds are in graphic design and animation and we've always been drawn towards hand-generated techniques. Back in 2007, a music video project came up in the design studio we were working for and one of the ideas was to create it entirely with embroidered illustrations. We hadn't seen that done before and were keen to experiment and learn something new, so we jumped straight in and learned how to embroider for the animation.

Could you briefly introduce your creative process? What is the trickiest part?

All our projects start as a sketch, usually a pencil on paper, though nowadays we are starting to use tablets and computers to help with the design phase. It's much quicker to test ideas, play with the visuals, and make tweaks while it's still a sketch. Once we have shown these sketches to the clients, we then try to mock up the design digitally with as much detail as we can and have all the colors set so that our clients have a clear vision of how the artwork will look once embroidered. Some of the texture of hand embroidery is hard to demonstrate, so we usually collect samples from previous projects that show what type of stitch we propose using. The trickiest part of our process is managing time. Sometimes deadlines are very tight and hand embroidery is a slow process. However, now that we are more experienced, we are much better about scheduling time. That's why we have started using the iPad and computers more to help speed up the design process to allocate more time to stitching.

This *hiragana* (Japanese syllabary) is an excerpt from the series of gastronomic embroideries.

How do you divide your work? And what is the best thing about working with your twin sister?

Things are a little in flux at the moment as I (Maricor) have taken some time off work with the arrival of my own set of twins. But when we are both working, usually we will try to each come up with concepts at the sketch stage and whichever design is chosen by the client, that twin will take the lead and complete the project. If deadlines are tight, the other twin will step in and try to take on part of the embroidery work. The best thing about working with Maricar is that we know each other inside out, which makes the design process run a lot smoother.

Many of your embroideries involve typography. How did you come up with the idea of combining embroidery and typographic design?

With our backgrounds in graphic design, we worked with typography in many of our projects so it was a natural fit to experiment with combining lettering and embroidery. The first project either of us did after that first music video was a piece of song lyric Maricar stitched as a gift. And as soon as she started playing with color with the embroidery, we knew it was a medium we could have fun with.

Your embroideries are bright and colorful. Would you like to share some tips or experiences of matching colors with us?

It is important to collect colors. We find interesting color palettes in various places like photographs in a magazine or textures in nature and will document them in case we might want to use some for a project later down the track.

Your typographic embroideries have been applied to book covers. What do you consider the most while working on editorial illustrations?

We consider how we can communicate elements of the story in the details of the stitching, whether it's straightforward visual motifs or more subtle hints that we explore abstractly with color, texture or pattern.

What have you been working on recently? Is there any new project that you want to try in the future?

We've been partnering with some international homeware brands to design products for the home. We'd love to design more textiles for soft furnishings and get back to working on our personal experiments.

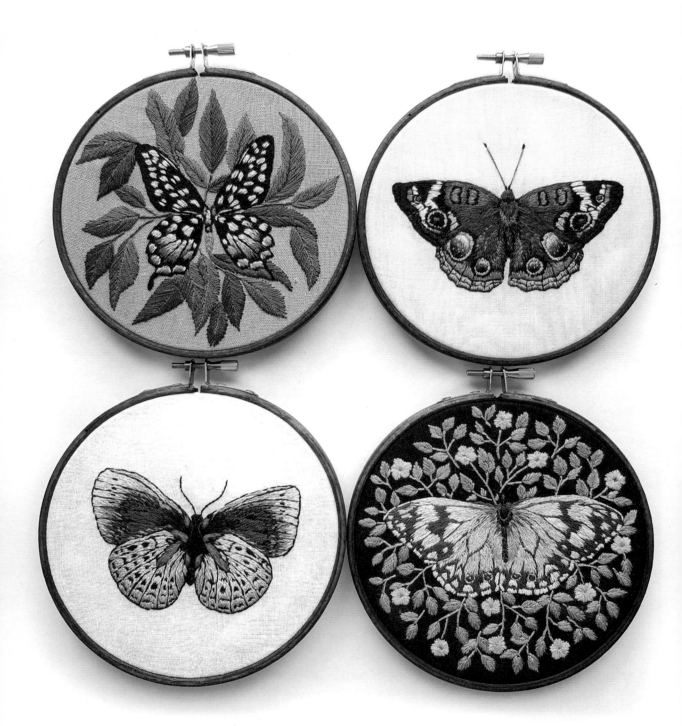

"One can never emulate nature, but I like to think that my work represents the colors and patterns without being photographic images."

Georgie K Emery

U.K.

Georgie K Emery is a self-taught embroidery artist who mixes her knowledge gained in studying textiles at Loughborough University where she specialized in printed textiles with traditional embroidery methods to create colorful embroidery designs. She draws her inspiration from nature and the seasons and loves to experiment with different techniques.

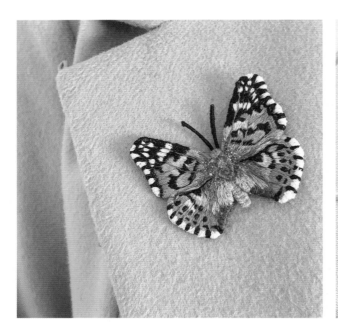

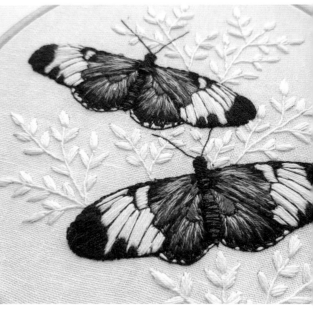

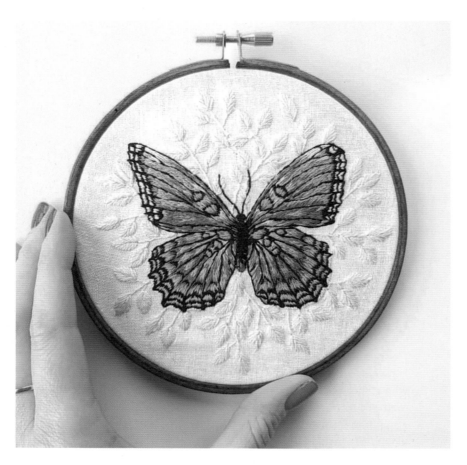

↑ Painted Lady Butterfly Brooch & Pair of Long-Wing Butterflies

The brooch is hand-stitched onto a felt back which makes it a solid and structured piece.
The two long-wing butterflies are stitched against white foliage which creates a subtle backdrop.

⁑

Tools: Wire, brooch clip

Materials: Kona cotton, felt, embroidery threads

Stitches: Long and short stitch, straight stitch, back stitch

↓ Butterfly on White 2019

Framed in a walnut hoop, this butterfly is hand-embroidered against a white foliage background.

⁑

Tool: Walnut stained embroidered hoop

Materials: White linen, embroidery threads

Stitches: Long and short stitch, whipped stitch

→ Hawthorn Roses

Inspired by walks around the U.K. and the foliage in the hedgerows, this piece shows a collection of six roses and three buds focused in the center of the hoop.

∷

Tool: Wooden embroidery hoop

Materials: Linen fabric, embroidery threads

Stitches: Satin stitch, French knot, whipped back stitch, straight stitch

↑ Winter Scene 2

Three layers of fabric were used to create this piece. The raw edges were covered up with hand-embroidered elements to disguise the fabric layers and create an enchanted winter scene.

❈

Tool: Embroidery hoop

Materials: Linen fabric, embroidery threads

Stitches: Running stitch, satin stitch, French knot

↑ Winter Scene 1
This scene features a village in a frosty woodland nestled in the mountains.
❉
Tool: Embroidery hoop
Materials: Linen fabric, embroidery threads
Stitches: Straight stitch, satin stitch, seed stitch, back stitch

← Midnight Forest
This scene features a winter woodland captured in a crescent moon and shining stars.
❉
Tool: Wooden embroidery hoop
Materials: Linen fabric, embroidery threads
Stitches: Straight stitch, satin stitch, split stitch

Interview with
Georgie K Emery

What is your creative process like?

I like to create a collection of designs. Once I have selected my latest theme, it is easier to get into a workflow and I'm able to produce three to five designs back to back. Otherwise, I find it harder to keep the momentum going between designs.

On my travels, I'm always taking pictures of various things from a leaf to interesting textures or compositions. As I seize a quiet moment to go through them, I sketch ideas inspired by the photographs. Having a composition and sketch that I'm happy with, I transfer it onto the fabric and select my color palette. I try to be as organized with a design as possible so that I don't give myself any excuses to procrastinate. Choosing a color palette is time-consuming, but you can't rush or skip because your design will be greatly affected by it. When everything is set, I can enjoy stitching up the design from start to finish.

What do you love about embroidery compared to other art forms?

I love how transportable embroidery is, the equipment and materials required will fit into a bag and you can take them anywhere with you. I also enjoy the textures involved with embroidery and the mindfulness the craft allows. Working on a project is like therapy for me, it's such a peaceful medium.

Why do you portray so many natural elements, especially butterflies, in your embroidery?

They hold a lot of personal symbolism for many people and it is a great subject matter to try and emulate in embroidery. They represent peace and life and exude such a magical presence as they gently fly around. There are also so many different varieties of butterflies, which provide a stream of inspiration and I still have plenty on my to-do list. One can never emulate nature, but I like to think that my work represents the colors and patterns without being photographic images.

Georgie injected her love for nature and gardening into these cute little veggie and fruit patches.

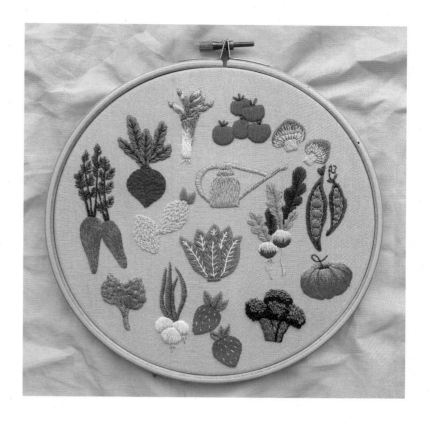

I spend a lot of time in the U.K. and France, photographing different species of butterflies for future designs and it seemed like a natural partner to combine the delicate floral embroidered backgrounds against the bright color palette of a butterfly.

When creating the pieces of butterflies and flowers, how do you make them fantastic, but simultaneously realistic?

Whilst the butterflies are a wonderful subject matter to stitch, they do come with the added challenge of trying to make both wings look exactly the same, a mirror image. This can be very difficult when your design is created by building layers upon layers of individual stitches. Sometimes when you've realized it's not quite right, you've already put down 20–50 stitches. But I believe that's also another great aspect of embroidery. Sometimes you must commit to the stitches you have sewn; you can't easily rub them out or paint over them.

How do you work on the color palette to make your artwork colorful and splendid, but not flashy at all?

It's taken me a few years to adapt and evolve a color palette that represents me. I do often reflect a lot of the same colors throughout my embroideries. One of the most challenging elements of art is the color palette. Just one wrong color or one small color change can modify the whole piece and really bring it to life. Or if you've picked a wrong color, it can, unfortunately, do the exact opposite. I like to select the color of my background fabric first and then I carefully select colors that compliment it as well as each other.

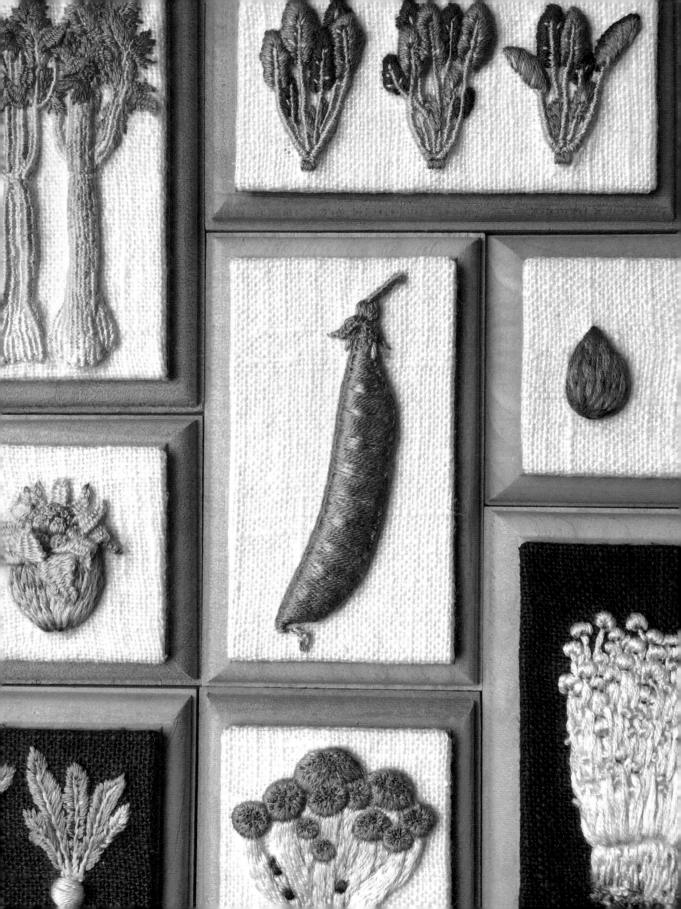

"Since I observe the vegetables carefully and embroider them with affection, the finishes are lovely."

Konekono Kitsune

Japan

Konekono Kitsune is a vegetable embroidery artist who uses three-dimensional embroidery techniques to bring various vegetables to life.

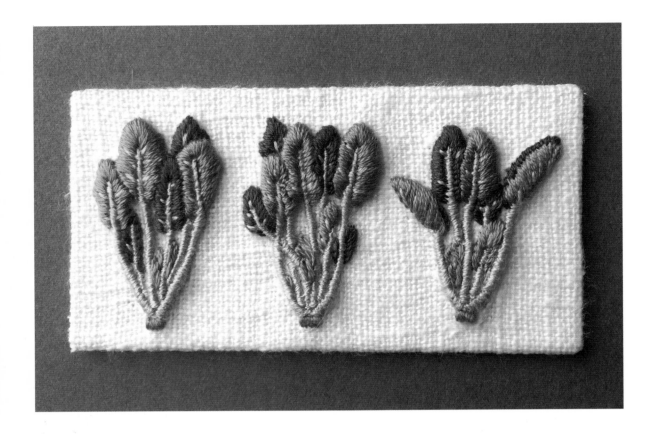

↑ Spinach

This embroidery depicts the main Japanese winter vegetable. The roots are colored with red threads subtly and are understated, but realistic.

※

Tools: Water-based pen, needle, handicraft bond
Materials: Linen cloth, DMC thread 25, felt, cardboard
Stitches: Satin stitch, straight stitch

← Onion

While embroidering an onion, the artist paid special attention to the peeled-off surface to bring more realistic details to the piece.

※

Tools: Water-based pen, needle, handicraft bond
Materials: Linen cloth, DMC thread 25, felt, cardboard
Stitches: Coaching stitch, satin stitch, French knot

↑ Celery

To create a gradation, the artist applied embroidery thread in four shades of green. The unevenness of the stem is expressed by repeating fine satin stitches.

✂

Tools: Water-based pen, needle, handicraft bond

Materials: Linen cloth, DMC thread 25, felt, cardboard

Stitches: Satin stitch, raised leaf stitch

← *Shiitake* **Mushroom**

The cap of the *shiitake* mushroom is glossy because of the satin stitches, which also give the mushroom a unique and plump texture.

❖

Tools: Water-based pen, needle, handicraft bond
Materials: Linen cloth, DMC thread 25, felt, cardboard
Stitches: Satin stitch, straight stitch

↓ *Shimeji* **Mushrooms**

This is an early work of Konekono Kitsune's. The whole image is cute and vibrant because all the small mushrooms are snuggling each other.

❖

Tools: Water-based pen, needle, handicraft bond
Materials: Linen cloth, DMC thread 25, felt, cardboard
Stitches: Satin stitch, long and short stitch, French knot

↓ *Enoki* **Mushrooms**

The large and small mushrooms are growing on top of each other. While creating this piece, Koneko tried to simulate the look of *enoki* mushrooms planted together in a cup.

❖

Tools: Water-based pen, needle, handicraft bond
Materials: Linen cloth, DMC thread 25, felt, cardboard
Stitches: Satin stitch, straight stitch, French knot

↑ Mixed Nuts

Before embroidering, the artist first finished the felt base carefully. She sewed the piece over and over again until she got the shape wanted.

⁙

Tools: Water-based pen, needle, handicraft bond

Materials: Linen cloth, DMC thread 25, felt, cardboard

Stitches: Satin stitch, straight stitch

Tutorial

Konekono Kitsune displays how she embroiders a realistic peanut with cloth, felt, and three colors of DMC thread 25, using blanket stitches and straight stitches.

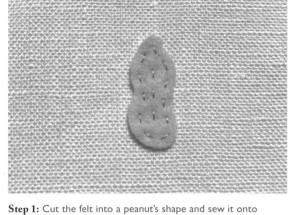

Step 1: Cut the felt into a peanut's shape and sew it onto the cloth.

Step 2: Sew the outline of the peanut using blanket stitches with thread #3047.

Step 3: Fill the center of the felt also with blanket stitches to emulate the texture of a real peanut.

Step 4: Use thread #422 to fill the gap left by the previous blanket stitches with straight stitches.

Step 5: Use dark brown thread (thread #436) to add details and nuances to the piece.

Interview with
Konekono Kitsune

How did you start your journey with embroidery? Can you tell us a bit about your background?

My grandmother was a master of handicrafts. Most of her works were embroidered, and I grew up surrounded by them. My mother loves handicrafts too, so there were many handicraft tools in my parents' house. Thanks to that, I have been using needles since I was little. At that time, needles and cloth were like pens and paper, and embroidery was like painting. When I grew up, I studied product design at university. Knowing that various shaped objects were actually created by people's hands from scratch, I began to feel the desire to create something with my own hands.

Why is embroidery special to you?

I feel relaxed when I concentrate on embroidery without thinking tiring things. I'm not a talkative person, and when I express my feelings solely with language, I worry about causing misunderstandings. Thus, for me, embroidery is an important way to express myself and share my feelings with others. I would like to continue embroidering and expand my connection with people.

Can you briefly introduce your creative process?

First, I decide which vegetable will be the subject by looking for seasonal vegetables at the markets. After that, I sketch roughly. Since I embroider while looking at the model, I do not need detailed sketches. Next, I sketch on the cloth. Using both thread and felt are the keys to giving the vegetable embroidery a three-dimensional look. The better the felt is shaped, the better the finish.

Konekono Kitsune embroidered this after a request from a farmer. The leaf ginger that she received as a model was very colorful and beautiful, and she tried to reproduce it. The color change from the root to the tip of the leaf is a distinct feature of this vegetable, so she used many colors to express it.

How do you make the embroideries cute, but real?

To make them cute, the most important thing is my feelings about vegetables. Since I observe them carefully and embroider them with affection, the finishes are lovely. To make the embroideries look real, I have some tricks. For example, when embroidering peanuts, I employ blanket stitches to simulate the lines of a peanut shell. Also, I might embroider the flesh and shell of a nut or bean separately or adjust the angle to make it more lively. For leafy vegetables, I try using different colors for the front and back of the leaves, adding the color of dead leaves, or creating some wormy leaves. Every vegetable has its own feature, so I have different ways to depict different vegetables.

For some embroideries, you use brown fabrics as the background. For others, you choose white fabrics. Why do you choose fabrics in different colors?

The color of the fabric changes depending on the vegetables to be embroidered. Usually, I use white cloth. Yet, when embroidering white or light-colored vegetables, a piece of brown cloth is necessary to prevent assimilation with the cloth. I do not know what kind of vegetables I will meet and embroider, so I might use more colors of cloth than just white and brown to my works. All in all, the main function of the fabric is to accentuate the vegetables.

Do you have any suggestions for those who just started embroidery?

I think embroidery is a very free way of expression and you can sew anywhere with just a needle and thread. Feel free to sew it wherever you like and you can even embroider on the hem of the clothes or the corner of a curtain rather than cloth. Draw like a child's doodle and don't be afraid of making a mistake because you can fix it right away.

"By embroidering flowers and plants I want to draw people's attention to the extinction of plants, which is overlooked compared to that of animals."

Juyeong Kim

Korea

Juyeong Kim is a Korean embroidery artist. She has been involved in embroidery for the last 20 years, and now she is operating a small handcraft workshop teaching embroidery.

Floral Embroidery

Through floral embroideries, Juyeong wants to raise people's awareness of the extinction of plants. Besides, she dyes the fabrics and threads with raw materials from nature, connecting her artwork with nature from another perspective.

143

← Grass-Flower Ring Made of Clover

Juyeong neatly embroidered the clover leaves to give this piece a comfortable and soothing look.

⁜

Tools: Carbon paper, tracing paper, pen, embroidery frame

Materials: Linen, DMC thread 25

Stitches: Satin stitch, outline stitch, straight stitch

↓ Relax in the Shade Filled with the Scent of Acacia

Juyeong gave points to the flowers and expressed the bench lightly with simple outline stitches. This contrast not only accentuates the flowers, but also makes the background relaxing.

⁜

Tools: Carbon paper, tracing paper, pen, embroidery frame

Materials: Linen, DMC thread 25

Stitches: Satin stitch, leaf stitch, outline stitch, straight stitch

→ Lovely Tulip Brooch

Though in a small frame, the tulip flowers are expressive.

⁘

Tools: Carbon paper, tracing paper, pen, embroidery frame

Materials: Linen, DMC thread 25

Stitches: Satin stitch, straight stitch, outline stitch, French knot

↓ Fresh Morning Glory

Juyeong made every stitch neat to create a serene atmosphere for this piece.

⁘

Tools: Carbon paper, tracing paper, pen, embroidery frame

Materials: Linen, DMC thread 25

Stitches: Satin stitch, long and short stitch, outline stitch, French knot

Interview with
Juyeong Kim

We can find many delicate and elegant flowers and plants in your artworks. Why do you enjoy embroidering flowers and plants?

When I was a child, I grew up in a house in the countryside where the surrounding natural environment, including various kinds of flowers and trees, was well preserved. In particular, I remember smelling the very nice fragrance of flowers and grass after the rain. Even after I became an adult, I missed the place and sometimes painted wildflowers. Now, I use embroidery thread to represent them.

Another important reason is that by embroidering flowers and plants I want to draw people's attention to the extinction of plants, which is overlooked compared to that of animals. Animals seem more important because they are cute and lively, while plants lack much awareness and interest, relatively. According to the announcement of the Ministry of Environment of Korea in 2018, there are 11 kinds of wild plants on the verge of extinction and 77 kinds not far behind. Considering this trend, it is obvious that the number of endangered wild flowers will increase gradually both now and in the future. Therefore, there is a need for not only Korea, but also the whole world to pay more attention to endangered wildflowers and plants. Currently, I am doing embroidery works with endangered wild flowers as motifs to hold an exhibition because I want to improve people's awareness of protecting wild plants.

Juyeong made hand-embroidered carnation brooches with three-dimensional-like texture as gifts to share love and warmth.

What do you love about embroidery? What you do want to communicate through your embroideries?

Threads and fabrics have warmth and I love the moment when I feel it's delivered by the finished work. Completed by hand, stitch by stitch, embroidery takes a very long time to create. Similarly, the destroyed natural ecosystem also needs decades to recover. So, the process of embroidering and my purpose of representing wildflowers and plants are related and consistent at some degrees.

Are there any stitches or materials that you prefer? How do they contribute to your artwork?

I dye my own fabrics and thread with raw materials from nature because natural materials are diverse and abundant. For example, it is possible to obtain a golden color by boiling the skin of an onion or marigold. You can sometimes get surprisingly mysterious blue colors through indigo dyeing regardless of whether it has fermented or not. Making embroideries with these natural dyes makes me very happy.

Your embroideries make people feel tranquil and relaxed. How do you achieve that?

I always think that humans also belong to a part of nature while creating my works. I think it's because my peace of mind is revealed in the embroidery works. Embroidery is like an infinite repetition of a work. In most cases, I work after meditating because it makes me more immersed in the work. I think that's why I can create works of high quality.

You are an embroidery teacher and an artist at the same time. How do you feel about these two different roles?

Frankly speaking, I want to devote all of my passion to making my work as an artist. However, teaching students is the driving force that sustains my life. I initially started teaching as a means to live a regular life, but now I am very proud of seeing my students gradually growing by learning from me. The sort of happiness it gives me is different from what I feel when immersed in my work because it reminds me of that I am a member of society and have a positive influence on others.

You run a YouTube channel showing people how to make embroideries. Why did you want to do it?

Actually, I don't feel free to do embroidery works while I'm being filmed under a camera. Nevertheless, the reason I upload my videos through YouTube is that I want to feel connected with more people.

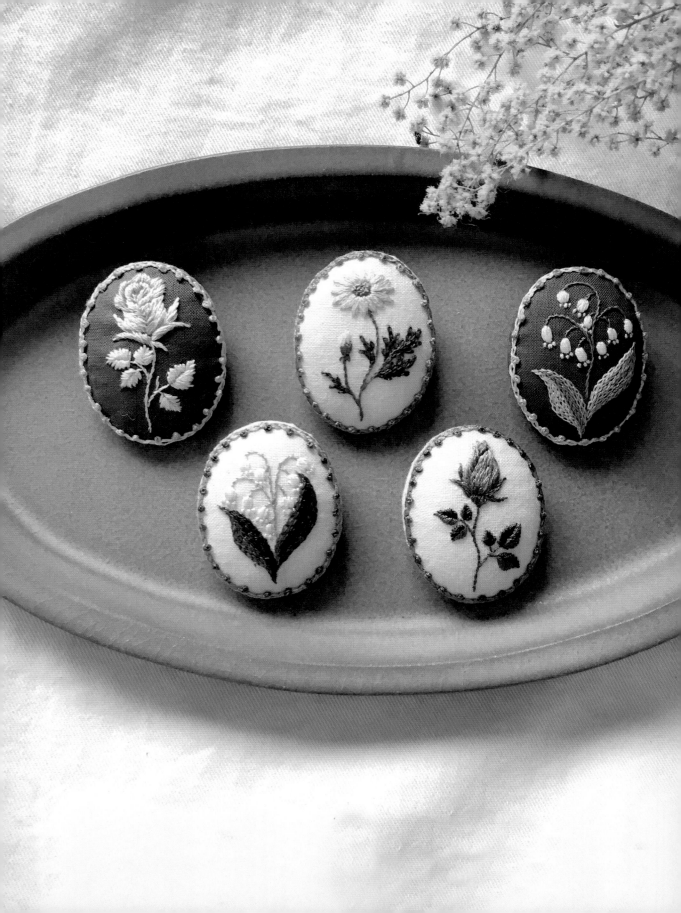

"The concept of my work is to create something close to people's hearts and to convey that I envision my embroideries to be natural, mild, and ephemeral."

Erika Sugano

Japan

Majoring in copper engraving at Osaka University of Arts, Erika Sugano started her career as an embroidery artist in 2015 under the name of maki maki. With the concept of "creating something close to people's hearts," Erika combines thread and ribbons and focuses on embroidering accessories that are soothing.

← *Daifuku*

Otedama is a type of traditional Japanese toy stuffed with beans. For this embroidered otedama, Erika took the round appearance from *daifuku*, a Japanese dessert—a round glutinous rice cake with sweet filling (commonly red bean paste). Round items always give people an impression of warmth and peace.

✂

Tools: Embroidery needle, frame, thread scissors, air soluble marker

Materials: Threads, linen, pearl beads

Stitches: Straight stitch, French knot

↓ Flower Garden

In these two cameo-like brooches, flowers blooming in the garden are enclosed in frames, like pictures with simple colors. Erika enjoys combining the texture of ribbons and the softness of thread.

✂

Tools: Embroidery needle, frame, thread scissors, air soluble marker

Materials: Threads, ribbons, cloth, brooch parts

Stitches: Straight stitch, French knot, outline stitch, satin stitch, chain stitch, lazy daisy stitch

↑ The World of Picture Books

On these sachets, Erika embroidered stories from picture books. They contain potpourris of lavender and rose, soothing the viewers through not only the texture and embroideries, but also the scent.
⋇

Tools: Embroidery needle, frame, thread scissors, air soluble marker

Materials: Threads, ribbons, linen, potpourris

Stitches: French knot, outline stitch, satin stitch, chain stitch

Flower Brooch Collection

Erika expresses her love for nature by
embroidering these flowers and plants. Following
a similar layout design, these embroideries are
rich in colors, materials, and content, so that
they are consistent overall, but
distinctive in the details.

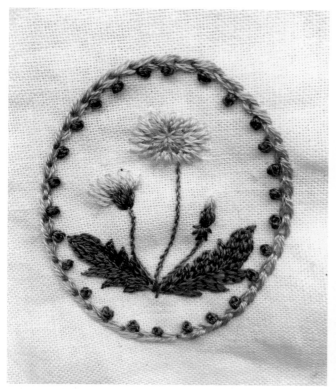

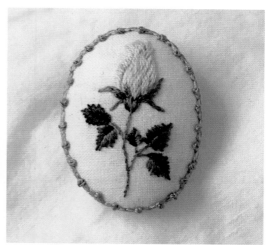

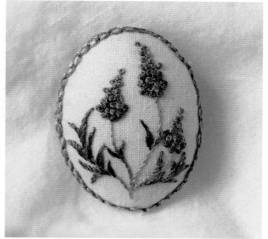

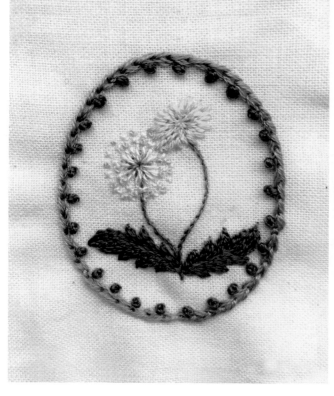

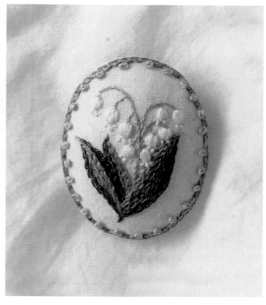

153

Tutorial

Here Erika shows how to make petals with ribbons instead of thread. It is simple but can be widely applied to many accessories. To follow this practice, needles with bigger eyes are recommended.

Step 1: Embroider the heart of the flower using French knots.

Step 2: Draw lines to mark the ribbon petals.

Step 3: Sew the ribbon petals using the ribbon itself as thread—pull the needle out from the back of the fabric, stretch the ribbon along the draft lines, and prick the needle over the ribbon on the fabric.

Step 4: Hold the ribbon and pull slowly, be careful not to pull too much in order to keep the shape of petals.

Step 5: Finish all the petals in order.

ces with similarly bared teeth
ng in the lobby. I was afraid
ut into
 r-
 n
 air
 the
 inished
 e the first

 uts of
 d to
 to

Interview with
Erika Sugano

How did you start creating embroidery art? Why did you choose embroidery as your career instead of copper engraving?

I have loved drawing and crafting since I was little. At university, I wanted to try something new and chose to specialize in copper engraving. After graduation, I rented a studio where I could do my engraving. But because of a broken shoulder, there was a time that I couldn't even hold a pencil. During that period, I started embroidery as rehabilitation. I continue embroidering because it always heals my tired mind and keeps me in a good mood even after the shoulder fracture was cured. Currently, I'm focusing on embroidery, but I still love copper engraving and want to try it again in a few years.

What do you love about your embroidery style?

I use both thread and ribbon in my embroideries. The thread is soft and warm, and the ribbon gives the embroideries a slight shadow and a three-dimensional sense. I enjoy my work combining these two materials in a well-balanced manner.

Your embroideries do not seem to involve many colors and most of the colors you use are in low saturation. Through your minimalist color palette, what kind of feeling or atmosphere do you want to create?

The concept of my work is to create something close to people's hearts and to convey that I envision my embroideries to be natural, mild, and ephemeral. That's why I choose calming and relaxing colors instead of flashy colors which might be tiring to the eyes.

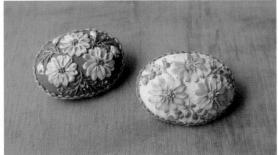

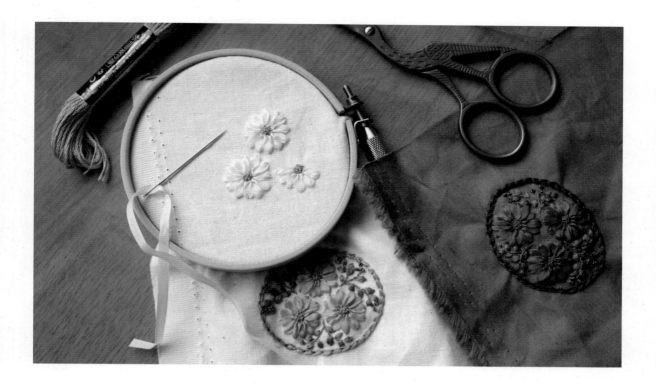

Why do you prefer making your embroidery projects small?

I enjoy small embroideries very much, especially some small accessories that are easy to carry along. Of course, I would like to try big-scale embroidery when I have time. I would also like to embroider on a dress.

Most of your embroidery projects are about flowers, so what is special about flowers that makes you enjoy embroidering them so much?

I live near a park surrounded by splendid natural landscapes, which can always relieve my fatigue. Since I was little, I have gained power from flowers, plants, animals, and landscapes, so I have a lot of choices when deciding the motifs.

Since you have taken part in many exhibitions, could you tell us how you feel when exhibiting your artwork in different places and creating embroidery projects at your studio, respectively?

In the venue of exhibitions, the harmony between the artworks and space is of great importance. If they agree, viewers can feel the scenery displayed even if they close their eyes. When creating my embroidery pieces, I always work in a small room, imagining the customers' satisfied expressions. I hope my artworks can take the viewers on a trip to see a wide world.

Could you say something to those who desire to take on embroidery?

Embroidery is a time-consuming process, so at first it may not work or it may be frustrating. But I didn't give up. I wanted to improve my embroidery, to show wonderful embroideries to the viewers, and to continue embroidering soothing art. I try to understand the viewers and to empathize with them, so I must keep going and embroider carefully. Embroidery is an art that can be easily started anywhere with needles and thread, so please try to take a small step, embroider something on your dress, handkerchief, and the like.

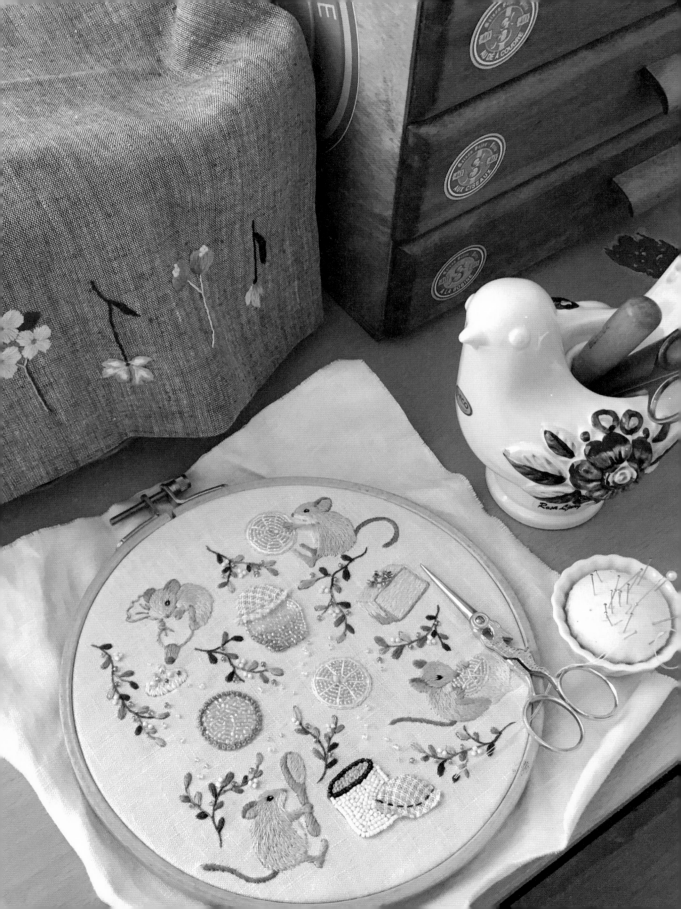

"We often think a great moment is triggered by something incredible, but I think every ordinary day is great enough for us to cherish."

Mayuka Morimoto

Japan

Mayuka Morimoto is a Japanese embroidery artist who gained popularity on Instagram and has published her own embroidery book in Japanese, which was then translated into Korean. She specializes in animal and flower embroidery and is keen on making the animals' fur as realistic as possible, hoping her work can cheer up and uplift every viewer.

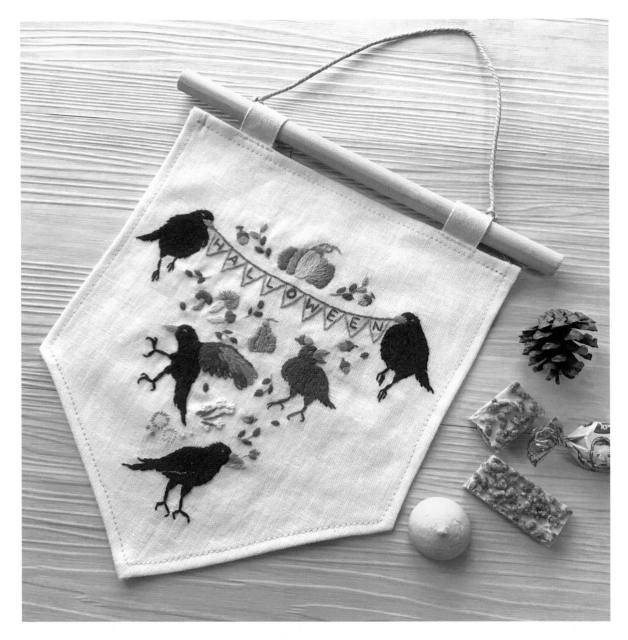

↑ Caw-Caw Halloween Party

Crows always leave the impression of being villains. But in this embroidery, they are enthusiastic and become the protagonists of a cute party.

✂

Tools: John James embroidery needle size 7, hoop

Materials: DMC thread 25, linen fabric

Stitches: Outline stitch, satin stitch, straight stitch, French knot

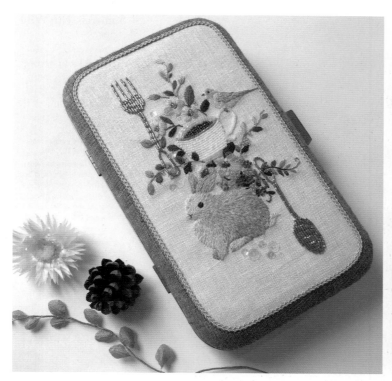

↑ Teatime in a Meadow

In this fantastic image of tea time in the forest, Mayuka used thread to create the birds and rabbit, and glass beads to finish the tableware.

✂

Tools: John James embroidery needles size 7 and 10, hoop

Materials: DMC thread 25 embroidery floss, linen fabric, glass beads, spangles, clasp box, felt piece, glue, double-sided tape

Stitches: Outline stitch, satin stitch, fishbone stitch, straight stitch, beads stitch

→ Hamster with His Favorites

Although it is a simple brooch, Mayuka used silk thread, which shines so strongly that the fur feels luxurious.

✂

Tools: John James embroidery needle size 7, hoop

Materials: Silk embroidery floss, linen fabric, line stone

Stitches: Outline stitch, straight stitch, long and short stitch, satin stitch

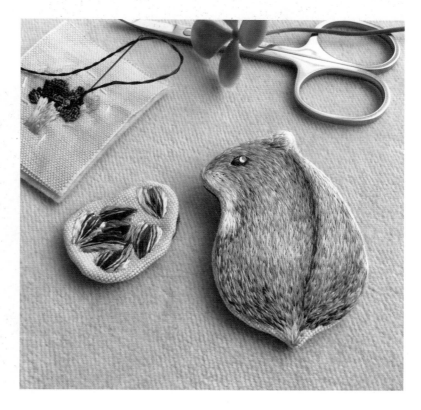

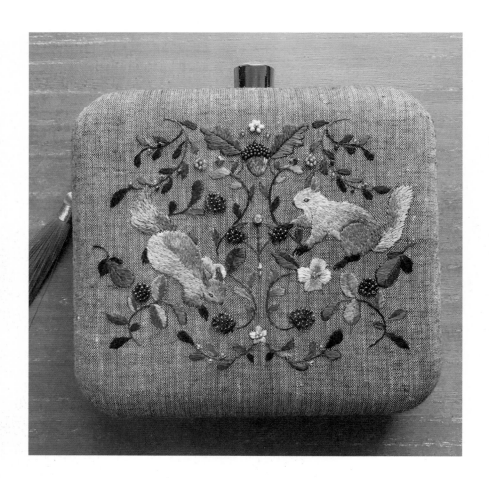

← Squirrels with Wild Berries

These two squirrels are collecting a lot of berries in the forest. The plump berries are made of glass beads that add gloss to the embroidery.

⁘

Tools: John James embroidery needles size 7 and 10, hoop

Materials: Silk embroidery floss, linen fabric, glass beads, clasp box, felt piece, glue, double-sided tape

Stitches: Outline stitch, fishbone stitch, straight stitch, beads stitch, long and short stitch, satin stitch

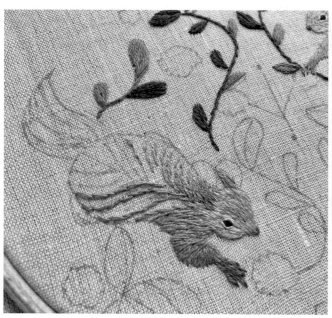

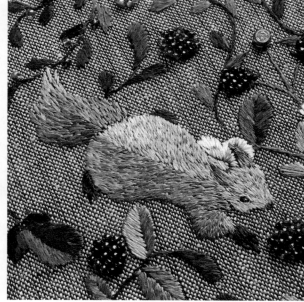

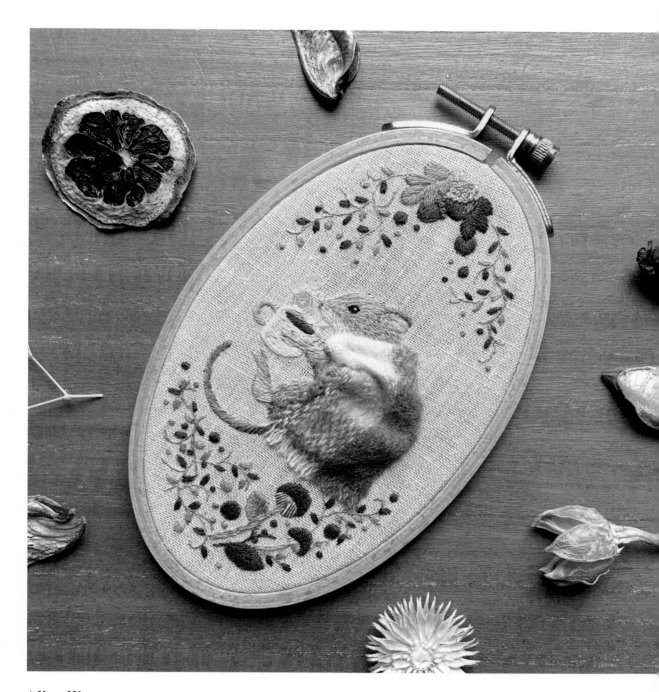

↑ Keep Warm

Mayuka created a mouse who is drinking hot tea on a cold night and wearing a blanket sewn with real wool fabric.

✂

Tools: John James embroidery needles size 7 and 10, hoop

Materials: DMC thread 25, linen fabric, piece of wool fabric

Stitches: Outline stitch, fishbone stitch, straight stitch, satin stitch, french knot

Tutorial

Through this tiny cameo-like embroidery of rabbit, Mayuka shows us how she employs outline stitches and straight stitches to express the texture of the fur and portray the rabbit in a realistic way without losing its cuteness.

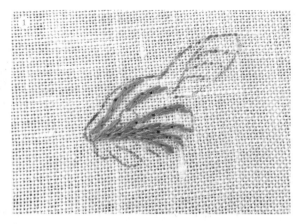

Step 1: Use outline stitches to embroider several flows of fur with two strands of thread.

Step 2: Keep stitching between each fur line.

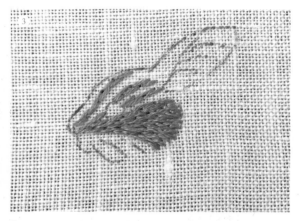

Step 3: With one strand of thread, use straight stitches to shape the face.

Step 4: Keep embroidering until the face is filled.

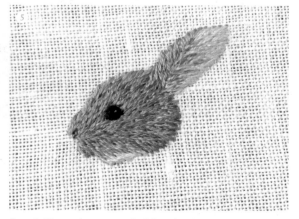

Step 5: Also with one strand of thread and straight stitches, finish the eye and ear.

Interview with
Mayuka Morimoto

Could you tell us about your artistic background and how you started your career as an embroidery artist?

I am fascinated by embroidery because it can be applied to various products such as bags, accessories, clothes, and so on. In 2015, I started creating my own embroidery pieces which were uploaded on social media. From then on, my embroideries became known to more and more people and I was invited to publish them in an embroidery magazine in France. After that, I got busier day by day. In 2019, my embroidery book was released in Japan.

Animals are one of the common themes of your artwork. Why do you enjoy depicting them?

I am attracted by their fluffy fur and tiny bodies. It is interesting to look at them because they seem to have their own small world.

The animals in your artwork seem to be living in a world of fairy tales, drinking tea, making cakes, and so on. By humanizing them, what do you want to express?

By portraying them in their small world acting like humans, I want to remind people of fun in our everyday lives. We often think a great moment is triggered by something incredible, but I think every ordinary day is great enough for us to cherish.

You said once that you wanted to embroider the fur of the animals as much as you can. What kind of techniques do you apply to present the texture of the fur?

I don't use difficult stitches. Usually, I use outline stitches and straight stitches for the animal fur. To make it more realistic, I usually add shadows to the finished coat by using darker colors also with straight stitches.

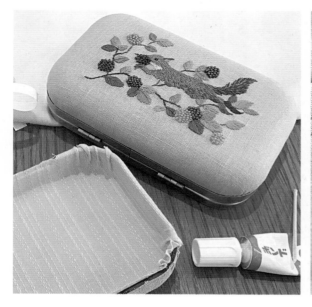
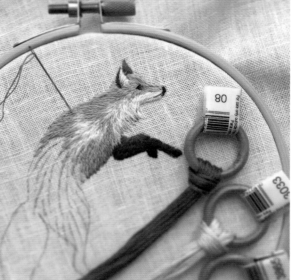

Mayuka's working environment. Tools and materials are well-organized.

Can you share your creation process with us? What do you think is the hardest part?

It is important to carefully draw the rough sketch and faithfully reproduce it so that it looks like an animal. I think the hardest part is to add shadow for animal fur.

Your artwork is applied to various items, such as bags, cases, and so on. What do you take into consideration when designing a piece of embroidery for application?

Actually, I finish the embroidery first and then choose what kind of items to apply it to. When designing the motif, it is very important to consider the impression and atmosphere of the design and to select the right materials that match the atmosphere before embroidering. For example, I like the quiet and peaceful atmosphere, so I prefer using light gray or off-white cloth rather than a colorful one. Depending on the atmosphere of the finished embroidery, I decide whether to make a casual accessory, a luxury bag, or a jewelry case.

Have you ever experienced any difficulties as a professional embroidery artist? How did you overcome them?

For many years, I couldn't support myself by embroidering and had to go to work for a living. During that period, it was very difficult to take the time to study art. The only way I could do it was by studying little by little every day after work. Finally I improved in my art and can support myself through it now.

Would you like to give suggestions to those who are experiencing a creative block and are losing heart?

It would be great if you can observe and love the beauty around you, no matter how small it is. Even if you are not living a satisfactory life, there are wonderful things that can inspire you everywhere.

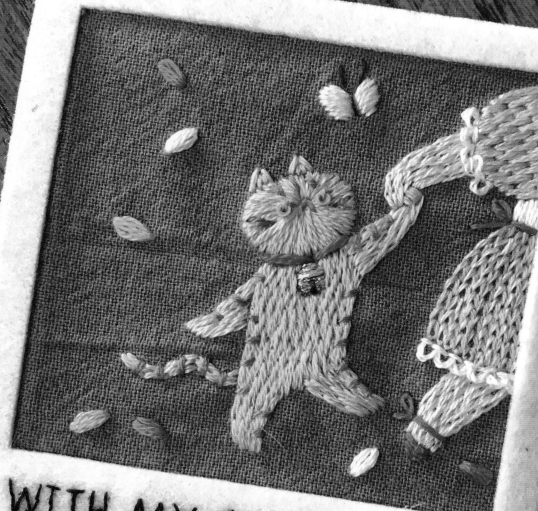

WITH MY SISTER

"No matter what subject I am working on, I think I'm going to keep making cute and lovely embroidery."

Nyang Stitch

Korea

Ji Sun Jeon, using the name Nyang Stitch, is a cat lover and embroidery artist from Korea. Mainly, she draws cats in embroidery because their fluffy, relaxed, and sometimes naughty look inspire her tremendously. She is always busy embroidering, desiring to capture the loveliness of cats.

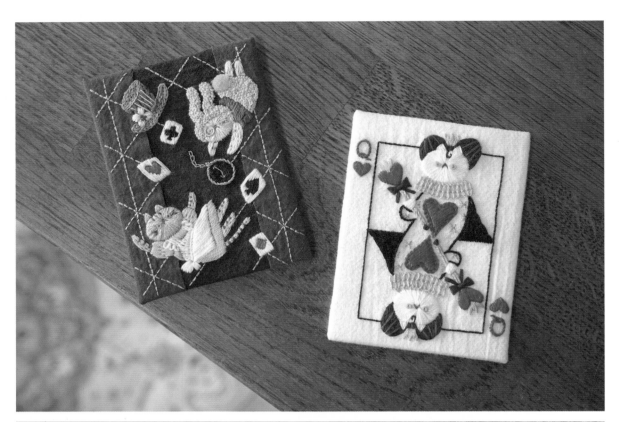

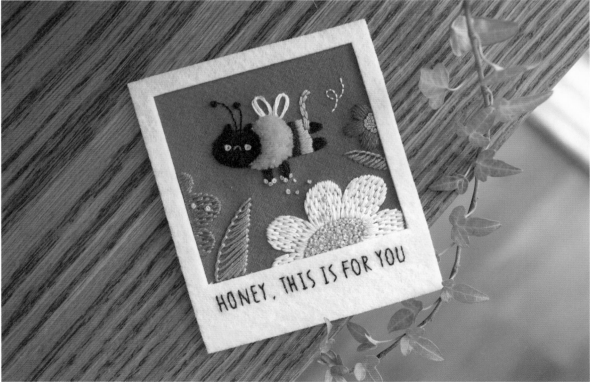

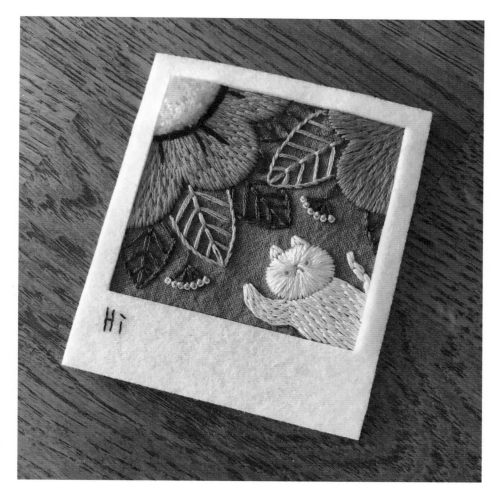

← Cat in Wonderland

These two embroideries are inspired by *Alice in Wonderland* and, in one of them, two fabrics of different colors are used as the background.

⁙

Tool: Needle

Materials: Cotton fabric, felt paper, DMC cotton thread, DMC metallic thread, golden ring

Stitches: French knot, fly stitch, satin stitch, Smyrna stitch, chain stitch, straight stitch, back stitch, outline stitch, threaded back stitch

← Memory 3

A felt paper was used to decorate the embroidery, simulating the form of a polaroid film.

⁙

Tool: Needle

Materials: Cotton fabric, felt paper, DMC cotton thread

Stitches: French knot, fly stitch, split stitch, ring stitch, Smyrna stitch, blanket stitch, long and short stitch, satin stitch, back stitch

↑ Memory 1

Reading "Hi," this embroidery photo captures a greeting from a white cat.

⁙

Tool: Needle

Materials: Cotton fabric, felt paper, DMC cotton thread

Stitches: French knot, fly stitch, split stitch, outline stitch, Smyrna stitch

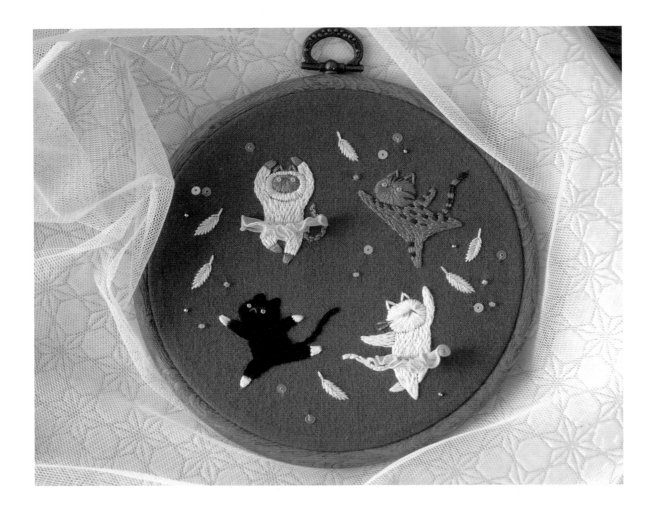

↑ Ballerina

Two of the cats are wearing skirts made of folded ribbons.

⁜

Tools: Needle, hoop

Materials: Cotton fabric, DMC cotton thread, ribbons, beads

Stitches: French knot, fly stitch, split stitch, satin stitch, fishbone stitch

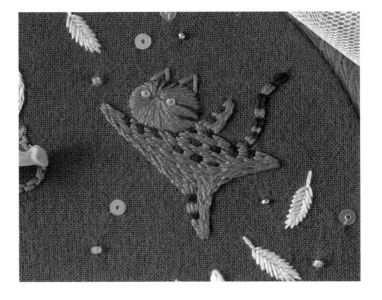

← Honeycat

The honey cat was embroidered in a small hoop and finished with a key ring. Specially, Nyang Stitch employed Smyrna stitches to make its fur and decorated its feelers with beads.

※

Tools: Needle, hoop

Materials: Cotton fabric, DMC cotton thread, DMC metallic thread, beads

Stitches: French knot, fly stitch, back stitch, satin stitch, ring stitch, Smyrna stitch

↓ Phonograph

In this piece, metallic thread was used to make it look antique.

※

Tools: Needle, hoop

Materials: Linen fabric, DMC cotton thread, DMC metallic thread

Stitches: French knot, fly stitch, split stitch, satin stitch, fishbone stitch, blanket stitch, straight stitch

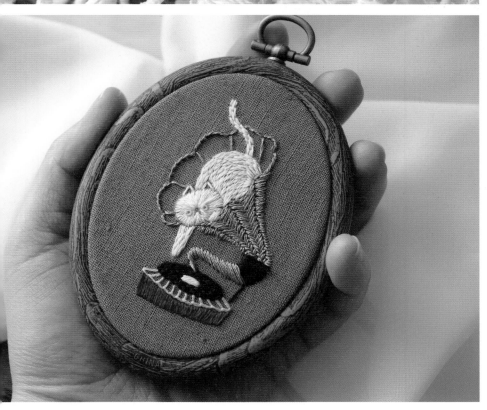

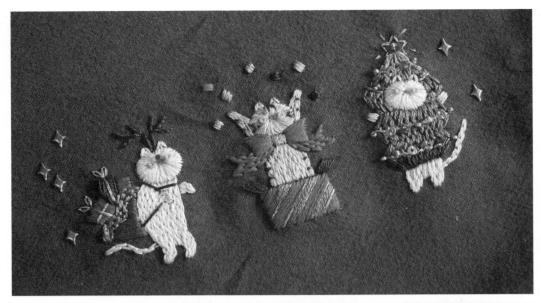

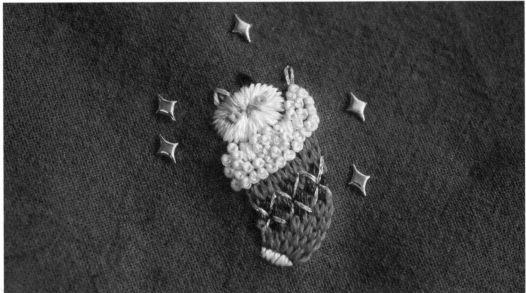

↑ Christmas 1

The artist employed common Christmas colors—gold, red, and green—to express the vibe.

✂

Tool: Needle

Materials: Cotton fabric, DMC cotton thread, DMC metallic thread, beads

Stitches: French knot, fly stitch, split stitch, satin stitch, straight stitch, lazy daisy stitch, back stitch, outline stitch

↑ Christmas 2

Using French knots and chain stitches, the artist intended to capture the warmth of the socks.

✂

Tool: Needle

Materials: Cotton fabric, DMC cotton thread, DMC metallic thread

Stitches: French knot, fly stitch, satin stitch, chain stitch, straight stitch

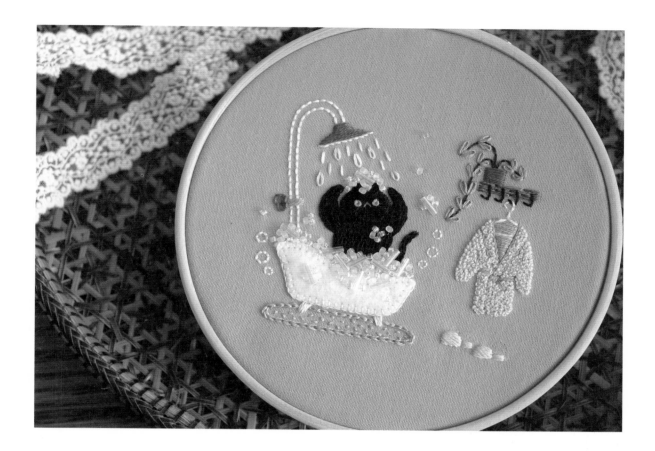

↑ Bubble Cat

Nyang Stitch used beads to make the bubbles and applied the appliqué technique to finish the bathtub, giving the piece different textures.
::

Tools: Needle, hoop

Materials: Cotton fabric, DMC cotton thread, beads

Stitches: French knot, fly stitch, split stitch, straight stitch, lazy daisy stitch, back stitch, chain stitch, outline stitch, satin stitch, blanket stitch

→ Tea Time

For the teacup, Nyang Stitch also used the appliqué technique, sewing a small piece of fabric to finish the whole embroidery.
::

Tool: Needle

Materials: Pouch, linen fabric, DMC cotton thread

Stitches: French knot, fly stitch, split stitch, straight stitch, lazy daisy stitch, ring stitch, blanket stitch, back stitch, outline stitch

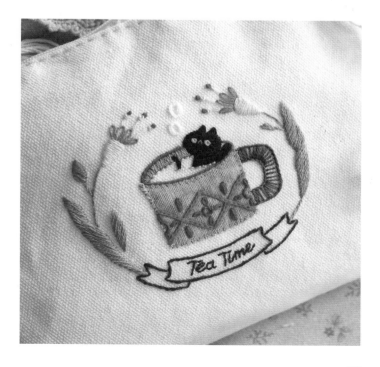

Tutorial

Nyang Stitch shows how to make a cat embroidery using some basic stitches, including straight stitch, split stitch, and French knot.

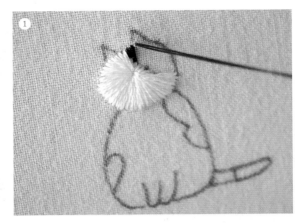

Step 1: Fill the cat's face by connecting the center and the outline.

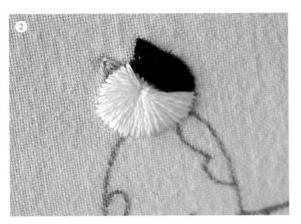

Step 2: Use different colors to embroider the cat's ears.

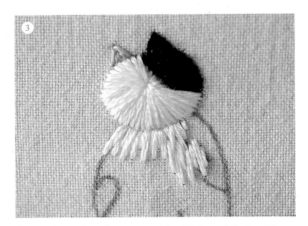

Step 3: To simulate the texture of fur, fill the cat's body with split stitches in different lengths.

Step 4: Also, use thread of different colors to embroider the cat's different coat colors.

Step 5: Finish the cat's mouth with fly stitches and the eyes with two French knots.

Interview with
Nyang Stitch

How did you start embroidery and become a professional embroidery artist?

I've liked the cozy feeling of fabric and thread since I was young, and sewing and knitting have always been my hobbies. After I grew up, I saw a book about embroidery in a bookstore, which drove me to start embroidery. I wanted to embroider my own designs instead of someone else's, and then my cat kindly became my model. That's how I became a cat embroidery artist.

Can you introduce your creative process briefly? Which part is the most difficult?

First of all, I choose the motif and then envision the piece. When the sketch is completed, I decide the colors and stitches for the key part. The rest will be worked on later to match the core. The most difficult part during the process is to choose the fabric that fits the design. Thus, I try to buy fabrics in as many colors and textures as possible so that I can fully visualize my imagination.

What attracts you to embroider cats?

Cats are sweet, haughty, and sometimes mischievous. I capture them vividly in my work, and their activeness keeps my work alive, which becomes the feature setting my work apart. Also, my cat embroidery has attracted many cat lovers who can relate to it and appreciate it.

How do you come up with so many ideas and make your embroidered cats do all kinds of things?

I'm trying to get ideas from my ordinary life to create something so sincere that many people feel touched. Take "Bubble Cat" as an example. I thought of that scene because I like bubble baths. I thought it would be pretty to use beads as

bubbles and achieve the softness of the bathrobe through French knots. In the case of "Ballerina," I watched a ballerina's performance on TV and envisioned a cat doing ballet with its chubby arms and legs. In short, my observation of my own life and my passion for cats lead to cats in my embroideries that pose and act like humans.

Are there any references to real cats in your embroidered world of cats?

Most embroidery cats don't have a model, except my cat Bong-zi who is a yellow cat with a white muzzle. If you find the loveliest and prettiest yellow cat in my embroidery, he's definitely Bong-zi! He is seven year-old cat who enjoys having a relaxing time on my lap.

You have set up your embroidery channel on YouTube. What was your motive? How does it feel when you are making embroidery and filming at the same time?

Many people were curious about how I embroidered a cat, so I decided to show them clearly through videos. Doing two things simultaneously makes it harder for me to focus on embroidery because I have to pay more attention to the angle than the embroidery. Therefore, I make a piece twice, once before shooting to check what I need to tell the viewers, and once during shooting to display the process. It's not easy work, but worth doing.

Apart from cats, will you try other subjects in the future?

There are no other subjects I'm interested in now. Yet, just like how I started my cat embroidery, there might be another interesting subject that pops up in my head one day. No matter what subject I am working on, I think I'm going to keep making cute and lovely embroidery.

"I like to think of my embroidered piece as a person, what's his or her character, and what's his or her persona like?"

Mariam Satour

Egypt

Mariam Satour is a contemporary embroidery artist living in Cairo, Egypt. She began her career as a graphic designer before she decided to leave the path and pursue her love and passion for embroidery. Mariam started stitching as early as the age of 13 and now she has her own home studio where she spends most of her days working on her pieces and experimenting with fabric and thread.

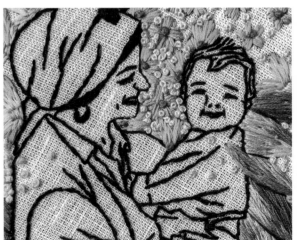

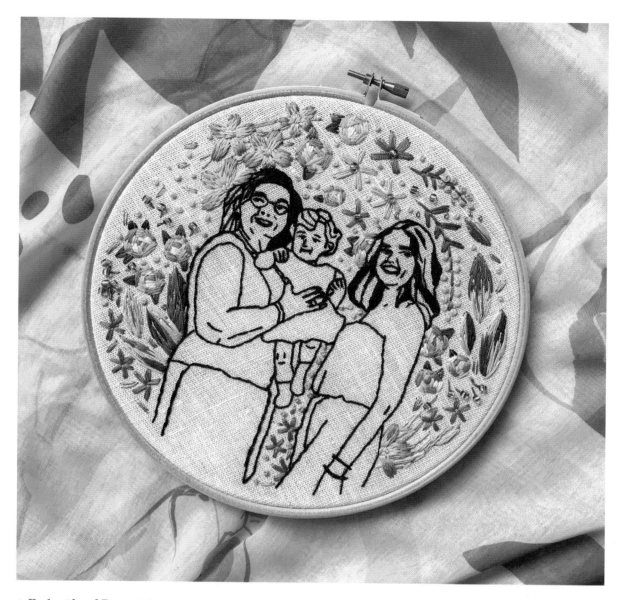

← Embroidered Portrait 1

This portrait represents human figures with minimal outlines and a fully embroidered
floral background.

⋇

Tools: Bamboo hoop, needle, fabric

Materials: DMC thread, linen

Stitches: Long and short stitch, French knot, back stitch

↑ Embroidered Portrait 3

This is a portrait of a little girl, her mother, and grandmother using concise black threads to draw
their outlines and delicate floral patterns to fill the background, which creates a perfect contrast.

⋇

Tools: Bamboo hoop, needle

Materials: DMC thread, beads, golden thread

Stitches: Long and short stitch, French knot, back stitch

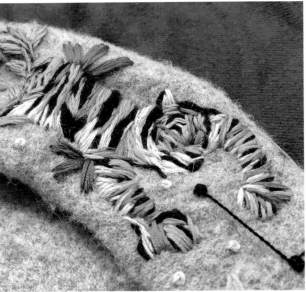

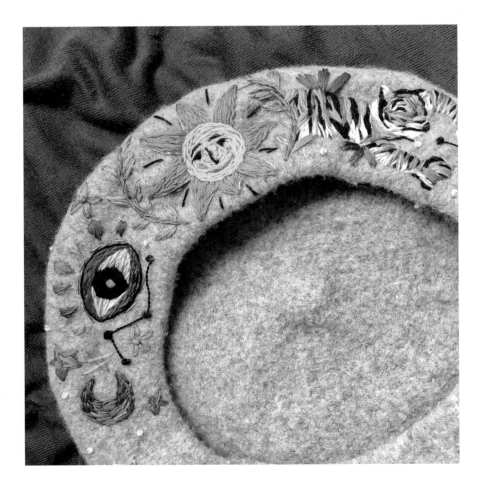

← Gray Beret with Whimsical Embroidery

Mariam went outside the box with a sketch of the moon, the sun, stars, an eye, and a tiger to create this whimsical and eccentric design.

⁑

Tools: Needle, Beret

Materials: DMC threads, golden thread

Stitches: Long and short stitch, French knot

→ Starry Night Shirt

After painting the background colors with paints and brushes, Mariam embroidered *The Starry Night* by Vincent Van Gogh on a white shirt. Though she employed some long and short stitches, most of the time, she embroidered the piece freely in terms of stitches.

⁘

Tools: Bamboo hoop, needle, brushes, palette

Materials: DMC thread, fabric paint

Stitch: Long and short stitch

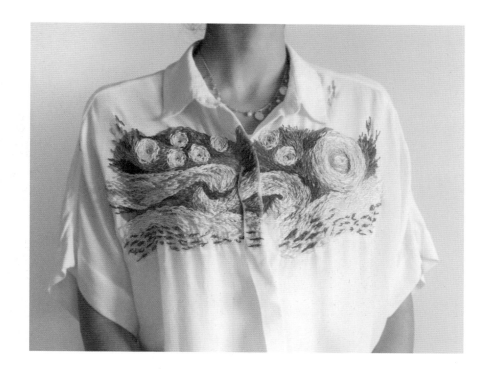

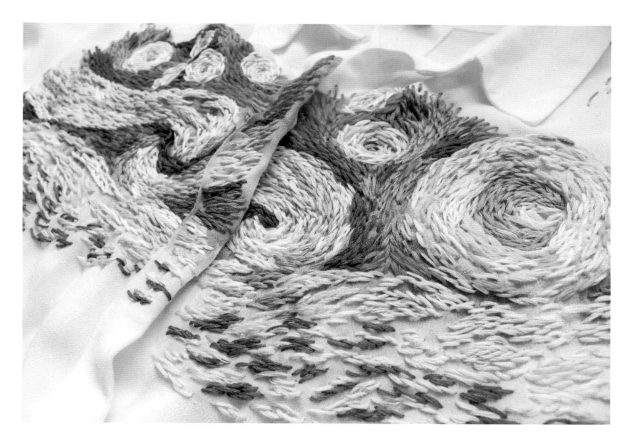

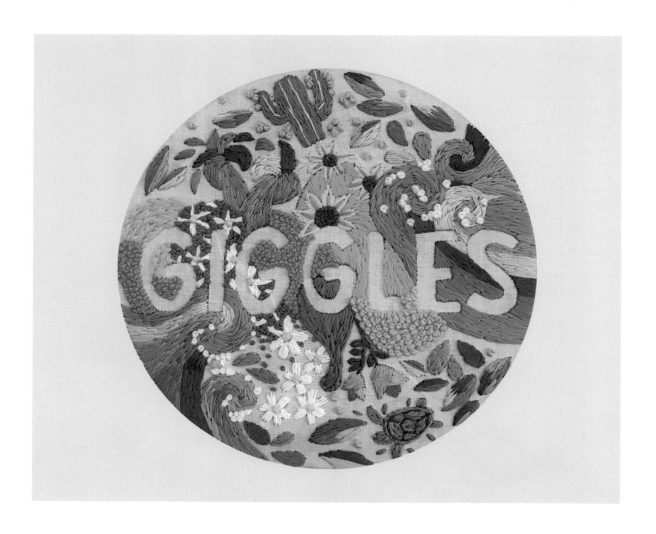

Giggles & Memoir Collection

They are different works by Mariam, but what they have in common is that they both have a light background, either light color fabric or painted with light colors.

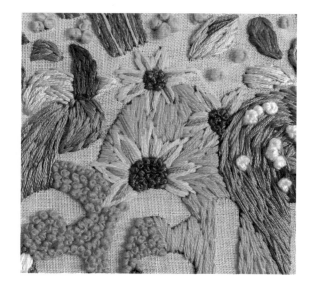

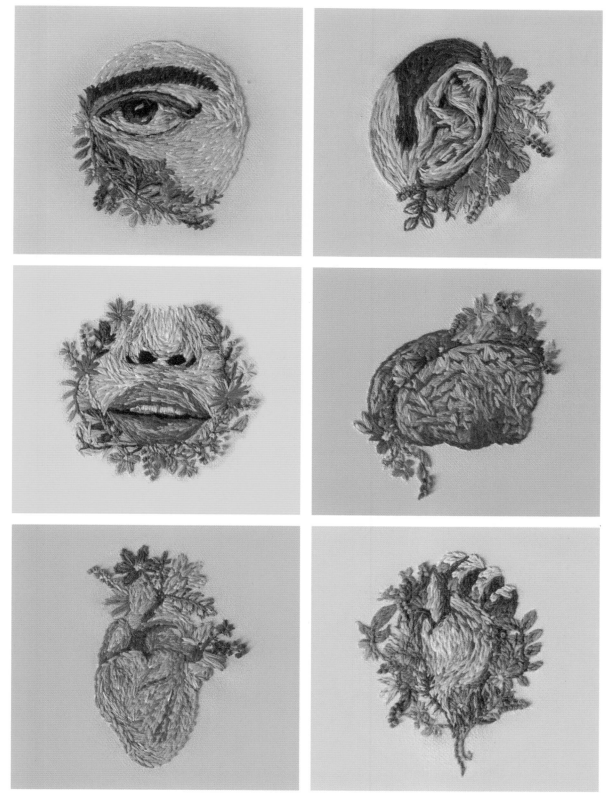

Interview with
Mariam Satour

When and how did you become a professional embroidery artist? Can you tell us a bit about your artistic background?

I've been very fond of arts and crafts from a very young age. As a kid, I was constantly drawing, painting, and making things. At the age of 13 during a summer break, I was introduced to needlepoint embroidery. Throughout the next 15 years, I just fell more and more in love with embroidery and started discovering its different aspects, though it remained as a hobby. Later, I went to art school, finished my degree in graphic design, and worked for several years in the advertising and branding fields. One day I decided to quit my job to pursue my passion for embroidery professionally and start my own business. This was the most beautiful part when it all started.

Why do you prefer embroidery?

I believe embroidery is a very powerful medium because being super flexible, it enables me to translate my ideas and concepts in a new way. The huge variety of materials, techniques, and the way I get to combine them always results in an endless pool of possibilities, so embroidery is like a universe with multiple dimensions.

Most of your embroideries are colorful, but for some portraits, you choose a concise black thread to outline the characters. What kind of visual effect do you want to create in this way?

When it comes to creating a visual embroidery, one of the most important elements to keep in mind is space. I love colors, colorful intricate embroidery work, and full heavy surfaces. Yet, in order to balance it out, I need to add the complete opposite to the equation. I need space and simple lines to help me achieve this goal—minimal but strong, creating a movement for the eye within the artwork. In the case of a portrait, simple outlines succeed in delivering the facial features and the essence of a person just perfectly.

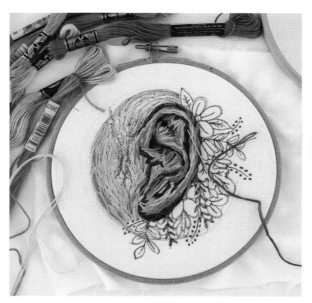

The colors of your embroideries are bright and eye-catching. How do you keep various colors harmonious within one piece?

A very important step in my creative process is picking out a color palette. To do so, I like to think of my embroidered piece as a person, what's his or her character, and what's his or her persona like? If this person has a favorite outfit, what would its colors be like? Then I start choosing the colors accordingly. Also, it's very important for every designer to be well-aware of color theory, color wheels, and have a good knowledge of the basic principles in choosing a balanced color scheme.

What are the common subject matters of your embroideries and why do you enjoy making your artworks revolve around them?

I think the answer to this question is botanicals. I love plants and flowers and they're a great visual element to execute, carrying a lot of meaning and symbolizing many things, like a hope, a memory, a feeling, a place, etc. Also, I find a lot of inspiration within modern art and different art schools.

What was the biggest difficulty that you have experienced? How did you get through it?

When I first started out as a professional embroidery artist, I realized that things take time, you can't rush your own growth. To put the time and effort into your work and not see the feedback and the results that you expected is extremely challenging. Patience is very important. Work, support from the people around you, and a tiny little bit of self-confidence (even if faked most of the time) are essential.

Do you have any suggestions for those embroidery lovers who desire to be full-time artists?

Just work! Focusing on the work is the most important thing. Think of how to improve it, learn new things about it, explore it, improvise with it, and always try new things. Don't fall victim to social media algorithms. Just free yourself and, eventually, it will pay off.

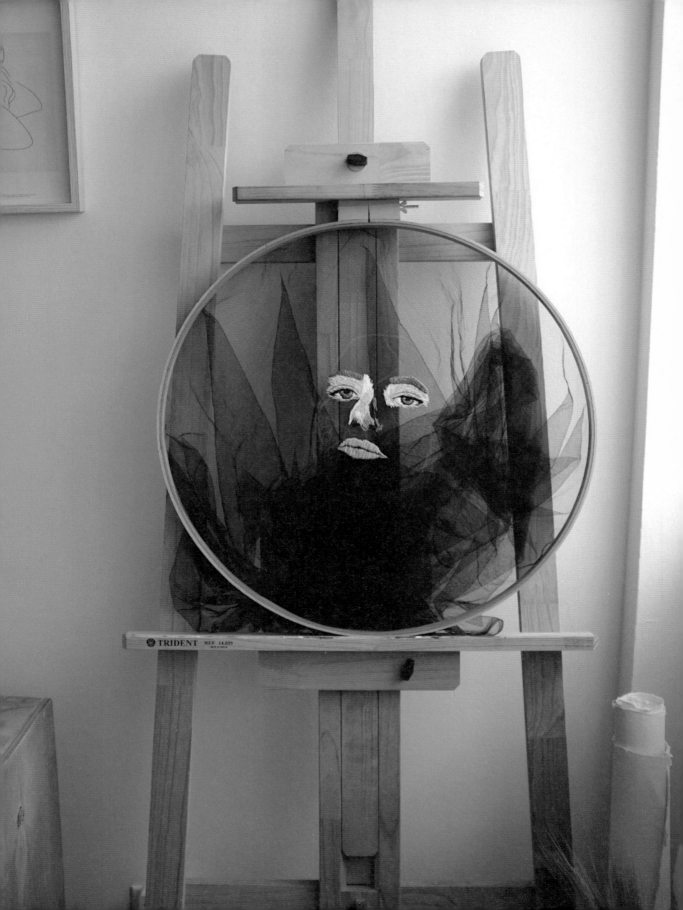

"I change a few ideas during the process because I love things to become more natural and spontaneous."

Elena Obando

Costa Rica

With a background in jewelry and goldsmithing, Elena Obando is a self-taught embroidery artist who creates portraits and birds on handmade tulle embroidery.

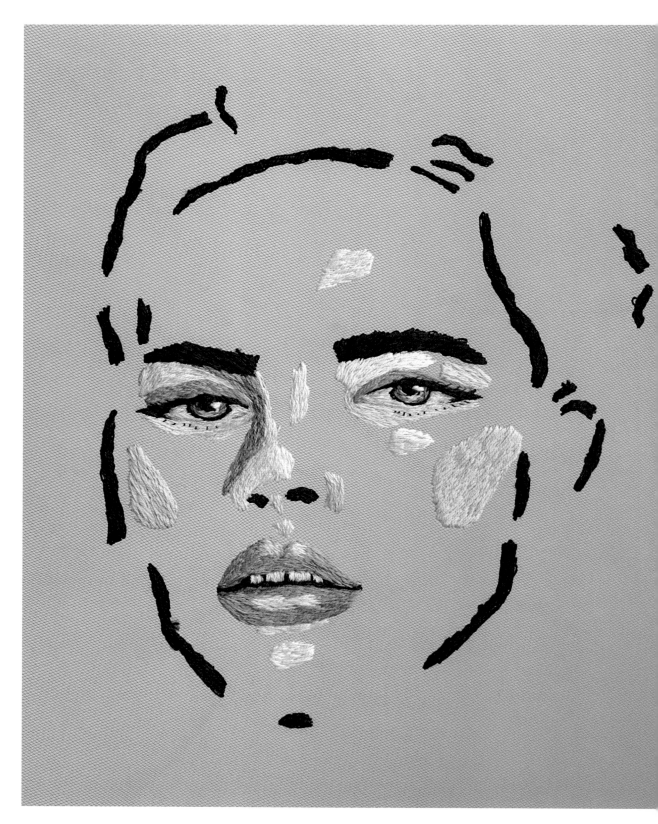

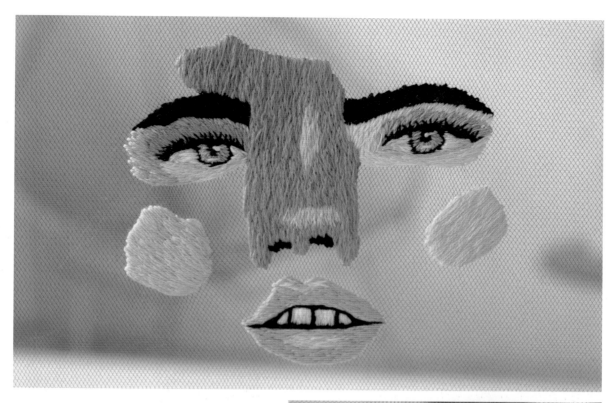

←↑→ Face Mask

Utilizing the transparency of the tulle, Elena has created plenty of embroidery face masks that are irregular faces based on different layers of colors and meant to simulate masks. These are some of her most common pieces of work.

❉

Tools: Tapestry needle No. 23, scissors, bamboo hoop, stand frame

Materials: DMC six-strand floss, tulle in white and black

Stitches: Long and short stitch, back stitch

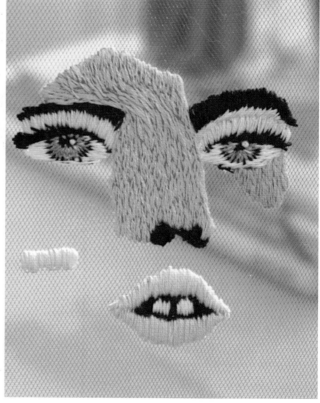

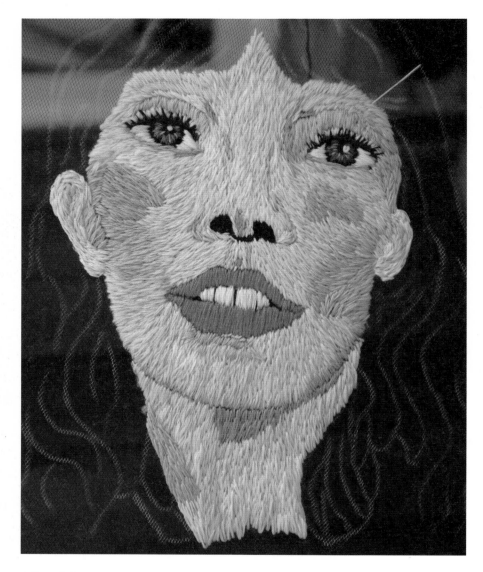

↑ Sonia's Portrait

Inspired by a girl who is a model and an artist, Elena combined the techniques of drawing and needlework to come up with a special effect on the tulle for this portrait.

:::

Tools: Tapestry needle No. 23, scissors, bamboo hoop, stand frame

Materials: DMC six-strand floss, tulle in white

Stitches: Long and short stitch, back stitch, satin stitch

→ Portrait of a Girl

The embroidery faces that Elena usually creates focus only on the eyes, mouth, and nose. Yet, this time she created a complete portrait because she wanted to represent a more realistic embroidery while using her own style and process to keep it consistent with her other works.

:::

Tools: Tapestry needle No. 23, scissors, bamboo hoop, stand frame

Materials: DMC six-strand floss and pearl cotton thread, tulle in black

Stitch: Long and short stitch

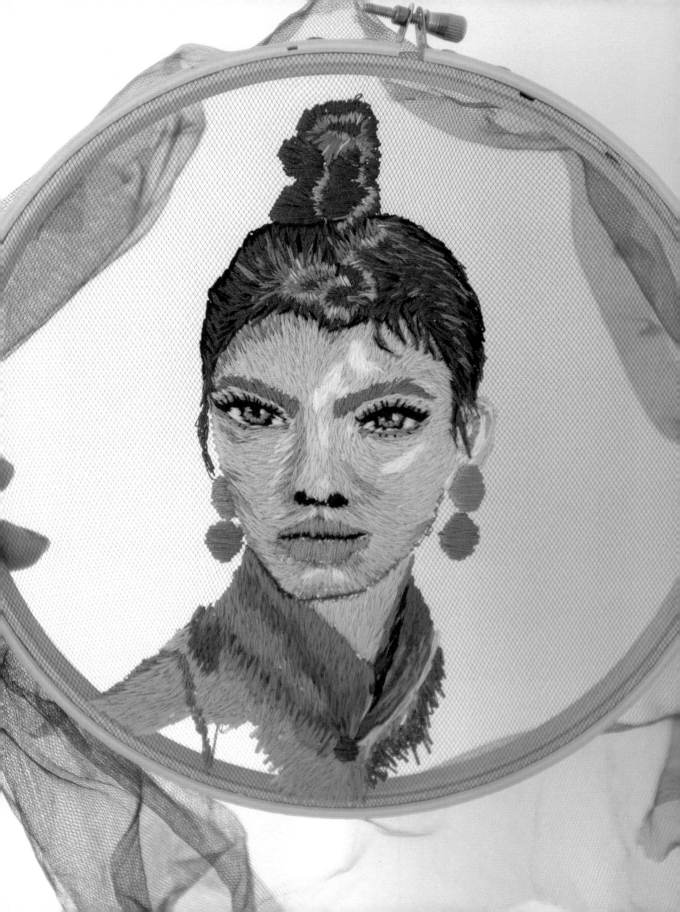

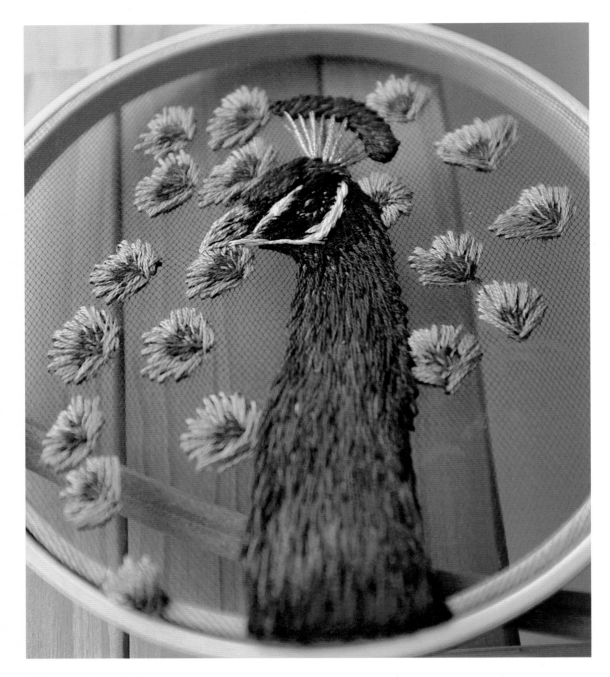

↑ The Indian Peafowl

The Indian peafowl is a native species from India. Elena kept the original colors of the peafowl, but added a little bit of the colors from the Indian flag to this embroidery. Instead of embroidering the tails realistically, she depicted only the eyespots so as to highlight the beauty of the transparency on the tulle.

✄

Tools: Tapestry needle No. 23, scissors, bamboo hoop, stand frame

Materials: DMC six-strand floss, tulle in black

Stitch: Long and short stitch

196

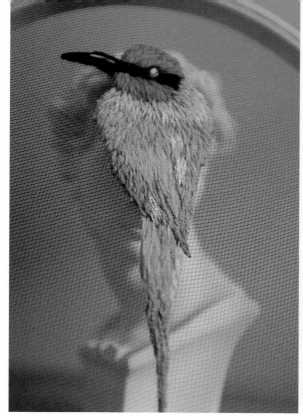

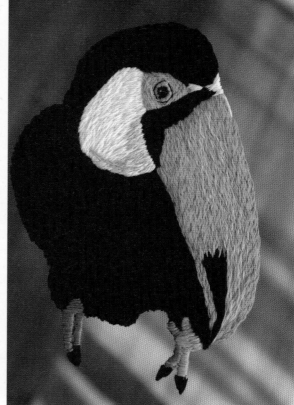

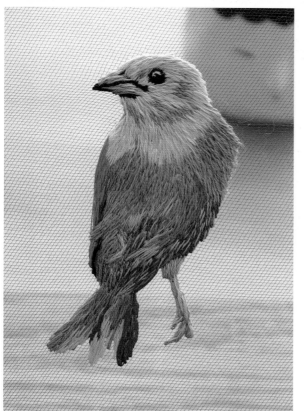

↑ Northern Carmine Bee-Eater

This piece captures an African bird with colorful feathers. Elena enjoyed blending colors with threads just like painting with very bright colors which are slightly different from her usual color choices.

⌗

Tools: Embroidery needle No. 10, scissors, bamboo hoop
Materials: DMC one-strand floss, tulle fabric in black
Stitch: Long and short stitch

↑ Pink Toucan

The toucan is one of the most important birds in the tropics like in Elena's home country of Costa Rica. She created this piece to honor them.

⌗

Tools: Tapestry needle No. 23, scissors, bamboo hoop, stand frame
Materials: DMC six-strand floss and pearl cotton thread, tulle in black
Stitches: Long and short stitch, back stitch, satin stitch

← Blue-Gray Tanager Bird

This is a South American bird with a monochromic palette of colors. Elena loved selecting the colors because it has different tones of blue, giving her the chance to play with them.

⌗

Tools: Embroidery needle No. 10, scissors, bamboo hoop
Materials: DMC one-strand floss, tulle fabric in black
Stitch: Long and short stitch

Interview with
Elena Obando

Could you tell us your artistic background? When and how did you start embroidering?

Growing up in my family, especially with my aunts and grandmother, I was surrounded by embroidery and needlework. Yet, I didn't make my own embroidery until 2016. Jewelry came first because it was something that I had in my mind and my plans since I was much younger. To learn the traditional techniques of goldsmithing, I enrolled in a jewelry school where I created some pieces mixing different types of materials. The idea of creating a silver piece with textiles struck me, so I replicated five different famous paintings each on a small piece of embroidery with a silver frame as a pendant. Then, I started looking for different stitches and techniques on the Internet and taught myself. That wasn't easy but, with a lot of practice and patience, I had the confidence to make mistakes and enjoy the process.

Why do you prefer embroidery? What is the special thing about it?

I love embroidery because it is actually another way of painting. I'm a big fan of painting art but I can hardly consider myself as an illustrator or great painter. In embroidery I found the easiest way for me to express what I have in my mind—the use of colors and fabrics is the way I see the world. I love colors and fashion and I also work as a graphic designer, so all these come together to make embroidery one of my favorite crafts.

Could you introduce your creative process briefly?

It is very spontaneous, but lately I've begun planning a little bit more. Usually, I create a sketch on paper first and select the colors. After that, I draw it on fabric and then start embroidering. But sometimes I change a few ideas during the process because I love things to become more natural and spontaneous.

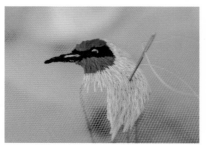

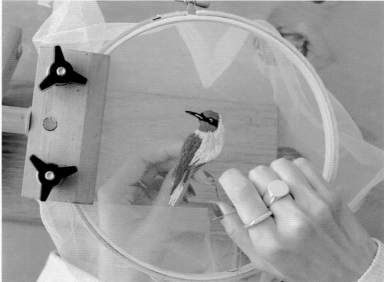

Birds are one of the subjects most commonly seen in Elena's artwork. This shows the process she used to embroider a northern carmine bee-eater.

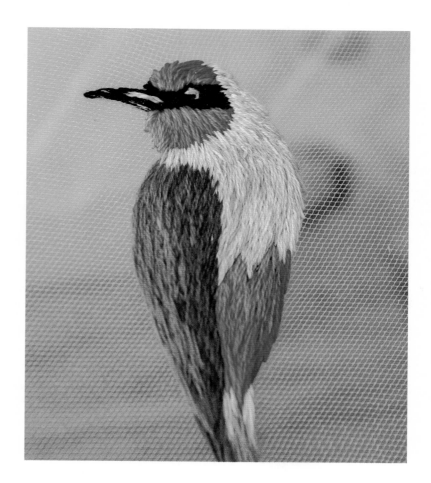

Why are you fond of tulle embroidery while embroideries on cloth are more commonly seen?

I started using natural linen and cotton fabric to practice the stitches when I was learning the techniques at the beginning. Then I tried different kinds of fabrics, especially with different colors to make my designs more interesting and colorful. One day when I was at the store looking for my next fabric, I found the tulle and bought a small size to embroider a bird just as an experiment. It wasn't an easy beginning, but I loved the final result.

We can find many incomplete faces in your embroideries, why do you like to make them?

When I started using the tulle fabric, I took advantage of its transparency and came up with the idea of simulating a mask to create these incomplete faces which look like they're floating in the air. I didn't want them to be too realistic and enjoyed applying a colorful palette to them. The whole process was an exploration of my own style and I feel I have found it with those faces.

How do you work on the color palette? Where do you draw inspiration for colors?

My selection of the palette is very intuitive. I really love pastel colors and try to use them in my embroideries a lot. Sometimes I search for images or places that I like for more inspiration on choosing colors. For my bird embroideries, it is easier because I can find a lot of beautiful colors from pictures of real birds.

"The part I enjoy the most is the feeling of flow I can get into when all my attention is absorbed and I can focus entirely on the flowers."

Olga Prinku

U.K.

Olga Prinku is an artist and creator of flowers on tulle embroidery and the author of *Dried Flower Embroidery: An Introduction to the Art of Flowers on Tulle.* With her passion for flowers and crafts, she has combined her gardening and flower-drying techniques with embroidery and has experimented with this new type of art she created in 2016.

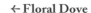
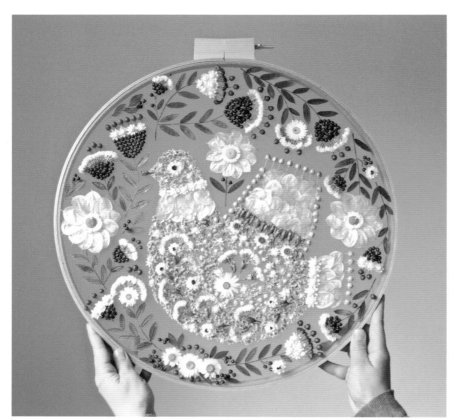

← Floral Dove

This design seeks to tell a story by combining a bird shape with flower motifs. This was the first time Olga used lunaria seed pods, and she was pleased with the translucent and shimmering effect they created in the bird's plumage.

❖

Tools: Polyester net fabric, 18-inch embroidery hoop, cotton thread, tulle, glue

Materials: Lunaria seed pods, rowan tree leaves, flax seed pods, statice

Techniques: Weaving, gluing (*no stitch involved)

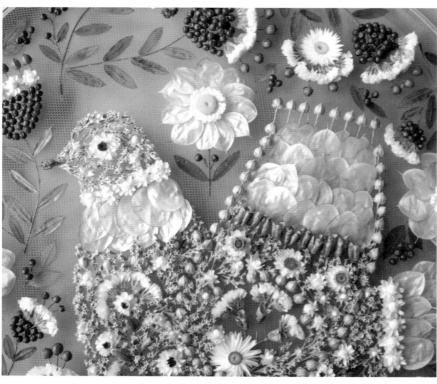

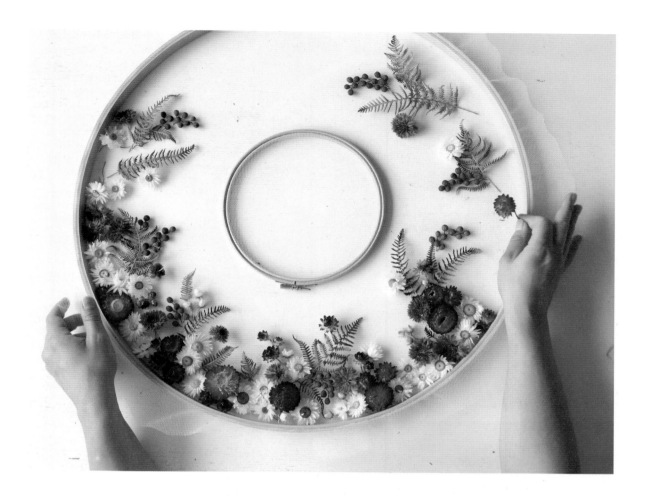

↑ Red and Blue

A large-scale hoop with a second hoop in the middle creates a double design. This motif is inspired by Russian folkloric patterns and uses foraged natural elements from the area where Olga lives.

::

Tools: Polyester net fabric, 23-inch embroidery hoop, cotton thread, tulle, glue

Materials: Ferns, strawflowers, holly berries, blue cornflowers

Techniques: Weaving, gluing (*no stitch involved)

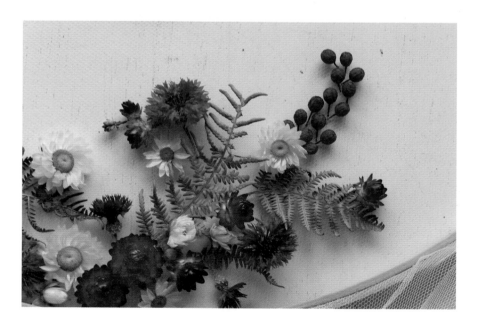

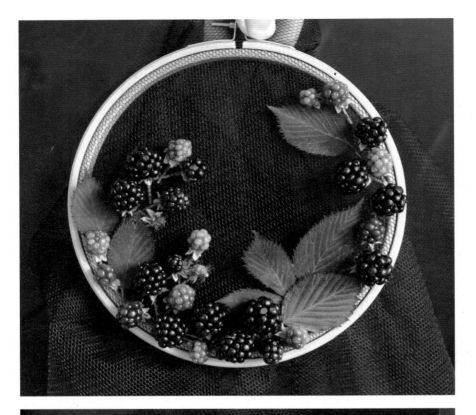

← Brambles

This six-inch hoop design is inspired by autumn bounty. Brambles or blackberries grow in many areas around where Olga goes walking, so she wanted to create a design as an homage to what grows wild in the hedgerows nearby.

⁖

Tools: Polyester net fabric, six-inch embroidery hoop, tulle, glue

Materials: Blackberry foliage, blackberries

Technique: Weaving (*no stitch involved)

↓ Blossom and Daisies

Inspired by the spring blossoms, this hoop was Olga's first attempt at drying and preserving blossoms from her garden and combining them with another flower called lawn daisies, which she also dried herself to create a pale pink semi-circle design.

⁖

Tools: Polyester net fabric, six-inch embroidery hoop, cotton thread, tulle, glue

Materials: blossom, ferns, lawn daisies, hydrangeas

Techniques: Weaving, gluing (*no stitch involved)

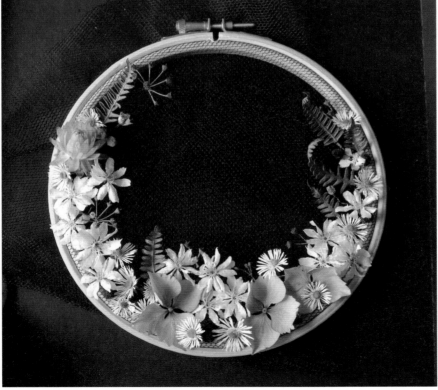

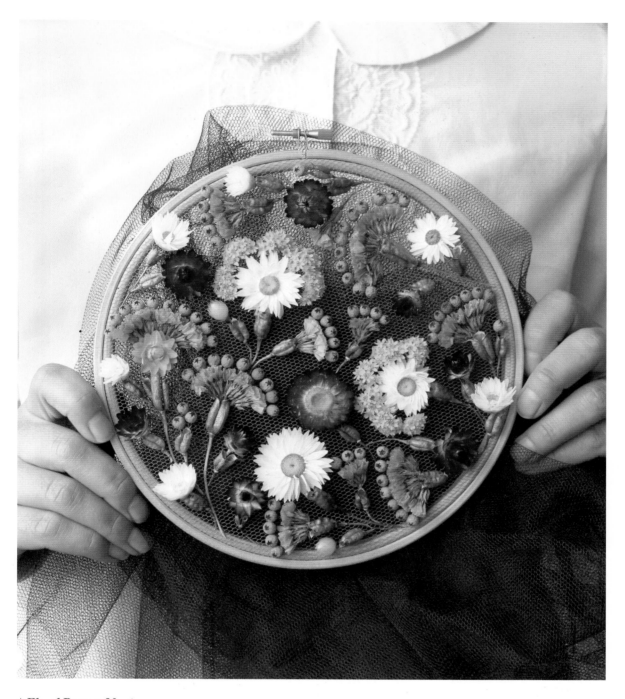

↑ **Floral Pattern No. 1**

This eight-inch hoop was one of Olga's first attempts to create a pattern covering the entire hoop and incorporating the simple, but fun motif of flowers made from foliage—in this case delphinium seed pods for the stalk and dried statice for petals, embellished with pyracantha berries.

⁙

Tools: Polyester net fabric, eight-inch embroidery hoop, cotton thread, tulle, glue

Materials: strawflowers, pyracantha berries, delphinium seed pods, statice

Technique: Weaving (*no stitch involved)

Interview with
Olga Prinku

Could you tell us about your artistic background? How did you start your career as an embroidery artist?

I have a degree in graphic design and I've always enjoyed making and crafting. I took courses in things like jewelry making, bookbinding, and printing by hand. Later when I was on maternity leave, I learned how to knit and started to sell knitted winter hats and Christmas stockings. I made wreaths to style photos of those knitted goods, and it was the wreath-making that eventually evolved into floral embroidery. Since it was a technique that came from my own imagination and took a while to develop and perfect, floral embroidery has a special place in my heart.

Could you share your creative process with us?

Usually, I don't have a clear idea of what the finished artwork will look like when I start creating a new piece. Instead, it starts with a particular plant or flower that I came across unexpectedly or wanted to experiment with in a new way. Typically, I decide on a color palette and lay out flowers and materials that fit that palette. Then I choose from those as I go along, freestyling as I create a pattern or design. Sometimes I have a particular shape in mind, such as a bird or a letter, and then I will start with the outline and creating that shape first. The part I enjoy the most is the feeling of flow I can get into when all my attention is absorbed and I can focus entirely on the flowers.

What has inspired you to create tulle embroidery with flowers?

I was inspired to try floral embroidery when I was making a wreath. I used a garden sieve as a frame and wove the foliage around it. It occurred to me that a sieve, with its mesh inside a circle, is similar to an embroidery hoop

Sometimes Olga buys ready-made materials for her artwork, but most of the time she enjoys planting and drying flowers herself.

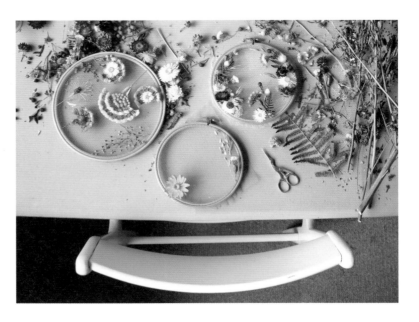

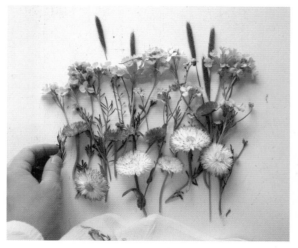
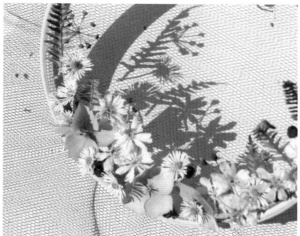

with tulle stretched over it and I started to experiment from there. Combining flowers with embroidery also has the potential to achieve complex, rich, and interesting textures and results.

What do you usually take into consideration when choosing the flowers and arranging them for an embroidery project? For example, how do you match the colors?

There are a few different ways I might choose a color palette: using monochrome, combining two or more colors, or basing it on seasons, such as oranges and browns in autumn, or reds and greens in winter. I also have a set of colors that I just love personally—including yellow and pink—and tend to use them a lot.

What do you need to do when preparing the flowers and other materials before you start embroidering?

In the beginning, I used fresh flowers, but now I employ solely dried and preserved ones. Sometimes I buy processed materials—it's getting easier and easier to find dried or preserved flowers online or in shops. But more often, I forage for them or grow them myself. In those cases, I dry my own materials by air-drying them or pressing them between the pages of a book. My favorite method is drying them in silica gel as it's suitable for a greater variety of plants and flowers.

What is the biggest difficulty that you have experienced so far? How did you overcome it?

I would say the biggest difficulty has to do with transporting the finished hoops as they are very fragile—flowers can fall off if they're not handled gently. There are specialty couriers who handle delicate objects and they're great, but also expensive. I've been trying different ways to make the hoops more robust, so that they can survive even if being transported by a regular courier. I've also been using more preserved flowers, which tend to be more flexible and less brittle.

Do you have any suggestions for beginning embroiderers?

Enjoy experimenting and be patient! Flowers on tulle embroidery is a new artistic technique and everything I've achieved with it has come through experimenting and observing as well as slowing down and not rushing to finish a design in a set amount of time.

"What sets embroidery as a hobby apart from embroidery as an art form is the uniqueness and originality of the work."

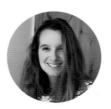

Natalie Ciccoricco

U.S.

Natalie Ciccoricco creates original multimedia works and analog works that consist of embroidery thread in combination with other materials—old images, books, magazines, natural materials, and ephemera being reused. By doing so, she hopes to bring new life to these materials, so that they can be enjoyed and appreciated once again. For her artworks, she draws inspiration from her dreams, her travels, all sorts of art and literature, and nature.

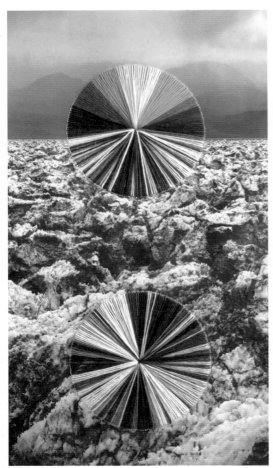 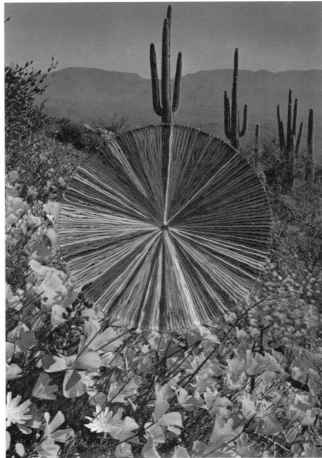

↑ Hole in Two

This embroidery is on a found image from an old book. The scenery is from the "Devil's Golf Course" in Death Valley National Park.

❊

Tools: Needle, scissors, knife, pin, artist tape

Materials: Thread, book sheet

Stitch: Straight stitch

↑ California Poppies

Reusing and repurposing materials is a big theme in Natalie's work. She likes to transform images from old books and magazines, so they get a second life and new meaning.

❊

Tools: Needle, scissors, knife, pin, artist tape

Materials: Thread, book sheet

Stitch: Straight stitch

→ The Sky, the Sea, and the Earth

The three "color holes" embroidered on this image of the Big Sur area in California symbolize the three elements of air, water, and earth.

❊

Tools: Needle, scissors, knife, pin, artist tape

Materials: Thread, book sheet

Stitch: Straight stitch

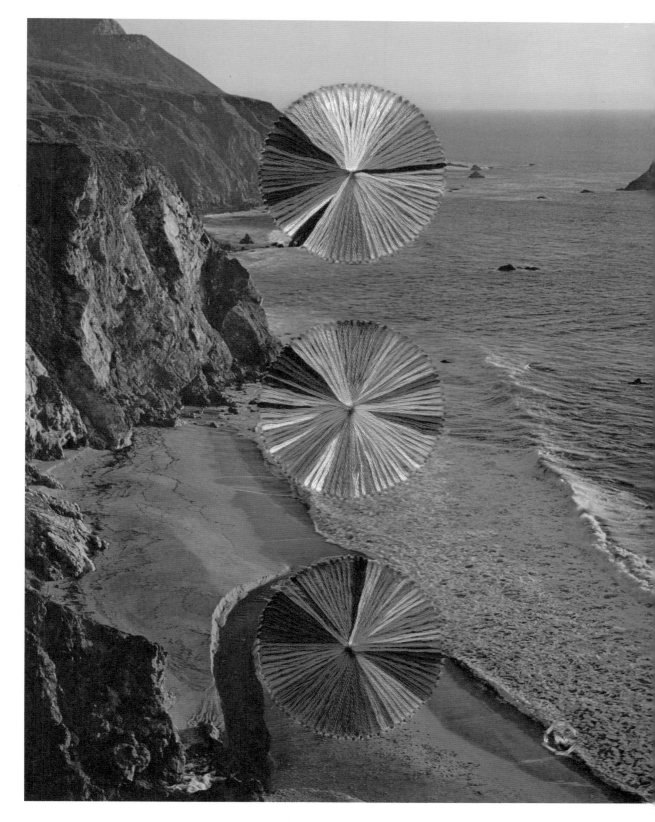

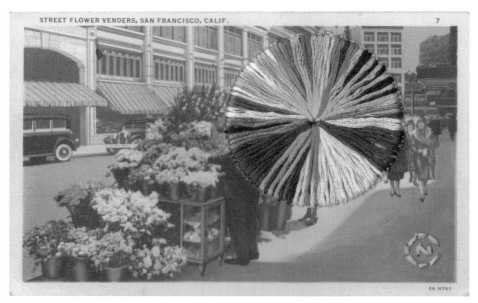

↑ Street Flower Vendors

This embroidery is sewn on a vintage postcard of a San Francisco street scene.

⚒

Tools: Needle, scissors, knife, pin, artist tape

Materials: Thread, postcard

Stitch: Straight stitch

↑ A Park Scene in Beverly Hills

To create the optical illusion of the color holes blending onto the paper, Natalie carefully picked out all the different colors to match the surrounding image.

⚒

Tools: Needle, scissors, knife, pin, artist tape

Materials: Thread, postcard

Stitch: Straight stitch

↑ The Bells & Arrowhead and Yucca

These embroidered postcards are framed in floating frames, which expose the backs of the artworks. This way, the stitches are visible and so are the details on the back, such as handwriting and pretty stamps.

※

Tools: Needle, scissors, knife, pin, artist tape

Materials: Thread, postcards

Stitch: Straight stitch

Interview with
Natalie Ciccoricco

How did you become a professional embroidery artist?

Years ago, when I was still in college, my mom gave my sister and me a bag full of embroidery thread that she bought from a thrift shop and asked us to do something creative with it. I always kept that in mind, but it took me years to sit down and play around with the thread. After I moved to California and my husband and I bought our house years later, I finally had the time and space to start a creative practice. I've been taking it one step at a time, but I'm very happy with my creative journey so far.

Why do you prefer embroidering on paper rather than on fabrics?

Since I started combining embroidery thread and paper collage, it seemed like a logical choice at the time. I like the rigidity of paper, which allows me to give the thread a certain tension that fabric can't provide. The downside is that it is less forgiving than fabric, as it can be torn more easily. I do like how I can experiment with the thread in different ways than I can on fabric, and I'm always thinking about new techniques and concepts.

How did the idea of combining twigs and threads come to you?

While sheltering at home due to the COVID-19 pandemic, I started creating my new "Nesting" series, which consists of embroidery artworks using natural materials found in our yard, on our deck or during nature walks. Exploring the juxtaposition between geometric shapes and organic elements, this new series has been an ongoing exercise to find beauty and hope in challenging times. I approached it like a daily creative study, while being cooped up at home.

Apart from twigs and sticks, stones can also be seen in Natalie's artwork. She has an open mind to explore the possibilities in materials and art.

What is the idea behind your "Color Holes" series? How did you start deconstructing the colors of the existing images such as postcards and photos?

This series is an exploration into color and the concept of multiple dimensions. I use embroidery thread on images of old books and magazines to create the visual illusion of a new vantage point—a glitch in space and time from which the image seems to explode or implode. Creating these pieces is like a form of meditation. I pick out my images from old books and magazines, carefully preparing them for embroidery and selecting the different colors of thread. My favorite part is stitching as it slowly reveals what the piece will look like. Although I have an idea in my mind of the end result, I am always surprised by the finished piece.

Most of your embroideries involve geometry. Why are you obsessed with it?

My love for geometric patterns stems from the idea that there are no straight lines in nature, but almost the opposite is true for embroidery—most stitches consist of straight lines, except stitches like French knots. It's the human manipulation of the medium that creates these straight lines. Using embroidery means that you are working with geometric shapes, even if you approach it freely and intuitively. Humans are naturally attracted to geometric shapes, as it gives the strange sense of control and order, even though it is a mere illusion.

Many of Natalie's Nesting artworks incorporate sticks that her son brings her. It melts her heart when he says: "Look Mama, here's a stick for your art."

How do you keep your mind open to experiment with all kinds of materials?

Once I started to make art, I was awakened to a new way of looking at the world. All of a sudden I got these thoughts of "I want to draw that" or "I love that shadow" or "I need to transform this object into something else." When I am creating, usually the result is like a snowball effect—the more I make, the more I open my mind to the infinite artistic possibilities out there.

In your opinion, what defines a good embroidery?

To me, good embroidery is a piece of embroidery with an original idea. If someone is able to use the medium in a way or style that I have never seen before, that really sparks my interest. Almost anyone can learn to embroider following a certain set of techniques or patterns. There's nothing wrong with that, but what sets embroidery as a hobby apart from embroidery as an art form is the uniqueness and originality of the work.

INDEX

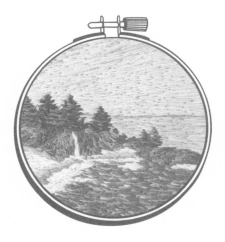

Agnesa Kostiukhina

instagram.com/agnesembroidery

064–071

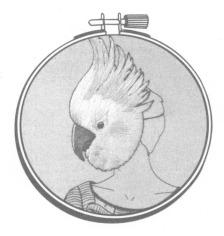

Amy Jones

instagram.com/cheese.before.bedtime

100–111

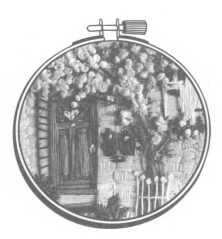

Artemis W Chung

instagram.com/mmiddleewc

072–079

Elena Obando

saturnorosa.com

190–199

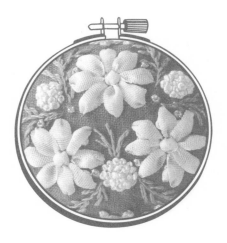

Erika Sugano

maki-x-maki.jimdo.com

148–157

Georgie K Emery

instagram.com/georgie.k.emery

122–129

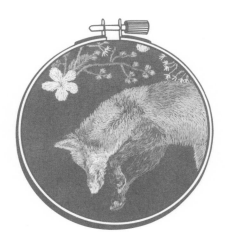

Jūra Gric

instagram.com/juragric

080–089

Juyeong Kim

instagram.com/ggoomso

140–147

Konekono Kitsune

instagram.com/konekono_kitsune

130–139

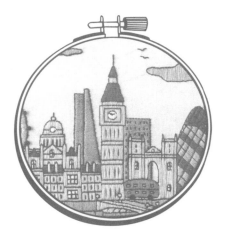

Kseniia Guseva

faimyxstitch.com

054–063

Mariam Satour

instagram.com/mariamsatour

180–189

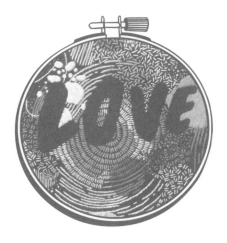

Maricor/Maricar

maricormaricar.com

112–121

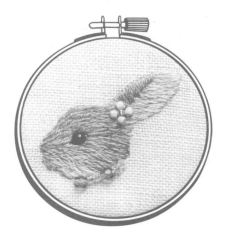

Mayuka Morimoto

instagram.com/cherin_mayuka

158–167

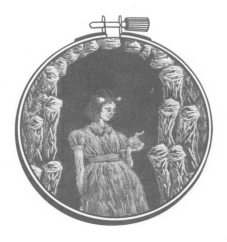

Michelle Kingdom

michellekingdom.com

090–099

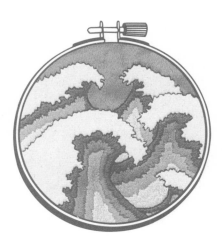

Mina Ivanova

instagram.com/mbroiderym

042–053

Natalie Ciccoricco

mrsciccoricco.com

208–216

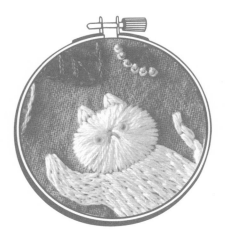

Nyang Stitch

instagram.com/nyang_stitch

168–179

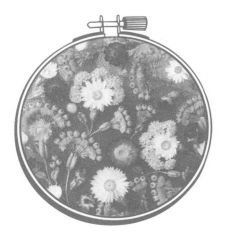

Olga Prinku

prinku.com

200–207

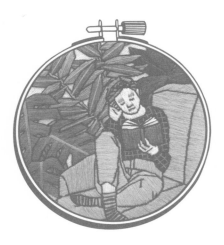

Sarah K. Benning

sarahkbenning.com

024–031

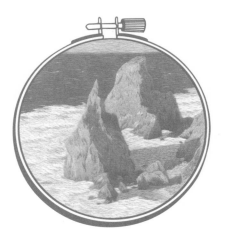

Tatiana

instagram.com/embroiderybynusik

032–041

Youngjin Jang

instagram.com/ette_etre

009–022

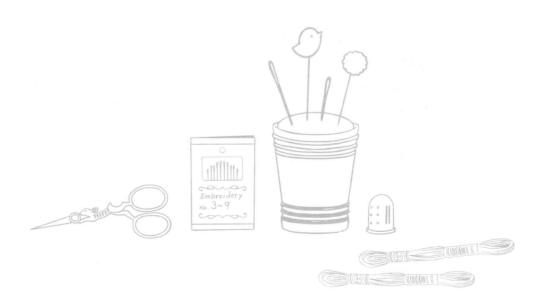

ACKNOWLEDGMENTS

We would like to express our gratitude to all of the artists for their generous contribution of images, ideas and concepts. We are also very grateful to many other people whose names do not appear in the credits, but who made specific contributions and provided support. Without them, the successful compilation of this book would not have been possible. Special thanks to all of the contributors for sharing their innovations and creativity with all of our readers around the world.